The Art of Leadership

Building Business – Arts Alliances

The Art of Leadership
Building Business-Arts Alliances

BY DAVID FINN AND JUDITH A. JEDLICKA

Abbeville Press
New York • London • Paris

Front cover: John Safer, "Twist 31," 1969.
Clear Lucite, 19 x 18 x 12 inches.
Collection of the artist, Washington, D.C.
Photograph by: David Finn

Back cover: Jean Dubuffet, "Conjugaison," 1975.
Acrylic on paper, mounted on cloth, 52⅜ x 119¾ inches.
The Patsy R. and Raymond D. Nasher Collection.
Photograph by: David Heald

Business Committee for the Arts, Inc.
1775 Broadway, Suite 510
New York, NY 10019-1942
http://www.bcainc.org

The text of this book was set in Trade Gothic Light.
Printed and bound in Japan.

First edition
10 9 8 7 6 5 4 3 2 1

Library of Congress Cataloging-in-Publication Data
Finn, David, 1921-
 The art of leadership: building business-arts alliances/by David Finn and
Judith A. Jedlicka.
 p. cm.
ISBN 0-7892-0566-1
1. Art patronage—United States—Case studies. 2. Corporate sponsor-
ship—United States—Case studies. . 3. Arts—United States—Finance—
Case studies. I. Jedlicka, Judith A. II. Title
NX711.U5F56 1998
707'.9'73—dc21 98-35321

Dedication

THIS BOOK IS DEDICATED TO DAVID ROCKEFELLER, WHO PROVIDED THE

VISION, LEADERSHIP, AND ENCOURAGEMENT THAT LED TO THE GROWTH OF

ENDURING ALLIANCES BETWEEN BUSINESS AND THE ARTS WORLDWIDE.

Table of
Contents

Foreword

Over years, David Finn and I have had a number of discussions about the factors essential to sustained growth in alliances between business and the arts. On nearly each occasion, we concluded that leadership is critical. Time and again we observed that companies led by individuals who possess a keen personal interest in the arts have enduring programs that benefit the arts, the company and the communities in which the company operates.

This book contains profiles of 29 business leaders who established or advanced their company's involvement with the arts. Each individual described in his own words how his interest in the arts evolved and how this influenced the company's programs. Several of these profiles were drawn from the national advertising campaign of the Business Committee for the Arts, Inc. (BCA). The title of the campaign, "The Art of Leadership," was developed by Arthur Lubow, President, AD Lubow, Inc., an advertising agency in New York. Thanks to the generosity of Christopher Forbes, Vice Chairman, Forbes Inc. and a Director of the Business Committee for the Arts, the ads first appeared in *FORBES* Magazine. They were well-received and led to the creation of this book as part of the 30th Anniversary initiatives of the Business Committee for the Arts.

In the process of developing this book, it occurred to me that it would be an omission not to include David Finn. He, along with his childhood friend, William Ruder, were in the forefront of the movement in the United States to link business with the arts. In 1948 they founded Ruder & Finn Associates and created within it a special division, Art In Industry, to bring business and the arts together. For more than a half century, David Finn and William Ruder — each an accomplished business leader and artist in his own right — have encouraged their employees and their clients to integrate the arts in their professional and personal lives.

The development of these profiles was a shared task. David Finn conducted the interviews and photographed many of the business leaders in a setting reflecting their interest in the arts. The interview with Yoshihara Fukuhara, Chairman of Shiseido Co., Ltd. was conducted by our good friend, Shisho Matsushima, Managing Director of Strategies Inc., in Shiseido's headquarters in Tokyo. I interviewed David Finn, compiled the background about each company's program and wrote the profiles.

This book offers a sampling — not a comprehensive survey — of business executives who share a personal affinity for the arts, as well as a commitment to building links between business and the arts that benefit both sectors, foster understanding and improve quality of life throughout the world.

— *Judith A. Jedlicka*

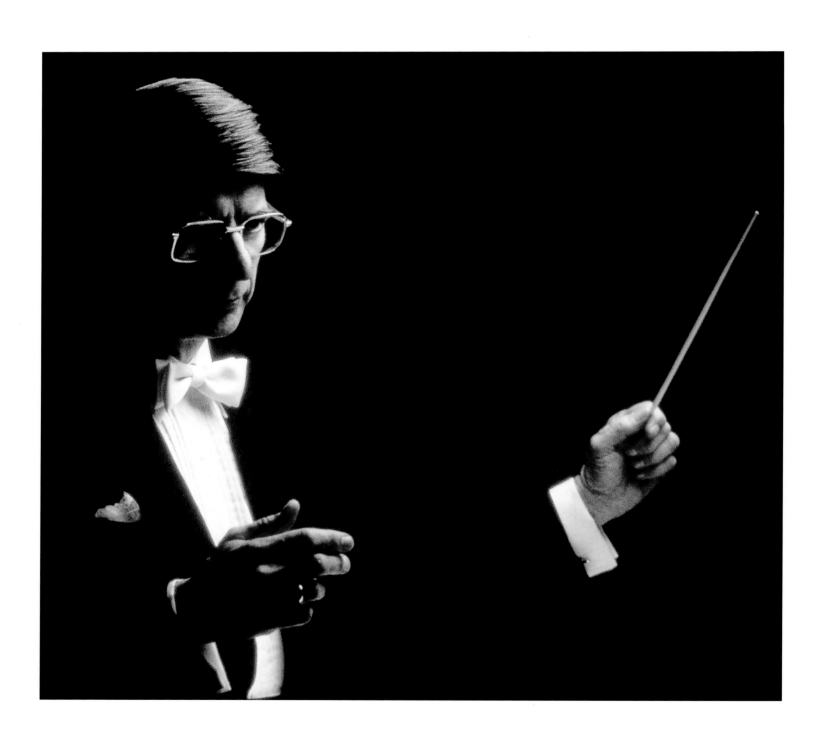

On the Art of Leadership

We began this book with the idea that the business leader is the key factor in determining the degree to which a company supports the arts. Leaders who appreciate high quality consider their involvement with the arts as a mark of excellence to which all can aspire. There is also an art to the way leaders instill in others an enthusiasm for the work they are doing. Both of these meanings are implicit in what we call the art of leadership.

By definition, a leader is "a person who by force or example, talents or qualities of leadership plays a directing role, wields commanding influence, or has a following in any sphere of activity." The difference between business managers and business leaders is that the former know how to organize work so that it is done efficiently, while the latter know how to create enthusiasm about work so that it is done with commitment. Managers direct; leaders inspire. Leaders stimulate a collective desire to achieve high levels of performance, to serve the interests of both the company and the community, to provide benefits to others while fulfilling personal ambitions. Like the conductor of an orchestra under whose guidance musicians realize the full potential of a composition, a business leader orchestrates the activities of large numbers of people working together toward a common objective.

The relationship between the business leader and the arts is part of an age-old tradition. The well-known examples of Pericles in ancient Athens, Maecenas in ancient Rome and the Medicis in fifteenth-century Florence, are often cited as prototypical examples of roles that enlightened leaders have played in the cultural life of their times. In the United States, the great entrepreneurs of the nineteenth century used their positions of leadership, along with their enormous wealth, to become the benefactors of such temples of beauty as the National Gallery of Art in Washington, D.C., The Metropolitan Museum of Art in New York and The Art Institute of Chicago.

During the twentieth century, in particular the second half, the idea of institutional involvement with the arts emerged among business leaders who succeeded the wealthy patrons of the past. Unlike their nineteenth-century predecessors, who often used the arts to celebrate their worldly success, the modern-day business leader incorporates the arts in the day-to-day functions of his or her company to provide uplifting cultural experiences for employees and the community, with the ultimate goal of enriching the quality of life.

To determine the validity of this concept, I interviewed each executive — with the exception of Yoshihara Fukuhara, Chairman of Shiseido Co., Ltd. — and encouraged each to talk about his personal interests, how he was first exposed to the arts, what the arts meant to him at different stages of his life, how the arts affected his business career, how his experiences led to his company's involvement with the arts and why and how his company's arts projects are worthwhile.

Like many of the executives in this book, I believe that there is no way to measure the effect of esthetic experiences. Indeed, by their very nature, the arts reach into unexplored territories. Associating business with the arts increases opportunities for individuals to expand their thinking beyond day-to-day perspectives, and encourages innovative and creative ideas in their work.

Will the partnership between business and the arts survive in the twenty-first century? The business leaders that we interviewed believe that it will, despite the rapid changes taking place in business; their observations encourage us to feel that the relationship, fostered by the Business Committee for the Arts since it was founded in 1967, is firmly established.

— David Finn

Opposite:
Herbert Blomstedt,
Director Designate,
San Francisco
Symphony.

Three Decades of Growth in Business-Arts Alliances

DURING THE 1960S, A DECADE FILLED WITH POLITICAL AND SOCIAL STRIFE GENERATED BY THE CIVIL RIGHTS MOVEMENT, A WAR IN SOUTHEAST ASIA AND FAILED PROMISES OF THE NEW FRONTIER AND THE GREAT SOCIETY, THE ARTS FLOURISHED IN THE UNITED STATES AS NEVER BEFORE. BY THE MIDDLE OF THIS DECADE THERE WERE A RECORD NUMBER OF CULTURAL ORGANIZATIONS — MUSEUMS, SYMPHONY ORCHESTRAS, THEATER, DANCE AND OPERA COMPANIES — IN CITIES LARGE AND SMALL. AND THE NUMBER OF AMERICANS PARTICIPATING IN THE ARTS HAD INCREASED DRAMATICALLY. SO, TOO, HAD THE CONCERN THAT THE ARTS COULD NO LONGER DEPEND, AS THEY ONCE HAD, ON WEALTHY INDIVIDUALS AND FOUNDATIONS TO FINANCE THEM. THERE WAS A GROWING SENSE THAT NEW SOURCES OF SUPPORT HAD TO BE FOUND.

MUCH OF THE COUNTRY'S HEIGHTENED INTEREST IN CULTURE WAS GENERATED BY PRESIDENT JOHN F. KENNEDY AND HIS WIFE, JACQUELINE.

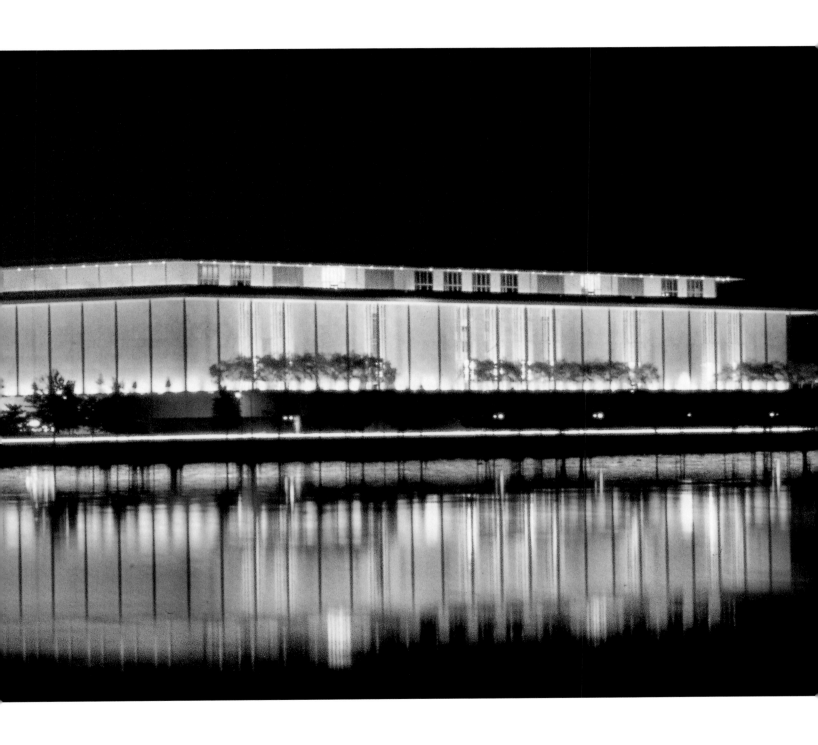

The John F. Kennedy Center
for the Performing Arts,
Washington, D.C.

Their commitment to the arts became evident during the 1961 Presidential Inaugural Ceremony, when moments after the Oath of Office was administered, Robert Frost — one of America's most beloved poets — stepped to the podium and read a poem he had written for the occasion. Once in The White House, the Kennedys frequently showcased the artistic richness of the country by inviting great artists — Marian Anderson, Pablo Casals, Aaron Copland, Edward Villella and Igor Stravinsky, among many others — to perform for visiting dignitaries during State functions, and they arranged to have some of these performances telecast nationally.

As Mrs. Kennedy worked with historians and art experts to restore the historic decor and antique furnishings throughout The White House, President Kennedy worked to gain support for the arts among members of his Administration and Congress. His efforts were focused on two ideas initially proposed by President Dwight D. Eisenhower. One was to create a national agency to encourage artistic activities throughout the country. The other was to build a

national cultural center in Washington, D.C. Under President Kennedy's leadership a plan took shape to establish the National Council on the Arts, the forerunner of the National Endowment for the Arts, and a strategy was developed to create a national performing arts center. It was not, however, until after President Kennedy was assassinated, that President Lyndon B. Johnson signed into law the establishment of the National Endowment for the Arts. Shortly thereafter, construction began on a national cultural center in Washington, D.C., which was named The John F. Kennedy Center for the Performing Arts, to acknowledge President Kennedy's efforts to advance the arts.

A year or so after the National Endowment for the Arts was established, two landmark reports about the state of the arts in America were published. The first was *The Performing Arts: Problems and Prospects*, produced by a special Rockefeller Panel, convened under the leadership of John D. Rockefeller 3rd. The other was *Performing Arts - The Economic Dilemma* by William J. Baumol and William G. Bowen, published by The Twentieth Century Fund. Both chronicled the extraordinary growth of the arts in the United States, defined their importance to national development and growth and explained some of the current and potential financial challenges facing the arts. Additionally, the reports revealed some relatively unknown facts — ticket revenues and admission fees covered only about half of the operating costs of most cultural organizations, and the shortfall was generally realized from contributions, most of which came from individuals and foundations. The reports suggested that as activities and operating costs increased, individuals and foundations might not be in a position to increase funding. They advised arts organizations to seek new support from government agencies and business, rather than increase admission and ticket prices and risk a decrease in attendance.

Copies of both reports were widely circulated. The Rockefeller Panel Report was distributed to several hundred business executives attending the June 1965 meeting of The New York Board of Trade. It generated considerable interest and concern. So much, in fact, that The Board of Trade formed an Arts Advisory Council to explore and suggest ways that business might assist the arts. In addition,

the Board collaborated with *Esquire* magazine to establish the Business in the Arts Awards. These Awards, first presented in 1966, were created to recognize companies that had developed exemplary alliances with the arts and to encourage other companies to follow their lead.

Speaking to business leaders attending the 50th Anniversary Conference of the National Industrial Conference Board, held in New York on September 20, 1966, David Rockefeller built on this momentum by encouraging the business community to form a national organization designed to foster ongoing business support to the arts. In his keynote address, *Culture and the Corporation*, he said that, The recent Rockefeller Panel Report "brought forth some disturbing and challenging facts....The arts are a vital part of human experience, and surely our success as a civilized society will be judged largely by the creative activities of our citizens in arts, architecture, music and literature....Improving the condition of the performing and visual arts in this country calls, in my judgment, for a massive corporate effort in which businesses

must assume a much larger role than they have in the past....The arts have traditionally drawn their support primarily from wealthy individuals and foundations which are no longer able to cope with their growing needs and not enough companies have moved in to take up the slack....I would like to propose that we seriously consider the establishment of a....Council on Business and the Arts."

The response to David Rockefeller's proposal was overwhelmingly positive. On November 15, 1967, he hosted the first meeting of a newly formed national organization, named the Business Committee for the Arts, Inc. (BCA). It took place in New York in the headquarters of The Chase Manhattan Bank where he served as the Bank's President. C. Douglas Dillon, former Secretary of the United States Treasury and then President of the United States Foreign Securities Corporation, was elected Chairman of the new organization and David Rockefeller was elected one of seven founding directors. All those present pledged to develop a network of business leaders who would work to encourage business to support the arts throughout the country.

First meeting of the Business Committee for the Arts, Inc. (BCA) Opposite: Roger L. Stevens, Chairman, National Council on the Arts.

"Business, as a responsible citizen, has a crucial leadership role to play in helping to solve the problems our artistic institutions face in meeting the growing public demand for their services. The arts, like education, are not and cannot be a paying proposition. They need constant help," said Mr. Dillon, as he announced the formation of the Business Committee for the Arts and challenged business to allocate ten percent of its annual philanthropic budget to the arts.

By 1969 more than 100 business leaders had joined the Business Committee for the Arts. Among them were executives from Texaco Inc., which had been underwriting broadcasts of Metropolitan Opera performances since 1940 and AT&T, which had been supporting *The Telephone Hour* since 1940. Many pledged to increase their own companies' links with the arts and some agreed to travel around the country

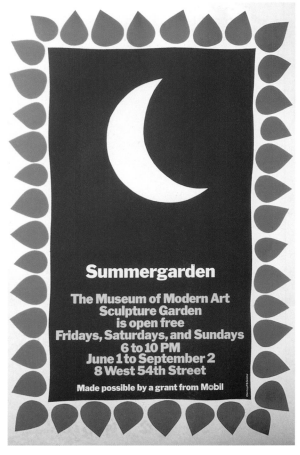

Summergarden

**The Museum of Modern Art
Sculpture Garden
is open free
Fridays, Saturdays, and Sundays
6 to 10 PM
June 1 to September 2
8 West 54th Street**

Made possible by a grant from Mobil

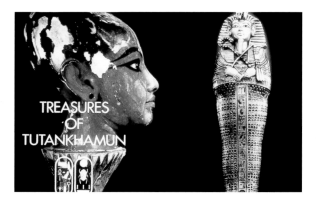

to talk with other business leaders and encourage them to do the same. In 1969 BCA undertook the first national survey to measure and track trends in business support to the arts, and two years later launched a national advertising and media campaign to heighten interest in the concept. These activities captured the attention of business leaders and resulted in increased business involvement with the arts both in and out of the workplace. Companies from coast-to-coast began hosting performances in their facilities, offering employees tickets to arts events, matching employee gifts to cultural organizations and collecting art to be displayed in

their offices and operating facilities. At the same time, they also increased grants to arts organizations for general operations and special projects.

At first, museums and public television received the greatest share of business support, especially for special projects. In 1970, for example, the Aluminum Company of America Inc. (ALCOA) made the first major grant to The Museum of Modern Art to underwrite *Collections of Gertrude Stein and Her Family.* Three years later BankAmerica Corporation supported a major exhibition of Andrew Wyeth's work in the M.H. de Young Memorial Museum, part of The Fine Arts Museums of San Francisco, and in the same year Mobil Corporation underwrote all costs associated with keeping the Sculpture Garden of The Museum of Modern Art open free to the public several nights a week during May and June. In 1977 Exxon Corporation announced a grant of more than $1 million to sponsor *Treasures of Tutankhamun,* which opened in the National Gallery of Art in Washington, D.C., and then traveled to four additional venues before closing in The Metropolitan Museum of Art in New York. In that same year, Philip Morris Companies Inc. created the first national advertising campaign designed specifically to inform the public about two traveling exhibitions it was sponsoring — *Two Centuries of Black American Art* and *Remember the Ladies* — and to encourage broader participation in the arts.

The heyday of business support to public television began in 1970 when Mobil Corporation made a $1 million grant to underwrite *Masterpiece Theatre.* The Company invested more than $100 million in this series and went on to sponsor many popular television programs, including *Mystery!, Classical Theatre, Ascent of Man, Life on Earth* and *The Living Planet: A Portrait of the Earth.* Another major supporter of public television was Xerox Corporation, which underwrote *The Autobiography of Miss Jane Pittman, Mission Possible, The Japanese* and *Film Odyssey.* In 1972 General Electric Company pledged $500,000 to the Corporation for Public Broadcasting (CPB) to underwrite the telecasts of the first International Performance Series produced by the French National Television Network. And, a year later Exxon announced its sponsorship of *Great Performances* — a sponsorship that lasted 15 years and resulted in the telecast of 500 live performances from

Lincoln Center for the Performing Arts. Shortly thereafter, ARCO made a grant of $1.2 million to fund the production of the series, *The Adams Chronicle.*

During the 1970s business also began providing significant support to the performing arts to encourage their growth and to increase accessibility. In 1973 Exxon formed a partnership with Affiliate Artists, Inc. to increase opportunities for gifted young American conductors to conduct American orchestras throughout the country. A year later the Company made a grant to Lincoln Center earmarked to produce the first major series of free outdoor summer performances. In 1978 AT&T announced a four-year commitment to support performances presented by seven major American orchestras in 100 cities. And, during the Nation's Bicentennial, Amoco Corporation, Exxon Corporation, IBM Corporation, Mobil Corporation, McDonald's Corporation, The Prudential Insurance Company of America and Xerox Corporation underwrote theater, music and dance performances presented

Robert MacNeil (center)
with guests attending The
New Hampshire MacDowell
Celebration,
supported by the New
Hampshire Business
Committee for the Arts.
Opposite (Top to Bottom):
Morton H. Myerson
Symphony Center, Dallas,
Texas; "Art, The Cultural
Bus," a program of the
Northwest Business
Committee for the Arts,
Portland, Oregon.

in The John F. Kennedy Center for the Performing Arts in Washington, D.C., to heighten appreciation of America's cultural heritage.

As interest in the performing arts grew and performance schedules increased, performing arts facilities had to be renovated and new ones built. In many instances business leaders and top-level executives assumed leadership roles in this process. In the early 1970s, for instance, H.J. Heinz Company encouraged 78 companies to invest in the renovation of Heinz Hall for the Performing Arts in Pittsburgh. Humana Inc. helped to develop the plan for the new Kentucky Center for the Arts in Louisville and agreed to supervise its construction, and Henry T. Segerstrom, Managing Partner of C.J. Segerstrom & Sons, and his family donated five acres of land, plus $1 million, to initiate the process of building the Orange County Performing Arts Center in Costa Mesa, California. In 1972, Donald R. Seawell, President and Chairman of the Board of The Denver Post, organized a group of the City's business, arts

and civic leaders to develop The Denver Center for the Performing Arts, and shortly thereafter, a group of Dallas business executives spearheaded a drive to create the Arts District in downtown Dallas, which includes the Morton H. Myerson Symphony Center and the Dallas Museum of Art.

The 1970s was also a time when companies developed and expanded their art collections and devised ways to share these collections with their employees and the public. Some invited art professionals into the business setting to present lectures about art and to train employees to serve as docents for the collection. A few lent works from their holdings to museums for special exhibitions. In 1976 the first of two major exhibitions, *Pittsburgh Corporations Collect*, featuring works from 17 Pittsburgh-area corporate art collections, opened in The Carnegie Museum of Art in Pittsburgh. Three years later the Montgomery Museum of Fine Arts presented, *Art Inc.: American Paintings from Corporate Art Collections*, an exhibition of works owned by 30 companies, which traveled to museums in the United States and abroad.

By 1979 the Business Committee for the Arts had organized 55 major conferences throughout the United States to promote alliances between business and the arts, and business support to the arts had reached $436 million a year. Many major companies were allocating about 10 percent of their total annual philanthropic resources to cultural endeavors, and small and midsize companies were beginning to make their first grants to arts groups in their communities. To increase business involvement with the arts at the local level, the Business Committee for the Arts fostered the growth of Affiliates. The first, based in Montgomery, Alabama, was established in 1980 under the leadership of Winton M. Blount, Chairman of Blount International, Inc. The next, in Orange County, California, was founded in 1981 by David S. Tappan, Jr., Chairman of the Board & CEO of Fluor Corporation. Others were organized in Atlanta, Tucson, Colorado, New Hampshire, Austin, El Paso, Dallas, San Antonio and Portland, Oregon. In 1980 the concept of building alliances between business and the arts moved abroad. The British business community established the Association for Business Sponsorship of the Arts (ABSA), the first of many international organizations that would be

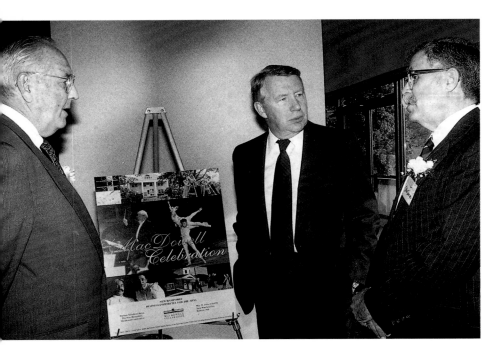

Company worked with The Metropolitan Museum of Art in New York to adapt designs from the Museum's textile collections for its home furnishings lines. This collaboration produced record sales for Springs and more than $4 million in royalties for The Met. It also captured the attention of marketing executives throughout the country.

In 1982 American Express Company added a new dimension to the relationship between business and the arts by launching the first major cause-related marketing agreement with arts organizations in markets in which the Company wanted to increase the use of its services. Through advertising, marketing and promotional efforts, American Express promised customers that designated arts organizations would receive a certain sum of money each time a new American Express account was opened or its credit card was used. This program generated approximately $22 million for the participating arts organizations and increased the Company's business by about 30 percent. Its success prompted other companies to develop similar initiatives. For example, in 1987 The Chase Manhattan Bank offered customers who used their ATM card free admission to the Solomon R. Guggenheim Museum's exhibi-

formed throughout the world, based on the BCA model, and a few years later a similar organization called the Association pour le Développement du Mécénat Industriel et Commercial (ADMICAL) was founded in France. In 1990 business leaders in Japan organized Kigyo Mécénat Kyogikai, the first association in Asia designed to promote business links with the arts. Six years later the International Network of Business Arts Associations was established to facilitate dialogue and cooperation among these associations and others operating in Austria, Belgium, Canada, Denmark, Germany, Greece, Ireland, Israel, Italy, Korea, The Netherlands, South Africa, Spain, Sweden and Switzerland.

As companies became more familiar with the arts and the demographics of the American arts audience, they began to seek new ways to incorporate the arts in their marketing, public relations and advertising strategies to advance their business objectives. Among the first to create a major licensing agreement with the arts was Springs Industries, Inc. The

tion, *Fifty Years of Collecting: An Anniversary Selection*, sponsored by Chase. This increased the use of the ATM card and the number of individuals attending the exhibition. In 1996 Advanta Corporation, a consumer financial services company, agreed to be the sole sponsor of *Cézanne*, an exhibition organized and presented by the Philadelphia Museum of Art in collaboration with Musée d'Orsay in Paris and the Tate Gallery in London. In the process of doing this, Advanta worked with the Museum to develop special marketing initiatives that helped broaden the Company's share of the market and at the same time increased exhibition attendance.

In the 1980s the relationship between business and the visual arts underwent dynamic changes. During the first half of the decade a number of companies, following in the footsteps of PepsiCo Inc., known worldwide for its corporate sculpture garden, undertook large-scale projects focused on making the visual arts part of the daily experience of employees and visitors. General Mills, Inc., for example, developed an award-winning sculpture garden which featured works by twentieth-century masters. Hallmark Cards, Inc. worked with The Nelson-Atkins Museum of Art to design a sculpture garden featuring some of Henry Moore's works owned by The Hall Family Foundation, while Georgia-Pacific Corporation, Philip Morris Companies Inc., Champion International Corporation, IBM Corporation, PaineWebber Group Inc. and The Equitable Life Assurance Society devoted exhibition spaces in their headquarters buildings to show art from their collections, and invited selected not-for-profit arts organizations to present special exhibitions.

The early 1980s was also a time when real estate developers purchased and commissioned a substantial amount of art for their projects, believing it would set their proper-

Top to Bottom (Left to Right): Richard Serra's "Core," General Mills Corporate headquarters, Minneapolis, Minnesota; Henry Moore's "Reclining Figure: Hand," aquired by the Hall Family Foundation for the Henry Moore Sculpture Garden, sponsored by Hallmark, Inc., Kansas City, Missouri; Carolyn Braaksma and Andrew Dufford's, "The Fence," The Museum of Outdoor Arts, John Madden Company, Englewood, Colorado. Opposite (Top to Bottom): A poster for "The Vatican Collections: The Papacy and Art," sponsored by Philip Morris Companies Inc.; Alexander Calder's "Hats Off," Pepsico Inc. headquarters, Purchase, New York.

ties apart from those of their competitors and attract tenants. John W. Madden, Jr., Chairman of the Board of John Madden Company, commissioned several large-scale works and created The Museum of Outdoor Arts as part of his Company's business park, Greenwood Plaza, in Englewood, Colorado. Henry T. Segerstrom, Managing Partner of C.J. Segerstrom & Sons, commissioned Isamu Noguchi in 1981 to create a sculpture garden, *California Scenario,* for his Company's multi-use office complex in Costa Mesa, California. Raymond D. Nasher, Chairman of The Nasher Company, purchased and commissioned a number of twentieth-century works which he installed in NorthPark Center, an upscale retail center in Dallas.

By the mid-1980s the costs associated with presenting major museum exhibitions escalated to record levels and business began exploring new ways to fund exhibitions. In 1986 Philip Morris Companies Inc. pledged $1 million to be named the primary sponsor of *The Vatican Collections: The Papacy and Art*, and agreed to help develop consortiums of additional business supporters to underwrite costs associated with

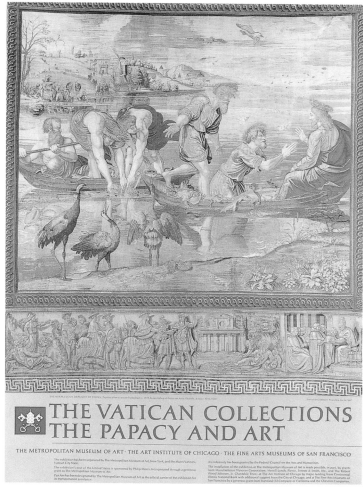

the presentation of this exhibition in three venues — The Metropolitan Museum of Art, The Art Institute of Chicago and The Fine Arts Museums of San Francisco. Nearly a dozen companies supported this exhibition, which was seen by more than one million individuals. A year prior, Ford Motor Company provided more than $1 million to be the sole sponsor of *The Treasure Houses of Britain,* which attracted 800,000 visitors to the National Gallery of Art in Washington, D.C. By the end of the decade, rather than supporting one major exhibition organized by an individual museum, Ford changed its strategy and developed a collaboration with five museums. The Company worked with The Carnegie Museum of Art in Pittsburgh, The Minneapolis Institute of Arts, The Nelson-Atkins Museum of Art in Kansas City, Missouri, The Saint Louis Art Museum and The Toledo Museum of Art in Ohio to mount a major exhibition of Impressionist paintings drawn from the permanent collections of these museums. This exhibition, *Impressionism: Selections from Five American*

Museums, was shown in all five museums and was viewed by more than 760,000 individuals.

The dramatic growth in the use of technology during the 1980s resulted in a number of new alliances between companies in this industry and the arts. In 1980, for example, Hewlett-Packard Company made the first major gift of hardware, software and technical assistance to the San Francisco Symphony to manage single ticket sales, subscriptions, fundraising appeals and word processing. Shortly thereafter, AT&T, IBM Corporation and Digital Equipment Corporation made similar gifts to other arts organizations across the country. By the end of the decade, these companies and others expanded their relationships with the arts by forming collaborative projects to design ways to use technology to enhance creative functions such as lighting and graphic design, collection management, rehearsal scheduling, on-site educational programs and extended learning initiatives.

As the 1990s began, there were many changes taking place in the United States — technological advances, a major recession, business restructuring, a growing concern about reforming K-12 education and a national movement to reduce government spending — all of which affected business support to the arts. By 1991 business support declined to $518 million from $634 million in 1988 — the first decline since 1967. To address change and to stem further reductions, the Business Committee for the Arts encouraged business and the arts to explore new ways of working together that would maximize resources, create stronger links between the arts and other community organizations, generate new support from small and midsize companies and incorporate the arts in business strategies.

In response to change and hoping to maximize resources and generate new support from companies that did not traditionally support the arts, several consolidated campaigns were established. In 1991 the National Corporate Theatre Fund announced its *Leadership Campaign for American Theatre*. Eight companies — American Express Company, AT&T, The BFGoodrich Company, GTE Corporation, IBM Corporation, Mobil Corporation, Praxis Media and Xerox Corporation — made major commitments to seed this $5 million campaign designed to generate new business support for 10 regional theaters. A year later,

Hewlett-Packard Company and Syntex Corporation provided the leadership, plus a total of $350,000 in grants, to establish the Silicon Valley Arts Fund, created to increase business support for 80 arts organizations in Santa Clara, California. In 1993 The Coca-Cola Company made a $500,000 matching grant to the Metropolitan Atlanta Arts Fund to encourage Atlanta-area businesses to support the Fund's $3 million campaign to help the City's small arts organizations achieve financial and artistic stability.

To maximize resources and to strengthen bonds between the arts and other not-for-profit organizations in the community, companies throughout the country increasingly began to fund joint initiatives during the 1990s. For example, in the Minneapolis-St. Paul area, Dayton Hudson Corporation supported cultural and health agencies to heighten awareness about AIDS prevention and its application to workplace issues. In San Francisco, Pacific Telesis Group funded The New Conservatory Theatre Centre's play

about AIDS prevention presented to youngsters in shelters, juvenile detention centers and drug rehabilitation facilities. In Ohio, Owens-Illinois, Inc., headquartered in Toledo, partnered with The Toledo Symphony to initiate a program to offer music lessons to juvenile offenders, hoping that these lessons would increase self-esteem, foster discipline and ultimately reduce repeat offenses. Jaeger Management Company, headquartered in Beverly Hills, brought businesses, foundations, government agencies and the public school system together to create Inner-City Arts, a multi-discipline arts facility that offers at-risk and latch-key children and their guardians creative educational programs. In a similar spirit, The Coca-Cola Company in Atlanta underwrote the *Ira Aldridge Program for Youth*, a theater initiative designed to help children living in low-income housing projects deal with personal and social issues. In Philadelphia, ARAMARK Corporation provided a start-up grant to enable the Settlement Music School to

create the *Kaleidoscope Preschool Arts Enrichment Program* to help underserved children develop basic skills needed to enter the public education system. In Waukesha, Wisconsin, GE Medical Systems sponsored a ticket sales promotion for the Milwaukee Ballet's performances of *Swan Lake,* which also benefited the *Wisconsin Trumpeter Swan Recovery Program.* In Los Angeles, the Seven Up/R.C. Bottling Company worked with the Los Angeles County Museum of Art to promote a community recycling effort. And, in Tampa, Eastman Kodak Company and several small companies — Creative Color Labs, EMR South and Keith Hall Photography — collaborated with the Tampa Museum of Art to sponsor *Silver Sand, Golden Images,* an exhibition focusing on environmental changes in Florida.

As the national movement to reform K-12 education reached its zenith during the 1990s, an increasing number of companies, large and small, began creating and funding arts education programs. One of the earliest of these was developed by Binney & Smith Inc., manufacturer of Crayola crayons and art supplies. The Company worked with educators to establish *Crayola® Dream-Makers,*™ a model program that provides guides and visual materials to help teachers incorporate the visual arts in their lesson plans. Another initiative was the Metropolitan Life Foundation's *Partnerships: Arts and the Schools.* Established in 1993, this competitive grant project supports arts education projects that serve specific community needs. To encourage high school stu-

dents to attend performances and cultural events in New York City, Citicorp, The New York Times Company and Ticketmaster funded *High 5 Tickets for the Arts,* a program which enables these students to purchase tickets for $5 or less. And, to encourage college science students in the Pittsburgh area to enrich their technical education by attending Pittsburgh Symphony Orchestra performances, Bayer Corporation created the *Science Students at the Symphony Series.* Students participating in this program may purchase concert tickets at 75 percent off the regular ticket price and attend a post-concert reception with musicians and Bayer executives.

Concern about the well-being of employees and their families, prompted in part by company restructuring and massive layoffs, led many companies to create workplace arts programs designed to spark creativity and to enhance morale. For example, GE Plastics in Pittsfield, Massachusetts, partnered with Jacob's Pillow Dance Festival to develop a workplace dance initiative to encourage employees to think creatively. Hercules Incorporated, headquartered in Wilmington, Delaware, invited students attending high schools in the City to design murals for the stairwells in its headquarters building. By doing this, the Company assisted the arts programs in local high schools and, at the same time, the murals enlivened the building and encouraged employees to use the stairs rather than the elevators. And, PaineWebber Group Inc. collaborated with The Studio in a School Association, Inc., in New York, to underwrite *Little Dividends®* — an annual family day of art workshops and events for its employees' children, held in the Company's New York headquarters.

The 1990s were also a time when companies developed

initiatives with the arts designed to help business retain and attract new customers, and to help the arts expand their audiences. In 1994, for example, Alamo Rent A Car, Inc. worked with museums to launch *Alamo Presents the Art of America*. Through a series of exhibitions, the first being *American Impressionism and Realism: The Paintings of Modern Life, 1885-1915*, which opened in The Metropolitan Museum of Art in New York and then traveled to museums in Fort Worth, Denver and Los Angeles, the Company heightened awareness of its services and broadened its customer base in its major markets throughout the country. In each venue Alamo provided a special book about the exhibition, as well as discount coupons for car rentals. In 1996 NYNEX Corporation, a regional telephone company, created *Added Attractions,*ˢᵐ a discounted and complimentary ticket program, to retain and attract customers and to provide additional support for many of the cultural organizations with which it worked. And, to increase public recognition of its new name, Xerox, The Document Company, awarded the Library of Congress a $1.1 million grant to support the rotating exhibition of great American documents, *Treasures of the Library of Congress*, which runs through the year 2000, the Library's 200th anniversary.

By 1994 as the recession began to show signs of end-ing, the number of companies involved with the arts had increased and business support reached a record high of $875 million. While major companies continued to provide substantial support, more and more small and midsize companies throughout the country were making consider-able investments in the arts. Among these companies, were — I.W. Marks Jewelers, Inc. in Houston, Texas; Fredrick J. Urbaska Investments, Billings, Montana; The Silvertree Hotel in Snowmass Village, Colorado; Slightly North of Broad, a restaurant in Charleston, South Carolina; ODS Health Plans, a managed health care provider in Portland, Oregon; and Loon Mountain Recreation Corporation in Lincoln, New Hampshire — all recipients of Business in the Arts Awards.

As the Business Committee for the Arts marks its 30th Anniversary, it is evident that the business leaders who embraced David Rockefeller's vision have advanced busi-ness involvement with the arts from an idea to a tradition — a tradition which over time withstands dramatic economic, social and political changes and one which will continue to grow and provide benefits to business and the arts, in addi-tion to enriching the quality of life for this and future genera-tions throughout the world.

—Judith A. Jedlicka

Left to Right: Publicity materials from "Alamo and the Arts;" artwork in Slightly North of Broad, Charleston, South Carolina. Opposite (Top to Bottom): children participating in "Kaleidoscope Preschool Arts Enrichment Program;" educational materials from "Kaleidoscope" and "Crayola Dream-Makers."

Culture and the Corporation

...THE ARTS ARE A VITAL PART OF HUMAN EXPERIENCE, AND SURELY OUR SUCCESS AS A CIVILIZED SOCIETY WILL BE JUDGED LARGELY BY THE CREATIVE ACTIVITIES OF OUR CITIZENS IN ART, ARCHITECTURE, MUSIC AND LITERATURE. IMPROVING THE CONDITION OF THE PERFORMING AND VISUAL ARTS IN THIS COUNTRY CALLS, IN MY JUDGMENT, FOR A MASSIVE COOPERATIVE EFFORT IN WHICH BUSINESSES MUST ASSUME A MUCH LARGER ROLE THAN THEY HAVE IN THE PAST. THE CORPORATE COMMUNITY AS A WHOLE HAS A LONG WAY TO GO IN ACCEPTING THE ARTS AS AN APPROPRIATE AREA FOR THE EXERCISE OF ITS SOCIAL RESPONSIBILITY.

I'D LIKE TO SHARE WITH YOU MY OWN REFLECTIONS ON WHY I FEEL BUSINESS SHOULD CONSIDER SUBSTANTIALLY GREATER INVOLVEMENT IN THE ARTS, AND HOW IT MIGHT GO ABOUT THIS. ALMOST IMPERCEPTIBLY OVER THE PAST SEVERAL YEARS, THE MODERN CORPORATION HAS EVOLVED INTO A SOCIAL AS WELL AS AN ECONOMIC INSTITUTION. WITHOUT LOSING SIGHT OF THE NEED TO MAKE A PROFIT, IT HAS DEVELOPED IDEALS AND RESPONSIBILITIES GOING FAR BEYOND

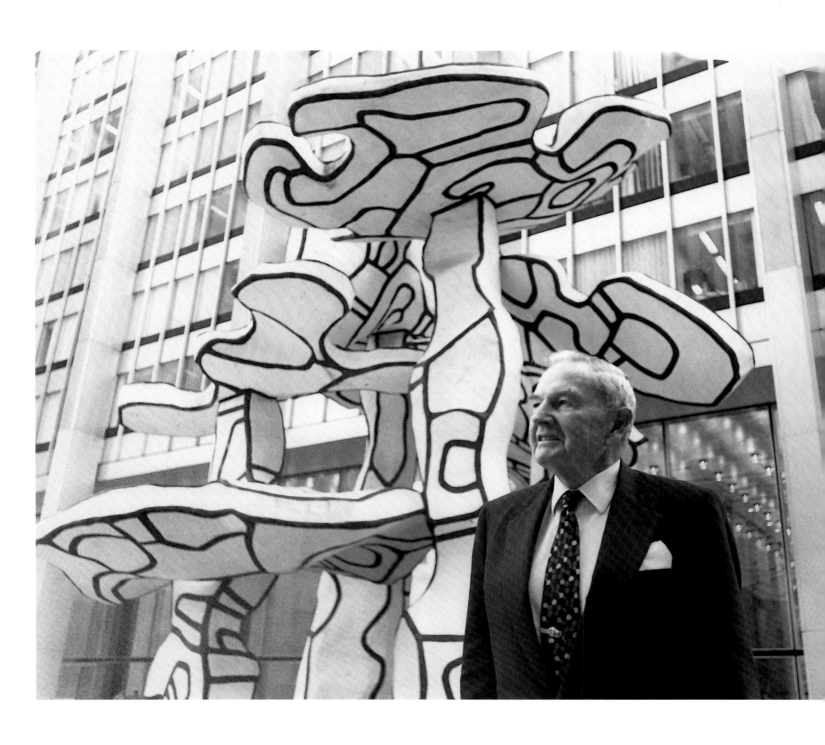

David Rockefeller
Former Chairman
The Chase Manhattan Bank

the profit motive. It has become, in effect, a full-fledged citizen, not only of the community in which it is headquartered but of the country and indeed the world.

The public has come to expect organizations such as yours and mine to live up to certain standards of good citizenship. One of these is to help shape our environment in a constructive way. When I speak about environment, I mean the vast complex of economic, technological, social and political forces that influence our cities and the people who live in them. In shaping this environment, the corporation must initiate its share of socially responsible actions, rather than merely responding passively to outside forces.

Mainly through the impetus provided by our businesses, we have achieved in the United States a material abundance and a growing leisure unprecedented in history. It is sadly evident, though, that our cultural attainments have not

kept pace with improvements in other fields. As people's incomes have risen, a proportionate share has not been devoted to artistic and intellectual pursuits. As leisure has increased, so has the amount of time given to unproductive and often aimless activities.

Corporations genuinely concerned about the environment cannot evade responsibility for seeing that this leisure is channeled into rewarding activities such as those the arts afford. We must face up to the task of bringing our cultural achievements into balance with our material well-being through more intimate corporate involvement in the arts.

From an economic standpoint, such involvement can mean direct and tangible benefits. It can provide a company with extensive publicity and advertising, a brighter public reputation, and an improved corporate image. It can build better customer relations, a readier acceptance of company products, and a superior appraisal of their quality. Promotion of the arts can improve the morale of employees and help attract qualified personnel.

At Chase Manhattan, we have seen first-hand evidence of these benefits from our own efforts in art and architecture. When we decided to build our new head office in lower Manhattan, we wanted to use modern concepts of architecture to express a contemporary image of banking instead of the traditional stodginess of the past. We were eager to have a building that, in addition to being highly efficient, would enhance the Wall Street area, give pleasure to the thousands who passed by it every day, provide a stimulating atmosphere for our employees, and, hopefully, exert some influence toward civic improvement.

Because there are stretches of pavement in the congested financial district which get less than 24 hours of sunshine in a full year, we felt that an open plaza would be a welcome addition to the scene. So we designed our building to occupy only about one-third of the two and one-half-acre site. The rest was devoted to the plaza which includes sycamore trees, circular granite benches, and a sculptured water garden.

When it came to decorating the interior of the building, we felt that fine art would be the best complement to the contemporary architecture we had chosen. So we set up a special Art Committee, which included some of the coun-

try's leading museum officials, and gave them a budget of $500,000. The works they selected for the reception areas and private offices ranged from primitive Americana to recently painted abstracts. Altogether, the bank has now accumulated about 450 paintings and pieces of sculpture, some of which are lent from time to time; others have been donated to museums.

So far as results are concerned, we believe the building has helped humanize the image of what was once considered a cold and impersonal business. We believe it has enlivened the downtown community and given pleasure, reassurance and delight to employees, customers and visitors. In fact, customers have told us repeatedly how much they enjoy doing business in these surroundings. And many employees have remarked on the added benefits of working in such an environment.

At lunch-hour during the spring, summer and fall months, the plaza is a popular strolling place. Band concerts and other forms of entertainment, which are staged regularly, draw capacity crowds and extensive coverage in the newspapers and on television. We have been told frequently — and we like to think it is true — that public-spirited gestures of this kind have reinforced our slogan about the 'friend at Chase Manhattan.'

...Without question the arts provide a fertile field for building the corporation's image. It has been estimated that the business community in the United States and Canada spends more than $600 million a year on public relations. If only a small percentage — say five percent — of this expenditure were directed into the field of the arts, the arts would receive over $30 million annually from this source alone. Added to the total support now received through corporate gifts, it would more than double the business community's present contribution to culture.

...The architecture of a company's buildings can contribute enormously to its environment — or, if poor in quality, can equally well detract from it. Good design can transform a whole area, and provide relief and refreshment for both the eye and the spirit. Those who have discovered this fact and have acted accordingly will be blessed for it by generations to come. But, alas, we have only to look around us here in New York to realize that far too many have still to learn this lesson.

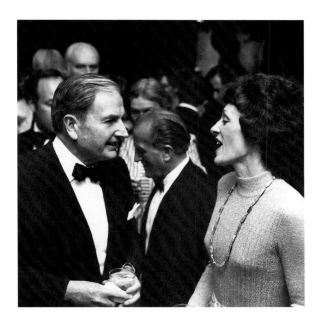

...The fact is that the sources from which the arts have traditionally drawn their support — primarily wealthy individuals and foundations — are no longer able to cope with the growing needs, and not enough companies have moved in to take up the slack. The recent Panel Report, sponsored by the Rockefeller Brothers Fund, on *The Performing Arts: Problems and Prospects* brought forth some disturbing and challenging facts. Reflecting the examination by concerned and expert citizens of the status of the theater, dance and music in America, it noted that only about half of the Nation's businesses contribute anything to the performing arts. Altogether, only a tiny fraction of corporate giving goes to meet cultural needs — less than $25 million in total. And a survey by the National Industrial Conference Board has pointed out that contributions to the arts in 1965 amounted to less than three cents of each corporate philanthropic dollar. The result is that progress has been too slow to sustain the necessary 'breakthrough' to a dynamic growth in the arts.

Corporate financial contributions to the arts are in roughly the same situation now that contributions to higher educa-

David Rockefeller with Joan Mondale, wife of Former Vice President Walter F. Mondale. Opposite: Alexander Calder's "Mobile," part of The Chase Manahattan Art Collection, The Chase Manhattan Bank, New York.

tion were a dozen or so years ago. At that time, the foundations became concerned about the problem and resolved to do something about it. They helped set up a Council for Financial Aid to Education to encourage greater voluntary support of colleges and universities, with special emphasis on corporate participation. It is no mere coincidence, I am sure, that over the past decade corporate contributions to higher education have increased by more than 150 percent.

Here, in the presence of so many distinguished leaders of business and industry, I would like to propose that we seriously consider the establishment of a comparable organization for the arts — a Council on Business and the Arts.

Such a Council, drawn from the ranks of businessmen knowledgeable in the arts, cultural leaders and representative artists, could provide strong impetus and clearly defined direction for what is often a rather haphazard process.

As I see it, this organization would devote itself to broadening the base of corporate support through four main avenues.

First, it would conduct research on a national basis to provide statistical analysis of the voluntary support being generated on behalf of the arts. These reports would furnish an authoritative yardstick for the appraisal of the progress being made in this area.

Second, it would provide expert counseling for business firms seeking to initiate new programs or expand existing ones. Such counseling could range from comprehensive program analysis and recommendations to special detailed treatment of varied kinds of aid.

Third, it would carry on a nationwide program of public information to keep corporations informed of opportunities that exist in the arts, and to apprise the artistic community of what corporations are doing in their particular fields.

Fourth, it would work to increase the effectiveness of cultural organizations in obtaining voluntary support from business and industry, and to encourage the involvement of more businessmen as trustees of cultural groups.

...I feel it would be enormously helpful for representatives of business and the arts to exchange views face-to-face, to seek new ideas from each other, to clarify misunderstandings and explore new possibilities. It would help bridge the gap between the sometimes rigid mentality of the businessman and the creative spirit of the artist. Both sides could

benefit far more from constructive critical interest than from biased attack or hostile neglect.

Of necessity, the concept of a Council on Business and the Arts must be outlined here in its broadest terms. Yet I would hope that the basic idea has sufficient validity to justify further exploration of its possibilities.

What a resounding acknowledgment this would be that the enhancement and development of the arts are worthy objectives for the exercise of corporate social responsibility. Too often the tendency is to regard the arts as something pleasant but peripheral. I feel the time has come when we must accord them a primary position as essential to the nation's well-being.

In our increasingly mechanized and computerized world, the arts afford a measure of consolation and reassurance to our individuality, a measure of beauty and human emotion that can reach and move most men. They are indispensable to the achievement of our great underlying concern for the individual, for the fullest development of the potential hidden in every human being.

Among our own people and those I talk with from other nations, there is insistent questioning about the significance of our material advances. What does it matter, they ask, that America has the largest Gross National Product or the biggest atom smasher or the fanciest automobiles? What does it matter that, in the words of Archibald MacLeish, 'we have more things in our garages and kitchens and cellars than Louis XIV had in the whole of Versailles?' Are these the only hallmarks of a truly Great Society? Clearly, they are not..

The ultimate dedication to our way of life will be won, I am convinced, not on the basis of economic achievements alone but on the basis of those precious yet intangible elements which enable the individual to live a fuller, wiser, more satisfying existence. I know of no other area in which you and I can spend our time and talents and energies more rewardingly.

Excerpts from Keynote Address
Delivered by David Rockefeller
September 20, 1966
50th Anniversary Conference
National Industrial Conference Board
New York, New York

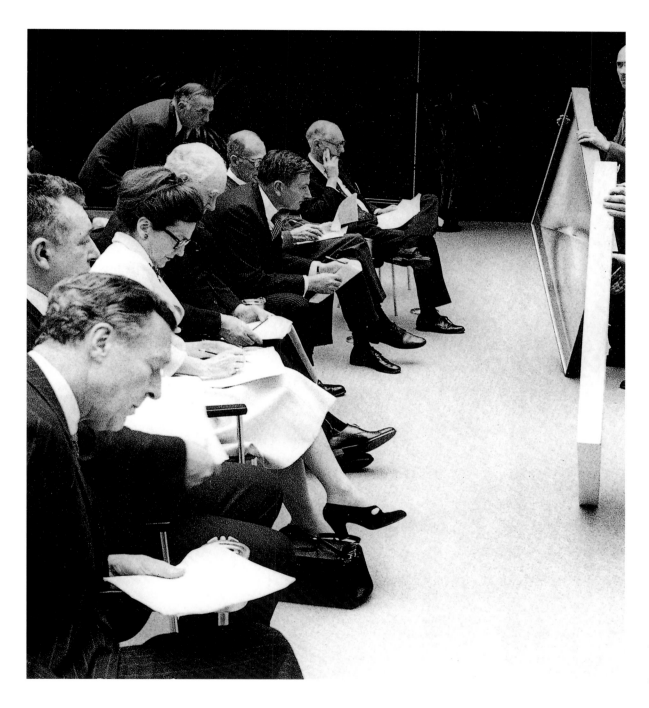

Members of the Art Committee meeting to select works for The Chase Manahttan Art Collection.

Reflections and Visions: Business-Arts Alliances

I AM VERY PLEASED TO BE HERE 30 YEARS AFTER THE CONCEPTION OF THE BUSINESS COMMITTEE FOR THE ARTS (BCA), AND TO BE PUBLICLY ACKNOWLEDGING THAT THE PATERNITY OF THIS ENTITY IS IN FACT THE RESPONSIBILITY OF MY FATHER. HOW EERIE TO THINK THAT HE WAS A YOUNGER MAN THAN I AM NOW WHEN HE PROPOSED THE FORMATION OF BCA.

SO MANY OF YOU ARE ROLE MODELS — FOR YOUR CHILDREN, FOR YOUR COLLEAGUES, FOR YOUR PEERS IN BUSINESS AND THE ARTS. WE ALL NEED ROLE MODELS, MENTORS, BEACONS OF INSPIRATION IN OUR LIVES. I WAS LUCKY TO HAVE ONE WHO LIVED RIGHT AT HOME — MY FATHER.

AS MANY OF YOU KNOW, MY FATHER IS A MAN OF HIS WORD, AND HE ORGANIZES HIS DEEDS TO MATCH HIS WORDS. THUS, NOT ONLY DID HE DO, AS A BUSINESS LEADER, WHAT BCA ENCOURAGES OTHERS TO DO, BUT IN HIS ROLE AS A PRIVATE CITIZEN HE HAS BEEN AN ACTIVE COLLECTOR OF ART FOR MORE THAN 60 YEARS. HE AND MY MOTHER HAVE BEEN CREATORS, AS WELL, OF BEAUTIFUL DOMESTIC SHELTERS IN THE CARIBBEAN, MAINE AND UPSTATE NEW YORK. AND, HE IS AN

David Rockefeller, Jr.
Chairman
Rockefeller & Company

active appreciator of the art and culture of very different peoples, from NativeAmericans to Saharan and sub-Saharan Africans. He is also a vigorous and committed trustee of cultural institutions, most notably The Museum of Modern Art and the Americas Society.

I have tried in my own life to emulate my father's word/deed symmetry, and, of course, that is a challenging assignment for me as Chair of Rockefeller & Co., Inc. On this occasion, I hold most in mind my father, as an example of a corporate leader, who not only preaches the external benefits of corporate giving to the arts, but also promotes internal enjoyment of those benefits by encouraging employees to thrive in an elegant workplace and by offering them the opportunity to gather for beautiful lunchtime concerts...

...What are BCA's challenges in the next 30 years? Let me suggest that there are three quite different spheres of business-arts support which ought to be examined.

First, and most obvious, is the sphere of the arts themselves. As we may learn from the just-completed National Endowment for the Arts study, *American Canvas*, there are some issues of great strategic importance which may be particularly susceptible to assistance from the business sector: namely, has there been unsustainable proliferation of arts institutions in recent decades, and has the market for the arts been defined too narrowly? I would urge, therefore, in these turn-of-the-century years, that members of BCA pay special attention to the strategic issues confronting the arts nationwide and that these issues be resolved in collaboration with arts leaders who are not in corporate isolation. Concepts such as "consolidation" or "market segmentation" are, in my view, studied too rarely by arts groups themselves. It may take some nudging from business to put these concepts directly on the arts table.

The second sphere worth examining is "the business community," a concept which is now less clear in its definition than it was 30 years ago, but nonetheless is vital to define anew. The Internet has fulfilled the prophecy of a global village. I do not believe that big corporations can finesse their responsibility to define and support the particular communities in which they operate most actively.

Some essential questions must be explored. Will the geography of customers or employees be what defines their community? How will national or global companies balance their impulse toward focused giving against their impulse to be more political and diffuse in support of the arts? I see these as principal turn-of-the-century challenges within this sphere.

The third sphere of consideration is companies themselves. What will our twenty-first-century working environment be like? Will our already reduced leisure time continue to erode? Will the culture of aerobics or the culture of "couch potatoes" prevail? And what will the role of the corporation be in shaping the answer to these questions? You might say that these are not strictly arts questions, but they certainly bear on our future capacity to appreciate and participate in the arts. Just as issues of transportation and family policies impinge upon business decision-making, so too, I believe, do issues of aesthetics in the working environment and employer encouragement of active leisure-time pursuits, including the enjoyment of sports, nature and the arts.

One of our most articulate champions of the importance of even closer connections between business and the arts has observed: "Mainly through the impetus provided by our businesses, we have achieved in the United States a material abundance...unprecedented in history. Corporations...must [now] face up to the task of bringing our cultural achievements into balance with our material well-being through more intimate corporate involvement with the arts."

As you may know — or may have guessed — those comments were made by my father. In fact, they were in the founding address of the Business Committee for the Arts which he delivered here in New York more than 30 years ago. Because my father is so far-sighted (and still doesn't wear glasses!) those remarks are as valid today as when they were first spoken in 1966.

Even more urgently today, I believe our business leaders — all of our leaders, in fact — must be as attuned to the importance of the nation's spiritual and cultural well-being as they are to our material well-being. Or, to put it in another way, our corporate captains should have as

keen an eye for the moral compass as they have for the bottom line.

I know that those of us here tonight are not the real audience for these remarks, because you have already demonstrated your own broad commitment to the concept of partnerships between business and the arts. But for our business colleagues who may be more skeptical, let me put forth a thought about why the arts need business support even more today than they did 30 years ago.

My thought is simply that we are living at the edge of a world in which our societies have never been more vulnerable to the social tension created by our cultural differences and, at the same time, a world in which technology can homogenize the news, the commercial images and the very definition of a "good life" can reach all five billion of us at the same instant.

In this context, I would suggest it is the arts which — because they simultaneously embrace the particular and the universal — can best help us to grasp this world full of tension and technology. The arts, after all, are conveyors of what is most individual about the artist; most local, regional or traditional about each of us; most idiosyncratic about every separate cultural microcosm.

And, at the same time, the arts stand for what is most universal and transcendent — the non-literary arts take us beyond language and communicate to us across great barriers of culture, geography and point of view. All the arts speak about what is noblest and highest in mankind — and, yes, what is basest and darkest. The arts call upon the trinity of mind, body and spirit. They join us together in song. They transfix us in space. They transport us from our immediate time and location.

In other words, the arts have the capacity to do what is perhaps most needed in the world today; they honor what is valuable and distinct in each human being, while they force us to acknowledge our shared condition.

This, then, seems reason enough for the business sector and the Business Committee for the Arts to keep at their good work, and, in these turn-of-the-century years, to concentrate efforts on the three spheres I referenced:
• the health of the arts themselves, with an emphasis on strategy and planning;

• the well-being of each business community, newly defined for our technological times; and
• the working conditions of employees.
There is still a lot to be done, isn't there? But, however large the future task, tonight is a moment to celebrate what the Business Committee for the Arts and its members have accomplished — led by you, and inspired by my father. Hats off!

On the occasion of its 30th Anniversary, the Business Committee for the Arts established the David Rockefeller Lecture to honor its founder and to advance his belief that the arts are essential to free enterprise and human achievement, and to encourage business to form alliances with the arts as an expression of their broader responsibility to their communities. This invitational lecture will be presented annually by a business leader who is internationally-recognized for forging enduring links between business and the arts.

The first David Rockefeller Lecture was presented on October 14, 1997 in the New-York Historical Society, New York, by David Rockefeller, Jr., Chairman of Rockefeller & Co., Inc., a leader in business and the not-for-profit sector. He is a Trustee of the Asian Cultural Council, The Museum of Modern Art (MoMA) and the Rockefeller Brothers Fund. A vanguard of arts education, he chairs MoMA's Trustee Committee on Education and was the Chair of Arts, Education and Americans, Inc. which, 20 years ago, produced the landmark book, "Coming to Our Senses: The Significance of the Arts for American Education." He serves as the Chair of the North American Nominating Committee for the Praemium Imperiale — the Japanese prize for outstanding international achievement in the arts — and he is a Founding Trustee of Boston's Cantata Singers, as well as one of its choristers. Additionally, he is a fellow of the American Academy of Arts and Sciences, Chairman of Recruiting New Teachers, Inc. and a member of the Harvard Overseers' Committee on University Resources. He is also involved with several organizations dedicated to preserving the natural environment and native cultures of Alaska.

Creating Added Value with the Arts

"My interest in the arts began with music when I was a boy. My two brothers and I built stereo systems and we had a record player with huge speakers. For the most part we played classical music because you could get more out of the speakers by playing the range of symphonic music rather than rock 'n roll, popular in the early '60s," explained Richard C. Notebaert, Chairman of the Board and Chief Executive Officer of Ameritech, a communications company headquartered in Chicago, Illinois.

"Why am I attracted to music? It is not that I studied it or that I play an instrument, it is really a matter of what feels right, sounds good and soothes my personality," admitted Mr. Notebaert. "My energy level is high. I run every minute of the day, but when it comes to music, I can just sit and listen to it for a half-hour without moving.

"I was born in Montreal. My father was Belgian — a manufacturer's representative — and my mother, a homemaker, was an American with dual nationality. I don't

Richard C. Notebaert
Chairman of the Board and
Chief Executive Officer

the Orchestra's *Silver Jubilee* concert featuring Plácido Domingo and conducted by Daniel Barenboim in Orchestra Hall." In 1986 Ameritech underwrote the Orchestra's tour of the Far East, and 10 years later sponsored the Orchestra's Berlin concerts, conducted by Daniel Barenboim, at the Berlin Festtage. "I contacted two German companies — Siemens and Deutsche Telecom — and asked them to fund these performances with us," recollected Mr. Notebaert. "We joined with these two companies again to underwrite the Orchestra's 1997 performances in Cologne, and the 1998 performances in Berlin. We are all very excited about this.

"We also collaborated with the Chicago Symphony Orchestra to undertake the $100 million remodeling of Orchestra Hall, rather than tear it down and build a new one," continued Mr. Notebaert. "In the fall of 1997, Ameritech sponsored a three-week festival that reopened the Hall. Additionally, the Company worked with the Lyric Opera of Chicago to renovate its performance facility, the Civic Opera House."

Ameritech supports other orchestras and opera companies in the communities it serves. In 1993 the Company was the title sponsor for the Indianapolis Symphony Orchestra's thirteen-city tour of five European countries and it continues to sponsor the Orchestra's month-long *Ameritech Yuletide Celebration.* During the same year, Ameritech collaborated with EDS to sponsor *Mostly Mozart* presented by The Greater Lansing Symphony Orchestra. Four years later, it began supporting *The Ameritech Family Music Network,* an educational program of The Cleveland Orchestra that includes a distance-learning component, as

recall my parents taking me to concerts or art museums as I was growing up. I went to the University of Wisconsin and earned two degrees — a Bachelor of Arts and Master of Business Administration. In 1969 I joined Wisconsin Bell, which is now part of Ameritech, and ever since I have continued to work in one capacity or another for the Company. I married in 1968, while I was still in college, and held two jobs to support us and pay for my education.

"My wife, Peggy, is very interested in music, and in fact, she was in a folk singing group in the '60s. She had a magnificent voice and played the guitar beautifully. I used to sit next to her at concerts and ask her to identify and explain what we were listening to. I must admit that I owe a great deal of my understanding of music to her," he recalled. "If I have one regret, it is that I never learned to play, not just any instrument, but the piano. I have a friend in Belgium who is in his mid-'50s. He recently took his first piano lesson, and has challenged me to do the same.

"Since I enjoy going to concerts of the Chicago Symphony Orchestra, I agreed to serve on the Symphony's Board of Directors. Ameritech provides the Chicago Symphony Orchestra with special project support. In fact, we sponsored

Top to Bottom: Orchestra Hall, Chicago; Lyric Opera of Chicago, "Wagner's Ring." Opposite: Chicago Symphony Orchestra, "Silver Jubilee," Plácido Domingo and Daniel Barenboim, Conductor.

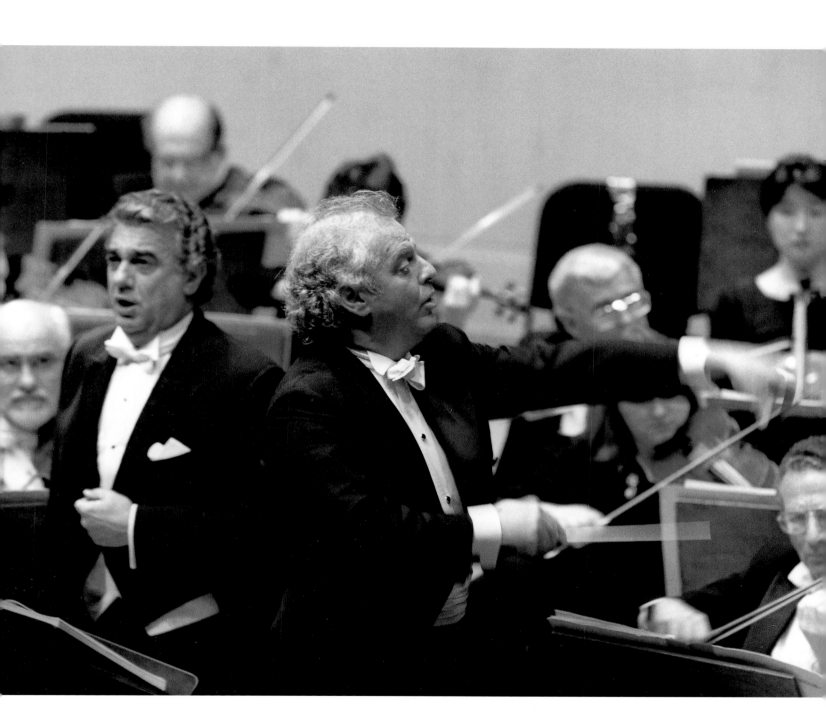

Top to Bottom: In Performance at The White House; The Art Institute of Chicago. Opposite: Ameritech's distance-learning program.

well as family concerts and a meet-the-artist program. In Detroit, Ameritech worked with the Detroit Symphony Orchestra to sponsor the *Ameritech Jazz Series and Youth Initiative,* and in 1996 the Company underwrote the Lyric Opera of Chicago's production of Wagner's *Ring Cycle.*

"Traditionally, we have a very strong relationship and presence in the communities in which we do business," explained Mr. Notebaert. "Our contributions policy and philosophy are very focused. We support the arts because of the benefits they provide. The arts are important to economic development and the quality of life of a community. We look at each project as a learning experience, as well as an opportunity to be a good corporate citizen.

"We also support the arts because it's in our best interest to do so. We have 66,000 employees living in cities we served, such as Chicago, Indianapolis and Milwaukee. People want to live and work in vibrant communities. They ought to be able to go to an art museum, a symphony concert or an opera performance without traveling too far from home." To help make the performing arts accessible to a greater cross section of individuals, Ameritech has supported *In Performance at The White House* since 1986. This program, broadcast on public television, features artists, among them Aaron Neville and Linda Rondstadt.

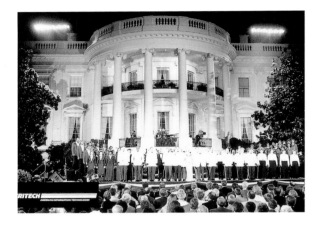

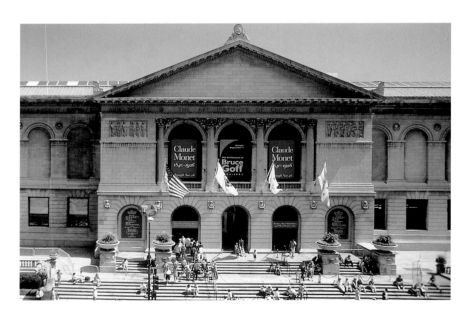

"Over the years we have sponsored a number of exhibitions in museums throughout our five-state Midwest region," continued Mr. Notebaert. "When we undertake an exhibition sponsorship, it is a team effort. We made the decision in 1995 to sponsor *Claude Monet: 1840-1926* in The Art Institute of Chicago. This Monet exhibition provided Chicago with a rare opportunity to enhance its image in much the same way as the Democratic National Convention did. Hundreds of thousands of persons came from all over the world to see the exhibition. They boosted the economy by staying in hotels for several nights and by spending money in restaurants and stores. Everything in the Museum gift shop was sold-out each day. And, the membership of The Art Institute increased to a record number.

"The Art Institute went one step further and looked at the economic impact of this exhibition — research that is not often done. This single exhibition generated an estimated $393 million in economic benefit to the City. Despite today's emphasis on sports, the Monet exhibition generated more revenues for the City of Chicago and the State of Illinois than the Chicago Bears. I'm a sports fanatic, and I'm not knocking the Bears, but do we ever consider that, from an economic point of view, a Monet exhibition can be equivalent to having an NFL franchise? In our experience the arts are definitely an economic development tool.

"We made a decision to sponsor another grand exhibition, *Renoir Portraits: Impressions of an Age* in The Art Institute of Chicago during the fall of 1997. This exhibition

featured 65 portraits by the artist. It was an exceptional exhibition and very good for Chicago.

"There is no doubt that appreciation of fine art is in the eye of the beholder. For me, it is not what the experts say, it is what strikes me. I went to the Monet exhibition about five times and to the Renoir exhibition several times. Before I visit an exhibition, I do my homework. I listen to tapes and read books about the artist and his work. I do the same thing before I go to the symphony or the opera. I prepare in this way because I am still learning and it makes the experience more enjoyable.

Over the years, Ameritech has sponsored an array of major visual arts exhibitions. For example, in 1990 the Company supported *Ed Paschke: Paintings,* which opened in The Art Institute of Chicago and was later shown in the Dallas Museum of Art and the Musée national d'art moderne in Paris. In 1992 Ameritech sponsored *America in 1492,* in The Newberry Library in Chicago and a year later, *European Masters: From the Polish Collection*, in the Milwaukee Art Museum. To celebrate the Centennial of The Detroit Institute of Arts in 1985, the Company underwrote *100 Masterworks.*

"I like the fact that Ameritech supports arts education," commented Mr. Notebaert. "When business supports the arts and arts education, we do it because we care. When government supports the arts, bureaucracy, regulations, censorship and the like interfere. When business does it, there are fewer questions, a lot less bureaucracy and more dollars going directly to the arts and their outreach programs."

To encourage arts organizations to develop and expand interactive distance-learning programs, Ameritech initiated the *Ameritech Technology Program for Arts and Cultural Organizations* in 1995. The Company made grants totaling nearly $500,000 to arts projects that are making innovative uses of telecommunication technologies. First-year grant recipients included: the Indianapolis Zoo, the Indianapolis Art Center, the Milwaukee Art Museum, the Illinois State Museum Society, the Detroit Historical Society, the Chicago/Detroit Arts Partnership in Education, the Columbus Museum of Art and Dance Kaleidoscope.

"We are contributing $2 million to the Library of Congress to digitize its collection so it becomes part of the country's

"SUPPORTING THE ARTS ALSO LETS OUR CUSTOMERS, SHAREHOLDERS AND EMPLOYEES KNOW THAT THERE IS MORE TO OUR COMPANY THAN JUST MAKING MONEY."

National Digital Library, and we are also helping libraries in Illinois and in Wisconsin with their distance-learning projects. Additionally, we have connected all the major public schools in Indiana for distance-learning programs, and we support a number of interactive exhibitions in our five-state operating areas, as well as the Ameritech Space News Center in the Adler Planetarium and Astronomy Museum in Chicago.

"It is more than civic responsibility that causes companies to support the arts," explained Mr. Notebaert. "We like the Ameritech name associated with anything that represents quality. We like the idea of brand recognition. I have received a number of letters from shareholders and retirees saying that they were proud to have the Ameritech name associated with the wonderful Monet exhibition.

"Supporting the arts also lets our customers, shareholders and employees know that there is more to our Company than just making money. It says that we really care about the intellectual and educational development of our communities."

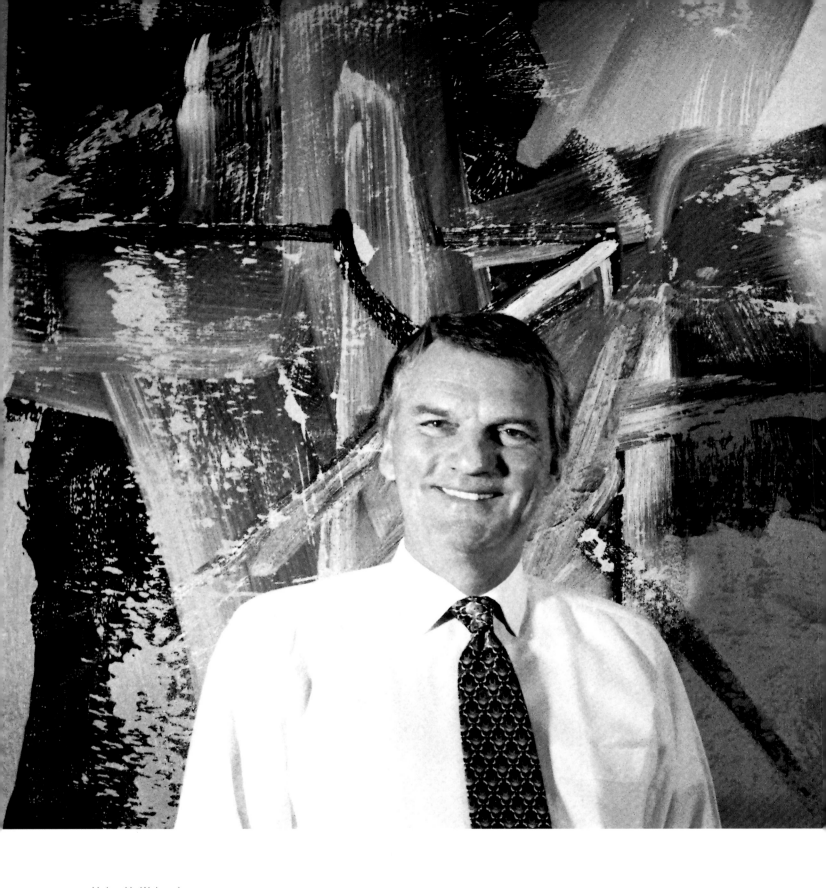

Helge H. Wehmeier
President and
Chief Executive Officer

Exploring the Synergies
Between Science and Art

"I GREW UP IN GÖTTINGEN, A SMALL UNIVERSITY TOWN OF ABOUT 80,000 PEOPLE SOUTH OF HANOVER, GERMANY. MY FATHER AND MOTHER, WHO LIKED MUSIC, WERE LISTENING TO HELGE ROSWAENGE, A FAMOUS SWEDISH TENOR, ON THE RADIO WHEN THEY WERE DECIDING ON A NAME FOR ME, SO THEY NAMED ME HELGE," EXPLAINED HELGE H. WEHMEIER, PRESIDENT AND CHIEF EXECUTIVE OFFICER OF BAYER CORPORATION, A LIFE SCIENCES, CHEMICALS AND IMAGING TECHNOLOGIES COMPANY, WITH ITS U.S. OPERATIONS BASED IN PITTSBURGH, PENNSYLVANIA.

"AS A YOUNG BOY, MY MOTHER TOOK ME TO THE THEATER AND TO CONCERTS OF THE GÖTTINGEN SYMPHONY ORCHESTRA WHICH WAS UNDER THE DIRECTION OF THE INTERNATIONALLY-RENOWNED

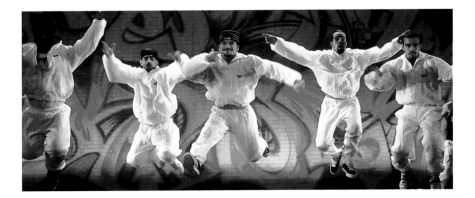

GhettOriginal Productions,
"Jam on the Groove."
Opposite (Left to Right):
The Bayer Broadcast Center
for the Arts, Pittsburgh;
South Carolina Aquarium,
Charleston.

director, Heinz Hilpert. I also listened every Sunday afternoon to radio plays for children. The stories were so alive and compelling — filled with vivid images that kept you on the edge of your seat. It was then that I had my first experience with radio as true 'theater of the mind.'

"My father was a civil servant, who died during World War II. When I was 11, I was sent to boarding school. There I played the recorder — like every German schoolchild, but I was not particularly good at it. I also read a lot, sometimes five books a week. I enjoyed everything from Carl Meyer, who wrote stories about Indian wars, to a book by Aristotle Onassis. I was fascinated by his description of New York, and was determined to travel there someday.

"After completing 13 years of study, called gymnasium in Germany, I had two and a half years of practical and theoretical training with Bayer. I left Bayer and went to work for an American import/export company in New York. I was twenty-two at the time, and traveled to the States on a freighter because it was all I could afford. I remember steaming into New York Harbor, past the Statue of Liberty, on a bright sunny September morning. The water was clear blue, with white caps, and the sun was shining brilliantly, intensifying the redness of the brick buildings. There it was — red, white and blue — the American colors. A friend met me and we drove up the East River Drive in his Thunderbird convertible. What a way to become acquainted with America. This introduction will always stay with me.

"I knew from my reading that when you come to America

without experience, you are paid very poorly. I envied the brakeman's wages every morning as I rode the subway from where I was living on East 71st Street to work on West 15th Street. At the end of the day, I walked home because I wanted to get to know the City and I wanted to save the ten-cents subway fare.

"I stayed with this company for a year and then I rejoined Bayer when they were looking for a young spark who knew America. I lived in New York until 1974, and it was during those years that I met my wife, who was interested in ballet. I remember being awed by how the dancers seemed to defy gravity and how they seemed to move in slow motion as the characters did in old Italian cowboy movies. It was absolutely fascinating. Ballet opened a totally new world for me, a world that my wife and I were determined to make our daughters aware of.

"Our daughters grew up going to ballet performances and concerts. I think it is important for parents to give their children the opportunity to become acquainted with the arts. It's like giving them a house with different rooms, each room is a different experience. As a parent, you open doors to certain rooms. You cannot make children love a particular room. They may not like the curtains, or the style of the room, or they simply may not be ready for it. Still, it is important to open the doors to those different rooms and to expose children to as many learning experiences as possible.

"A good well-rounded education must include the study of both the arts and the sciences. As a company we explore the synergies between arts and science," explained Mr. Wehmeier. "Of all subjects, the arts and sciences are the closest and most interrelated. They offer complementary ways of understanding the same object or event. Both explore man and his relationship to the world and they frequently challenge our preconceived opinions and prejudices. They also teach critical thinking, creativity and curiosity — skills that make for an educated and innovative work force.

"At Bayer, we are committed to enhancing the quality of life in the communities in which we work and live. Henry Ford once said that a 'business that makes nothing but money is a poor kind of business.' The arts are part of the Bayer tradition, part of the culture of our Company. If someone is exposed to and comfortable with the arts, then

he or she is more likely to be able to think 'outside the box' and tackle problems more creatively," commented Mr. Wehmeier. "As a research and science-based company, we need people who embrace risk-taking and problem-solving — the very skills learned from hands-on science and arts education."

In Pittsburgh and throughout its U.S. plant communities, the Company supports a variety of arts and science educational organizations through the Bayer Foundation, which was established in 1953. For example, it made a grant to the Pittsburgh Ballet Theatre's *Campaign for Permanence,* which was used to underwrite lectures, demonstrations and education materials, as well as free performances for at-risk students. It also sponsors the *Bayer Ticket Fund* of the Pittsburgh Dance Council, a subsidized ticket program that serves economically and physically challenged individuals. In Elkhart, Indiana, Bayer supports a jazz festival featuring 100 musicians from all over the world. The Company also made a significant contribution to establish the South Carolina Aquarium in Charleston. Nationally, Bayer supports the arts education program of The John F. Kennedy Center for the Performing Arts and the National Foundation for the Advancement of the Arts.

In addition, Bayer created *Making Science Make Sense,* an award-winning two-pronged initiative, that provides hands-on science programs in conjunction with a national public education campaign promoting science literacy. A component of this initiative is the *Arts and Science Summer Institute,* supported by Bayer and the Commonwealth of

"A GOOD WELL-ROUNDED EDUCATION MUST INCLUDE THE STUDY OF BOTH THE ARTS AND THE SCIENCES....BOTH EXPLORE MAN AND HIS RELATIONSHIP TO THE WORLD AND THEY FREQUENTLY CHALLENGE OUR PRECONCEIVED OPINIONS AND PREJUDICES. THEY ALSO TEACH CRITICAL THINKING, CREATIVITY AND CURIOSITY — SKILLS THAT MAKE FOR AN EDUCATED AND INNOVATIVE WORK FORCE."

Pennsylvania, which includes training teachers to integrate arts and science curricula to speed the learning process and to help K-8 students master academic skills.

"My wife and I frequently attend symphony concerts, and I serve on the Executive Committee of the Board of Directors of the Pittsburgh Symphony Orchestra," said Mr. Wehmeier. "It concerns and surprises me how much more coverage the newspapers give sports than they do the Symphony. The irony here is that the Pittsburgh Symphony Orchestra is world-renowned — well known in Europe, Israel and Australia — yet no one in these places knows about our football and hockey teams."

Bayer is involved in several programs with the Symphony that reinforce the synergies between art and science. One is the *Bayer Science Students at the Symphony* program, created in 1993 to encourage Pittsburgh-area college science students

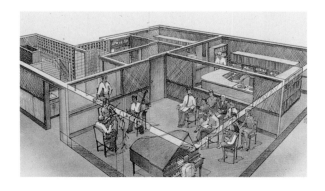

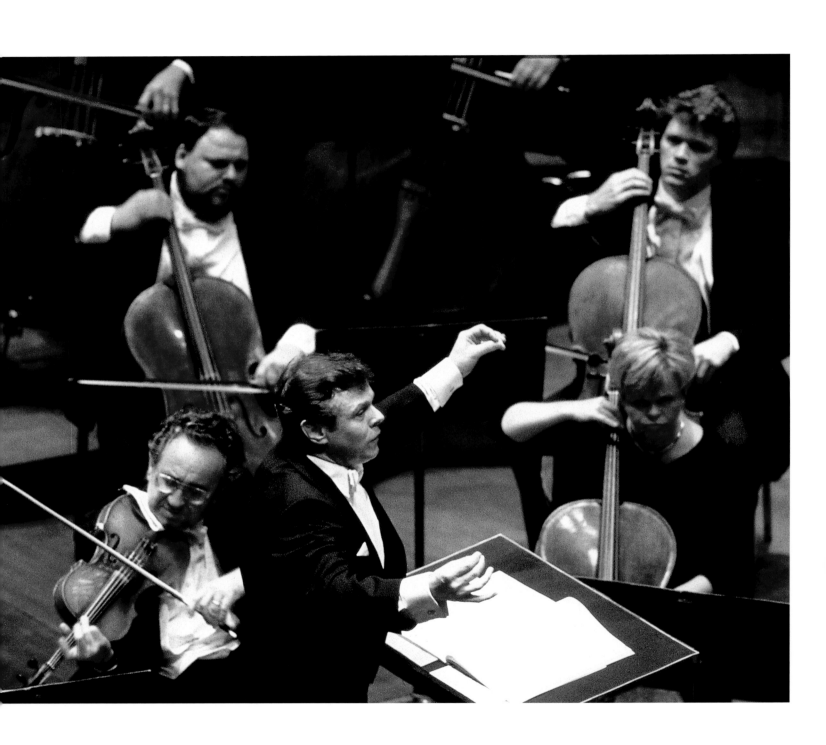

to develop an appreciation of classical music. The Company underwrites 75 percent of the cost of a three-concert series and hosts a special post-performance reception for the students where they mingle with members of the Orchestra, as well as Bayer executives and scientists. During the first half of 1997 more than 700 students participated in this program.

"When I commute back and forth to the office I listen to the radio. I have a great hunger for news. I like to know what's going on in the world. I listen to National Public Radio and WQED-FM — our wonderful classical music station in Pittsburgh," commented Mr. Wehmeier. "In fact, several years ago we made a major grant to this station to preserve and to modernize it. The Bayer Broadcast Center for the Arts was built with our grant and we have subsequently helped the station expand its signal into Western Pennsylvania." The Company also supports the *Bayer Sunday Arts Magazine,* a broadcast series of reviews about

exhibitions and performances throughout the region.

"We are making major investments in the Capital campaign of The Pittsburgh Cultural Trust and we are also underwriting a study to examine the economic impact of the arts in Pittsburgh. Business and arts leaders are working with the Trust to develop a cultural district in downtown Pittsburgh," he explained. "A healthy, viable downtown is good for everyone. It will help the arts and it will make it easier for us to recruit the individuals we need for our business.

"My interest in the visual arts came much later in life," recalled Mr. Wehmeier. "I collect without having a scientific approach. My main criteria are — do I like it? Do I connect with it?" Bayer has developed a corporate art collection of more than 140 works created by international emerging and contemporary artists. The collection is exhibited in the Company's U.S. headquarters in Pittsburgh and its worldwide headquarters in Leverkusen, Germany. It is frequently visited by arts groups and individuals from around the world.

"When we look back 5,000 years ago, what do we admire most about mankind?" pondered Mr. Wehmeier. "Do we admire the way the first ax was formed? Or, do we admire more the paintings found in the caves of France? We are more impressed, and we relate more, to the people reflected in the paintings, not so much the ax. The arts help us see the spirituality of a people. They are the bridge between people throughout space and time."

Top to Bottom: Publications for Bayer-sponsored programs; Ayano Ninomiya, 1997 Bayer Corporation ARTS Awardee, National Foundation for the Advancement of the Arts. Opposite: Pittsburgh Symphony Orchestra, Marris Jansons, Music Director.

Supporting the Arts
as a Way of Life

"WHEN I WAS QUITE YOUNG I LIVED WITH MY MOTHER AND FATHER AND MY WIDOWED GRANDMOTHER ONG. I DEVELOPED AN INTEREST IN THE ARTS BY READING BOOKS IN MY GRANDFATHER'S LIBRARY," RECALLED JOHN D. ONG, CHAIRMAN EMERITUS OF THE BFGOODRICH COMPANY, AN AEROSPACE AND SPECIALTY CHEMICAL COMPANY LOCATED IN RICHFIELD, OHIO. "I GREW UP IN UHRICHSVILLE, OHIO, A TOWN OF ABOUT 6,000 IN THE EAST-CENTRAL PART OF THE STATE. WE ALWAYS LISTENED TO THE SATURDAY RADIO BROADCASTS OF THE METROPOLITAN OPERA, SPONSORED BY TEXACO, WHICH I WILL NEVER CEASE TO APPRECIATE BECAUSE THERE WERE NOT TOO MANY OPPORTUNITIES TO EXPERIENCE THE ARTS IN MY HOMETOWN. WE ALSO LISTENED TO BROADCASTS OF NEW YORK PHILHARMONIC PERFORMANCES AND THE NBC SYMPHONY ORCHESTRA, UNDER THE DIRECTION OF ARTURO TOSCANINI.

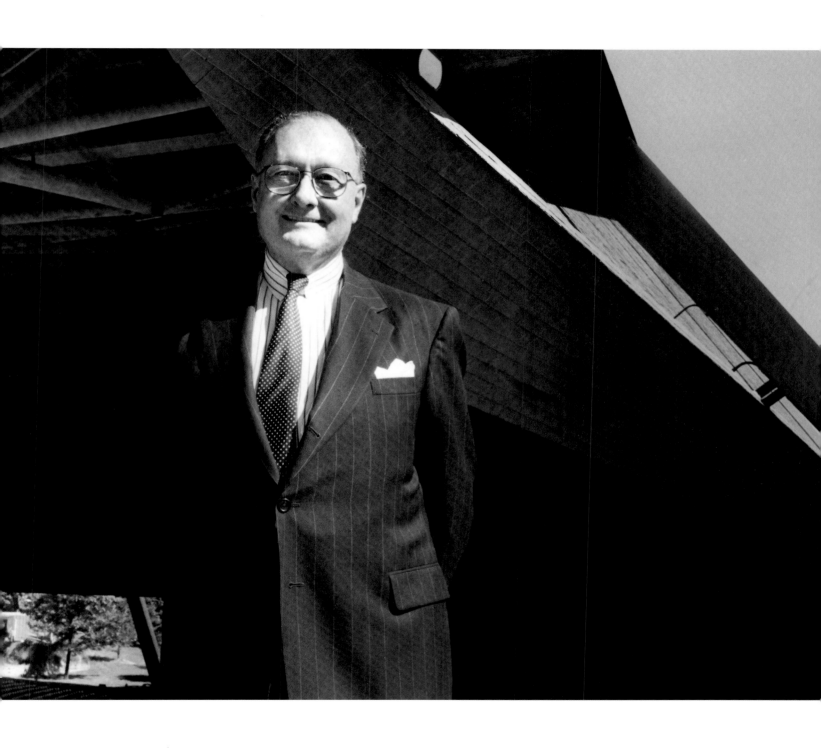

John D. Ong
Chairman Emeritus

the law firms in Ohio that interested me. My parents were living in Ohio and I borrowed my father's car to drive from one appointment to the next. I scheduled my interview with the Company sponsoring my trip — which was BFGoodrich — last, because I never had any intention of working for a corporation. When I arrived, the entire BFGoodrich law department took me to lunch and the General Counsel offered me the job for $700 more a year than the best offer I'd had from any of the Ohio law firms that I talked with earlier in the trip. I told the general counsel that I had to think about it. Two weeks later I received a telegram from him which raised the offer from $6,500 to $7,500 a year. Sheer greed and economic insecurity caused me to accept. I spent four years in the law department. In 1966 I became the Administrative Assistant to the President of the International Division and four years later I was asked to head this Division." In 1975 Mr. Ong became President of the Company and four years thereafter, he was named Chairman.

During John Ong's 36 year career with BFGoodrich he transformed the Company's core business and became the driving force behind BFGoodrich's involvement with the arts in Ohio and throughout the country. Under his leadership the Company established a foundation in 1988 that allocates about 10 percent of its giving to the arts and gives special consideration to arts organizations in which its employees are actively involved. The Company also matches

"As a youngster I took piano, trumpet and viola lessons. In high school I played the viola in the orchestra and the trumpet in the school band, as well as in a little dance band. My interest in music continued during my undergraduate days at Ohio State University and as a law student at Harvard. Now, I love to sing and I enjoy going to concerts and the opera. I also enjoy collecting books. I have a collection of 7,000, which includes first editions of twentieth-century fiction, leather-bound sets and various volumes about history, natural history, field sports, travel, philosophy, art and music.

"My career at BFGoodrich began in 1961 quite by accident. After I completed law school, I joined the Army, and served for about four years. By the time I left the Army, I was married, we had a new baby about two months old and had no savings to speak of. While I was at my last duty station in New Orleans, I saw an ad in a bar journal placed by a large Midwestern industrial company seeking a young lawyer for its international operations. I answered the ad and the Company sent me a round-trip ticket and offered to pay all of my expenses — which was quite unusual in those days — if I came for an interview. I accepted the offer and I took what I recognized was unfair advantage of the Company by lining up interviews with all

Top to Bottom: Akron Art Museum, "Rings: Five Passions of the Art World;" Blossom Music Center, Cuyahoga Falls, Ohio. Opposite: Cleveland Opera, "Cinderella."

employee contributions to arts organizations of their choice through a matching gifts program.

"Sponsoring the arts and entertaining our customers and business contacts at arts performances and events, as well as encouraging our employees to participate in the arts, is a way of life for us at BFGoodrich," explained Mr. Ong. "We have a program that makes tickets for performances and visual arts exhibitions available to our employees and their families, and we encourage our employees to serve on the boards of arts organizations in our headquarters region and throughout the country. Our executives are members of the Boards of the Akron Symphony Orchestra, the Ohio Ballet, The Phoenix Symphony Orchestra and many other cultural institutions." For nearly two decades, Mr. Ong has been a member of the Board of the Musical Arts Association, which operates The Cleveland Orchestra and the Blossom Music Center. He serves as the Chairman of this Board and has

had leadership positions in a number of the Associations major fundraising campaigns. Additionally, he is Chairman of the Board of Trustees of Inventure Place, the organization responsible for the National Inventors Hall of Fame. He has also been a Director of the Business Committee for the Arts since 1989 and was Chairman of its Board from 1991 to 1993. And, he is a director of the National Corporate Theatre Fund and was the National Chairman of the Fund's *Leadership Campaign for American Theatre,* a $5 million initiative designed to encourage businesses to support the not-for-profit theater companies in their communities.

Under John Ong's guidance, BFGoodrich has become a major supporter of most of the arts organizations in Northeastern Ohio including The Cleveland Orchestra, the Cleveland Opera, the Akron Symphony Orchestra, The Akron Civic Theatre, the Ohio Ballet and the Akron Art Museum. In 1991 he chaired The Cleveland Orchestra's 75th Anniversary

Campaign and the Company made a six-year $500,000 grant designated for The Orchestra's Annual Fund and its New York performances. Five years later he agreed to serve as Chairman of The Orchestra's *21st Century Campaign* and BFGoodrich announced a $1.25 million leadership grant to the effort. A portion of this grant was earmarked for The Orchestra's 1996 performances in Cologne, Germany.

"THOSE COMPANIES THAT SUPPORT THE ARTS REAP BUSINESS BENE-
FITS, IN ADDITION TO ENHANCING THE QUALITY OF LIFE IN THE COM-
MUNITIES IN WHICH THEY OPERATE. THEY WILL LEAVE AN INDELIBLE
MARK ON OUR SOCIETY."

"During BFGoodrich's 125th anniversary year in 1995, we underwrote The Cleveland Orchestra's performance of Mahler's *Eighth Symphony* in Carnegie Hall. We gave a pre-performance dinner for persons of importance to the Company and then we attended the concert. It was a very special performance," recalled Mr. Ong. "Robert Shaw, undoubtedly the greatest choral conductor of his generation, conducted the *Eighth Symphony* with an amplified orchestra. There were about 120 instruments including double brass and a 540-voice chorus. It was a spectacular, once-in-a-lifetime experience. Probably few of us will ever hear this piece performed with these forces again. We had a spectacular response, even from those who were not especially interested in music. They realized that they had heard something very special."

Nationally, BFGoodrich supports The John F. Kennedy Center for the Performing Arts, the National Symphony Orchestra and Lincoln Center for the Performing Arts, Inc., as well as exhibitions such as *Patty Wagstaff — National Aerobatics Champion.* Patty Wagstaff is one of eight women aviators featured in the Smithsonian National Air and Space Museum. The Company has also worked with the WACO Historical Society, Incorporated in Troy, Ohio, to organize and travel an exhibition about the WACO Aircraft Company, which once occupied the Troy facilities now used by BFGoodrich to manufacture aircraft wheels and brakes.

"I must admit that I am concerned that the next generation of individuals who are soon to assume leadership positions in business may not be as committed to philanthropy and to the arts as I am," said Mr. Ong. "In days past," he continued, "companies assumed the responsibility for nurturing an interest in and commitment to philanthropy among executives and recognized each executive for his or her philanthropic accomplishments. I am not certain that new CEOs are setting an example for their rising managers as my generation has. I am also concerned

with how we involve small and midsize entrepreneurial companies with the arts.

"We must do something about this. I am extremely enthusiastic about the programs of the Business Committee for the Arts designed to reach small and midsize companies, as well as BCA's *Executive Lecture Series,* which enables individuals like me to talk about the value of the arts to business with future business executives and owners attending the leading graduate schools of business in this country.

"The economic benefits that the arts bring to business greatly transcend and outlive normal business cycles," continued Mr. Ong. "Creativity in business is not confined to the laboratory and the pilot plant. In every function of a business organization the premium is on intellectual curiosity, mental flexibility and the instinct to create bold new approaches to opportunities and challenges. It is the responsibility of business to foster a creative environment in the workplace and the broader community. Those companies that support the arts reap business benefits, in addition to enhancing the quality of life in the communities in which they operate. They will leave an indelible mark on our society."

Left to Right: Ohio Ballet, "Andante Nobilissima;" Cleveland Orchestra, Christoph von Dohnányi, Music Director. Opposite: Severance Hall, home of the Cleveland Orchestra.

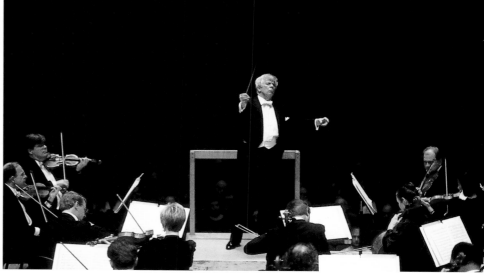

Winton M. Blount
Chairman of the Board

Enhancing the Lives
of Many Generations

"My involvement with the arts really developed as a result of a visit I made to a post office in Detroit when I was United States Postmaster General during the Nixon Administration," recalled Winton M. Blount, Chairman of the Board of Blount International, Inc., an international manufacturing company based in Montgomery, Alabama. "I opened a door in this old building and discovered a room filled with paintings created by the employees of that post office. I was told these works were about to be exhibited to give the workers recognition. I thought it was a superb idea. I suggested that we develop a national show in Washington, D.C., to showcase the talents and lift the spirits of some of the 750,000 workers in the postal system. It was a wonderful success."

Alabama Shakespeare Festival complex, Montgomery. Opposite: Brown Bag Lunch Series, Montgomery.

During his term as Postmaster General, Winton Blount, or "Red" as he is known to friends and colleagues, streamlined and transformed the Post Office Department into the United States Postal Service. After a three-year stint in Washington, D.C., he returned to Montgomery to run for the United States Senate and to focus on building his own company. "I always wanted to own my own business," said Mr. Blount. "My grandfather built a short-line railroad in Alabama at the turn of the century. It was called Bump and Slide Easy. I remember him telling me that he was at an international railroad show in Canada around 1915. He struck up a conversation with the President of Canadian Pacific who asked him how long his railroad was. My grandfather replied, 'Fifty miles.' The Canadian railroad executive then said, 'The only difference in our railroads is that yours is 50 miles long and mine is about 5,000 miles.' My grandfather replied, 'No, there is another difference. I own mine.' That story always stuck with me.

"I started my own company in 1946 after returning from serving as a pilot in the U.S. Army Air Corps during World War II. I was 25 at the time. I did not have a great vision about what my company would be, I just remembered my father drumming into me that I could be anything, as long as I was the best. After the War, I went to Atlanta and bought a crane and four new D-7 Caterpillar tractors from the War Surplus Administration. I brought them back to Union Springs — the town where I was born. It's about 40 miles east of Montgomery and has a population of about 3,000. I told my brother what I had done and he asked, 'What the heck are we going to do with this equipment?' I replied, we're going into the construction business —

which we did. We started by digging fishponds in Bullock County, Alabama. And, when we built all the fishponds the county we could stand, we moved on!

"We grew rapidly. We took lots of risks. We worked hard and we hired a lot of good people. Ten years after we started, we built the Nation's first intercontinental ballistics missile base near Cheyenne, Wyoming. Then we got the contracts to build the launch pad at Cape Canaveral where Neil Armstrong lifted-off for his voyage to the moon, the New Orleans Superdome and the $2 billion King Saud University in Saudi Arabia. In 1985 we acquired Omark and we began evolving into an international manufacturing company.

"In 1973 many companies were gearing up to celebrate the 1976 American Bicentennial. There was no single national theme — just do your own thing. I wanted Blount to celebrate the Bicentennial in a way that was unique and meaningful. Having seen how art could engage and motivate people in the Postal Service, I decided to assemble a collection of American paintings that could be displayed throughout our offices and could be made available for public viewing. I didn't have any particular ideas about which artists to include. I just wanted to bring together a collection of outstanding paintings from across the 200 year sweep of our Nation's history.

"I read in *Time* and *Newsweek* about Larry Fleischman. He was a premier dealer in American art and the owner of the Kennedy Galleries Inc. in New York. One afternoon I dropped by his gallery unannounced and spent two and a half hours with him looking at paintings. I told him I wanted to buy American paintings at a top price of $500 each. To say I was naive about prices was an understatement. Larry

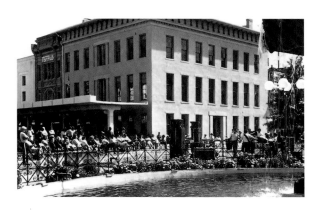

did not say a word about my budget. He just showed me paintings. I did not buy anything that day, but I did make a mental note to add some zeros to my $500 limit.

"One of my first acquisitions was Stuart Davis' *Summer Twilight*, painted in 1931, for which I paid about $100,000. Shortly after that I bought Edward Hopper's *New York Office*." The Blount Collection eventually grew to include more than 300 works dating from the 1770s through the mid-twentieth century. It includes works by John Singleton Copley, Frederic Church, Winslow Homer, Mary Cassatt, John Singer Sargent, Marsden Hartley, Charles Burchfield, Georgia O'Keeffe, Jack Levine and Andrew Wyeth. Many works from The Blount Collection have been lent to museums throughout the country.

"In 1971 Larry had been asked by Pope John Paul II to help obtain some fine works of twentieth-century American art for the Vatican collection," continued Mr. Blount. "He invited me to join this effort by becoming a member of the Friends of American Art in Religion. Larry and I received a lot of good-natured kidding about our affiliation with the Vatican. Several persons, mostly Roman Catholics, wanted to know what a New York Jew and a Southern Alabama Baptist were doing hanging out with a crowd like that! We had a great time over the years. In fact, in 1976 I was asked to chair a three-day seminar in Rome titled, *The Influence of Spiritual Inspiration on American Art* which was attended by about 300 scholars. At one point in the session, I was handed a note by a Cardinal telling me that the Pope wanted to join us and say a few words. The Pope came in and I introduced him. Afterwards, one of the Cardinals came over and said, 'Red, the Pope is never introduced.' Well, I said, I was running the meeting and if he speaks at my meeting, he is introduced! Over the years I received a number of honors from the Pope in the very room in which the seminar took place.

"As I became more involved with art I got to know other CEOs who were buying art for their companies. I thought it would be great to put together an exhibition of art collected by American businesses. We worked with the Montgomery Museum of Fine Arts and in 1979 we opened an exhibition called, *Art Inc.: American Paintings from Corporate Art Collections*. It included works owned by PepsiCo, Chase

Manhattan Bank, Westinghouse, General Electric and our Collection. During the opening night party which was at my home, someone asked me, 'Well, Red, what are you going to do for an encore?' I replied, we ought to get the Vatican to let us borrow some of its treasures and show them first in Montgomery and then in other cities in the United States. Everyone thought it was a great idea. The exhibition happened, but it never came to Montgomery. It opened in New York and then traveled to Chicago and San Francisco.

"I ventured into the performing arts in 1982, a year after Carolyn and I were married," recollected Mr. Blount. "She is very knowledgeable about Shakespeare and she was on the board of the Alabama Shakespeare Festival [ASF] which performed in Anniston, about 100 miles northeast of Montgomery. One day Carolyn and several ASF board members asked to meet with me. ASF was in desperate financial shape. They came to ask for $80,000 to bail out the company. I asked some of Blount International's financial and legal people to examine ASF's books and operations. With this analysis in hand, I invited the ASF people to come back to my office for another meeting. I told them they had two problems. First, they were nearly bankrupt. They owed $300,000, not $80,000, and they couldn't

"ART IS A NECESSITY, NOT A LUXURY. ART IS AS ESSENTIAL TO THE HUMAN SPIRIT AS FOOD, CLOTHING AND SHELTER. THE ARTS ENRICH MY LIFE, AND BECAUSE I BELIEVE BUSINESS LEADERS HAVE A RESPONSIBILITY BEYOND THE OFFICE, THE ARTS BECAME ONE OF THE VEHICLES THROUGH WHICH I FULFILL THAT RESPONSIBILITY."

The Blount Collection, Montgomery Museum of Fine Arts. Opposite: Winton M. Blount with children in front of the Montgomery Museum of Fine Arts.

open their doors. Second, they could not continue to operate with their high standard of excellence for only six weeks a year and sell tickets to 20,000 persons. I told them that if they would move to Montgomery, Carolyn and I would build them a year-round theater. They accepted my offer on the spot." The offer included a 35-acre parcel of land, plus the project construction cost provided by Blount International. The total gift exceeded $21.5 million and was the single largest grant ever made to a regional theater in the United States.

On August 10, 1983 ground was broken for the Alabama Shakespeare Festival complex, named The Carolyn Blount Theatre. The facility, which opened in 1985, includes the 750-seat Festival Stage and a 225-seat flexible performance space, the Octagon, plus rehearsal halls, recording studios, costume, scenery and prop shops, as well as video and educational facilities, administrative offices, a cafe and a gift shop. Each year more than 500 performances are present-

ed in the complex which are attended by approximately 200,000 persons. Since relocating to Montgomery, more than 2 million individuals, including more than 500,000 youngsters, from Alabama and surrounding states, have attended ASF performances. Mr. and Mrs. Blount are members of the Board of Directors of the Alabama Shakespeare Festival. Mr. Blount is also on the Board of Directors of the Folger Shakespeare Library in Washington, D.C., the National Actors Theatre in New York, and is a former member of the Board of Governors of the Royal Shakespeare Theatre in Stratford-on-Avon, England.

Three years after the ASF complex was completed, the new Montgomery Museum of Fine Arts opened directly across from the complex in what has become the Wynton M. Blount Cultural Park. Mr. Blount gave the Museum a grant of $500,000 toward the construction of its new building, plus 41 paintings, valued at $15 million, from the Blount Collection. He and his wife serve as members of the Museum's Board of Directors. In 1995 Mr. Blount added an additional 45 acres to the Cultural Park, which includes landscaped gardens, outdoor sculptures and meditation areas. The Blounts plan to leave an additional 60 acres and their home to the Park, and are continually adding features to the site.

Over the years Blount International has provided support to a variety of performing and visual arts organizations and projects in its operating communities, including the *Young Artists Competition and Concert* of the Montgomery Symphony Orchestra and *Jubilee,* the annual Montgomery-area spring festival, the Montgomery Ballet, Alabama Public Television and the Huntsville Museum of Art. In 1994 the Company underwrote *Made In America*, an exhibition chronicling the heritage of the fine and decorative arts of Alabama, which opened in the Birmingham Museum of Art and then toured the United States. Beginning in 1978, and lasting for more than a decade, the Company sponsored the *Brown Bag Lunch Series*, free lunchtime concerts in downtown Montgomery which continue today under new sponsorship.

In 1992 President Ronald Reagan appointed Mr. Blount to serve on the President's Committee on the Arts and the Humanities. In the same year, he was awarded the National Governor's Association Distinguished Service Arts Award and three years later he delivered the *Nancy Hanks Lecture on*

Arts and Public Policy, before an invited audience, in
The John F. Kennedy Center for the Performing Arts.
He was elected to the Business Committee for the Arts
Board of Directors in 1980 and served as the organization's
Chairman from 1985 to 1987. In 1980 he and a group of
Montgomery-area business leaders founded the Montgomery
Area Business Committee for the Arts, the first affiliate of the
national organization, to foster business involvement with
the arts at the local level. In 1995 Mr. Blount received the
Leadership Award presented by the Business Committee
for the Arts and *FORBES* Magazine, in recognition of his

exceptional leadership, vision and commitment to developing
and encouraging alliances between business and the arts.

"Art is a necessity, not a luxury. Art is as essential to the
human spirit as food, clothing and shelter," said Mr. Blount.
"The arts enrich my life, and because I believe business lead-
ers have a responsibility beyond the office, the arts became
one of the vehicles through which I fulfill that responsibility.
My wife, Carolyn, and I share a sincere desire to return a por-
tion of that with which we have been blessed. In our way we
are doing our best to ensure that art remains a public posses-
sion and enhances the lives of future generations."

Henry T. Segerstrom
Managing Partner

Defining a Cultural Landscape

"My mother was a major benefactor of The Bowers Museum of Cultural Art in Santa Ana and my wife, Renée, currently serves on the Board," said Henry T. Segerstrom, Managing Partner of C.J. Segerstrom & Sons, a real estate development company located in Costa Mesa, California. "The Bowers is a museum that reflects the heritage of Orange County. I remember performing in a play in the Bowers when I was in grammar school," he recalled.

Two years before the end of the nineteenth century, Henry Segerstrom's grandfather, Charles J. Segerstrom, arrived in Orange County, California, 16 years after leaving his homeland in Sodermanland, Sweden. Since their

arrival, the Segerstrom family has maintained strong ties to the community, first as farmers, and later as land developers.

"When I was 17 I went to Stanford University to study economics. I attended plays and concerts while there," continued Mr. Segerstrom. "My studies at Stanford were interrupted when I enlisted to serve in World War II. Rising from Private to Captain in Field Artillery was a very broadening experience, one that I value greatly." After the War, Mr. Segerstrom returned to the United States in May of 1945 to recuperate from injuries sustained during active combat in France. For the next few years — in between operations and hospital stays — he continued his college studies at Stanford and received his bachelor's degree in 1946. Two

years later, with a Master's Degree in Business Administration, he joined his family's business in Orange County, which was then focused entirely on farming.

In 1948 C.J. Segerstrom & Sons acquired land and warehouse buildings in Costa Mesa from the federal government that had been used during World War II for a large preflight training center. "We gradually moved away from farming and began focusing on real estate development — first industrial buildings and then shopping centers," he explained. "We made a conscious decision to stay in Orange County. Many of our neighbors left, but we had a strong commitment to the area since it was so much a part of our family history.

"I believe my interest in art comes through architecture. The creative challenges associated with architecture are inspiring and I find it exhilarating working with talented people. Architecture is an integral part of my own business. Our buildings and developments have benefited from the art of fine design, and I have been fortunate enough to have worked with some of the world's most respected architects including Cesar Pelli, Chuck Bassett, Charles Lawrence,

Top to Bottom: Orange County Museum of Art, South Coast Plaza, Costa Mesa; Isamu Noguchi's "California Scenario," Costa Mesa.

I.M. Pei and Victor Gruen. My interests and activities have also involved me with world-class performing artists including Rudolf Nuryev, Mikhail Baryshnikov and Luciano Pavarotti. These experiences have been inspiring and enriching. I think we can learn a lot from people through association, and my interest in art continues to grow through exposure and curiosity. I like to explore art museums. I like color and sculpture. Although I have never studied art, I find that I enjoy it and my commitment to it grows from personal conviction, rather than from pragmatic objectives. I also enjoy the performing arts.

"In 1975 we became involved with the South Coast Repertory Theatre when the Theatre's founders and board members asked our Company for a gift of land — which we gave them — to build a new theater," recounted Mr. Segerstrom. "In 1988 the South Coast Repertory Theatre received a special Tony Award given annually to recognize America's Best Regional Theater. A few years later we were approached for land again on which to build a performing arts center adjacent to the South Coast Repertory Theatre," he continued. "At the time, the Los Angeles Philharmonic

and visiting orchestras performed in local high school auditoriums. These venues did not meet acceptable performance standards. As an aspiring and arts-loving community, this was not a satisfactory situation. Because of our family roots in Orange County and my personal desire to create the finest possible performing arts hall, I was challenged by the opportunity to participate in a solution to the problem."

In 1979 C.J. Segerstrom & Sons donated five acres of land and $6 million to initiate the development of the Orange County Performing Arts Center. Appointed Chairman of the Center's Trustees, Henry Segerstrom spearheaded the Center's building drive, which realized $73 million entirely from the private sector. During the first 10 years, the Segerstrom family contributed more than $10 million, exclusive of the value of the land, to the Center. In 1985 the

Company commissioned Richard Lippold to create *Firebird,* a spatial sculpture that appears to soar through the glass front wall of the Performing Arts Center lobby. A year later, the Center's main hall was named Segerstrom Hall. "Our family is very proud of this recognition, but the project would not have been successful without the support of other business leaders and art lovers in the community," said Mr. Segerstrom. He joined the Center's Board of Directors in 1980 and served as its Chairman and Chief Executive Officer from 1987 to 1990. He also served as Chairman of the Center's Trustees from 1981 to 1986. For five years, beginning in 1991, Mr. Segerstrom was Vice Chairman of the Center's Endowment Campaign. During that time he increased the Endowment Fund from $3 million to $16 million. "We currently have an endowment that yields more than $500,000 a year which is used for the Center's operating expenses.

"I believe cultural facilities are an integral and enriching aspect of the evolution of a cosmopolitan society. Without access to the performing and visual arts, communities are likely to stagnate," observed Mr. Segerstrom. "A critical mass of both economic development and a sufficient population base must be in place before a major performing arts center can be justified and supported by a community. These factors existed in Orange County so the Performing Arts Center has proven to be a great asset for the entire community.

"Now that Orange County has a world-renowned performing arts facility, we are looking at plans for a new symphony hall and a major visual arts facility. We are also developing other cultural facilities for future generations," continued Mr. Segerstrom. The Bowers Museum recently established a museum for children called Kidseum with substantial support from Segerstrom family members. C.J. Segerstrom & Sons is also supporting a new hands-on science-based Discovery Museum located in Santa Ana.

The arts abound throughout C.J. Segerstrom & Sons' major retail centers — South Coast Plaza, Crystal Court and South Coast Plaza Village — and its office complexes in Orange County. In addition to the installation of art and displays that promote the arts, the Company provides space for a museum satellite gallery and gift shop in South Coast Plaza and frequently hosts fundraising events for arts organizations in its retail sites.

"We have incorporated sculptural art both inside and outside of our office buildings and in our retail complexes to enhance the daily experience of visitors and those who work in the office and retail complexes," explained Mr. Segerstrom. "I have had the good fortune to work with many contemporary artists. For example, I admired Isamu Noguchi's work and wanted to commission him to design a sculpture garden for one of our office complexes. I had seen pictures of some of his work — a fountain in Detroit — in an art magazine. I was very taken by it. I knew Noguchi was born in California, and that he never had a major environmental commission in the State. It seemed to me that emotionally he would like to leave an imprint in the place of his birth. So I arranged a meeting with him in New York. I went with my building plans, which included a site for his work. He reviewed and rejected them. I returned home disappointed, but not defeated. I sent him a handwritten letter telling him of my admiration of his works and my commitment to his design. He agreed to meet me again. He visited the site in California and then accepted the commission for a major garden which he named, *California Scenario.* This outdoor sculpture garden represents the ecology of the State of

California and is considered by many to be the finest sculpture garden that Noguchi ever created. I think it may have been his favorite. I once asked him why I was the only individual with whom he ever worked. He had only worked with museums, corporations or public bodies. His answer was marvelous. He said because he never trusted anybody. We maintained a close personal relationship until he died.

"I often marvel about the success of the Orange County Performing Arts Center. Arts institutions are financially fragile and can expire quickly without disciplined management. We cannot neglect that aspect of our arts," continued Mr. Segerstrom. "Because there is a need to provide sound business management for not-for-profit arts organizations. I decided to sponsor a business course in not-for-profit management at the Stanford Graduate School of Business. I am pleased to say a number of students have pursued careers in not-for-profit management after taking this class.

"The arts enrich us and help us build our communities. They express the values and creativity of our society, but the arts are also a business in themselves," commented Mr. Segerstrom, who received the Leadership Award in 1993 from the Business Committee for the Arts and *FORBES*

Magazine for his exceptional leadership and vision in fostering business alliances with the arts. "If we have good business management of our arts institutions, they will attract the hard-nosed businessman who can say, 'Here is a well-run business.' Such confidence then broadens our financial support base for the benefit of both artists and art lovers."

Top to Bottom: Orange County Performing Arts Center, Costa Mesa. The Bowers Museum of Cultural Art, Santa Ana. Opposite: South Coast Repertory Theatre, "Saint Joan" (Left to Right), Ron Bousson, Ruth de Sosa.

Enriching Communities and Enriching the Arts

"IN THE SECOND GRADE I WAS THE STAR IN A TOM SAWYER OPERETTA. I ALSO TOOK PIANO LESSONS, SANG IN THE ALL-STATE CHOIR AND SIMILAR GROUPS IN NEW JERSEY, BUT LIKE MOST KIDS, I WAS MORE INTERESTED IN SPORTS," ADMITTED WALTER V. SHIPLEY, CHAIRMAN OF THE BOARD AND CHIEF EXECUTIVE OFFICER OF THE CHASE MANHATTAN BANK, A GLOBAL FINANCIAL INSTITUTION HEADQUARTERED IN NEW YORK, NEW YORK.

"MY FATHER WORKED FOR A PRIVATE BANK AND COMMUTED TO NEW YORK. HE ALSO PLAYED PIANO FOR SILENT MOVIES, AND THE ORGAN IN CHURCH ON SUNDAY," HE CONTINUED. "MY MOTHER WAS NOT A PROFESSIONAL. IN HER ERA, WOMEN RAISED KIDS, TAUGHT SCHOOL OR WERE NURSES. TODAY SHE'D BE ONE OF THOSE WOMEN WHO COULD RUN FOR THE PRESIDENCY OF THE UNITED STATES. MY PARENTS WERE COMFORTABLE, NOT WELL-OFF. THEY DID A LOT OF

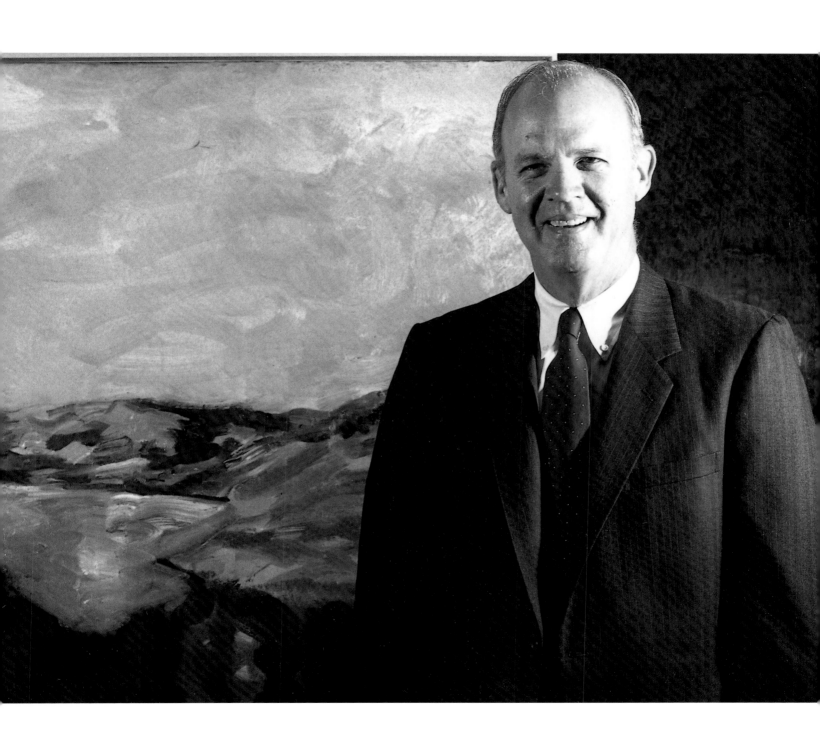

Walter V. Shipley
Chairman of the Board and
Chief Executive Officer

traveling and collected eclectic things as they traveled, mostly Chinese art and Oriental objects, as opposed to paintings. Just by growing up in that environment I developed an appreciation of different cultures and their art.

"I married at an early age and had five kids when I was very young. We lived in a suburban environment that did not lend itself to proactive involvement with the arts. Although I have a keen interest in music, my interest in the arts is broad based. I opted to get involved with Lincoln Center for the Performing Arts, as opposed to a specific symphony orchestra, opera or ballet company. I chaired The Lincoln Center Consolidated Corporate Drive for five years while I was Chairman of Chemical Bank. I continue to play an active role in fundraising activities as a member of the Center's Board of Directors. I also serve on the Board of Trustees of the American Museum of Natural History and I have a challenging role as a Trustee of the Lila Wallace-Reader's Digest Fund, which is a major funder of the arts.

"We encourage everyone at Chase to volunteer their time and expertise to serve not-for-profit institutions, from small arts organizations such as A.R.T./New York to major institutions like Carnegie Hall. We also encourage our employees and retirees to attend performances and arts events by using a Chase culture card, which is called *On the Town.* When employees use it, they may obtain free or discounted admission to performances, exhibitions and events presented by more than 200 New York, New Jersey and Connecticut arts organizations supported by the Bank. This program serves our people and it helps our grantees increase their audiences."

Mr. Shipley joined Chemical Bank in 1956, became its President in 1982, and its Chairman a year later. Under his leadership, Chemical, which merged with Manufacturers Hanover Bank in 1991, supported initiatives that made the arts more accessible to the public, fostered the efforts of arts organizations to serve the underserved, built audiences and enriched arts education opportunities for children attending New York City Public Schools. For example, for 15 years Chemical sponsored *Met in the Parks,* a series of free concerts presented by the Metropolitan Opera in parks throughout the New York and New Jersey metropolitan area. These concerts were attended by more than 200,000

individuals annually. Through its *Competitive Grants Program,* Chemical supported a collaboration between The Museum of Modern Art and The Studio in a School Association, Inc. to develop a model arts education program that is now being replicated in New York City public elementary schools. Additionally, Chemical sponsored the Emmy Award-winning public television documentary — the *Chemical Bank Lincoln-Douglas Debate* — a public speaking competition opened to students in all New York City public high schools. In 1995 Chemical made the first major grant, in the amount of $250,000, to the $12 million *Annenberg III Challenge Initiative,* a program designed to reinstitutionalize the arts in the curricula of New York City public schools. The Bank also took the lead in developing The Center for Arts Education, established to raise the funds needed to meet the required two-to-one challenge to fulfill the terms of the Annenberg grant and to orchestrate

arts education programs in the public schools.

"In 1996 Chemical merged with The Chase Manhattan Bank. One thing about the coming together of Chase, Chemical and Manufacturers is the absolute sense of responsibility that each had to the community," noted Mr. Shipley. "Each had it more than any of the other big banking institutions in New York. They were each very visible and very involved in the belief that what's good for the City, good for the people in the City, good for business in the City, is good for the Bank and its shareholders.

"When you merge, you try to take the best of each organization. It's not one culture or one tradition that dominates. It's a mixture. For example, Manufacturers Hanover had an orientation toward sports. Chemical was more education oriented. The former Chase had a strong orientation toward the arts. Now, we have a mix of the three."

Prior to the merger, Chase had nearly a forty-year history of

Left to Right: "Met in the Parks," New York; Jean DuBuffet's "Group of Four Trees," Chase Manhattan Plaza, New York. Opposite: Carnegie Hall, New York.

supporting the major cultural organizations in its operating communities in the United States and abroad. The Bank supported a number of concerts in Europe and Asia, as well as exhibitions in the British Museum. In the United States, Chase funded organizations such as Lincoln Center for the Performing Arts, Inc., the Big Apple Circus and The Boys Choir of Harlem, as well as small arts groups. Chase was one of the first companies in New York City to support emerging arts organizations, a practice which often helped these groups leverage additional business support.

Over the years, Chase has also been a major supporter of dance in the United States and abroad. In 1990, the Bank funded the Martha Graham Dance Company's commission for a new work by Twyla Tharp. Three years later, it sponsored the Graham Company's Centennial Tour in the U.S. and abroad. Chase also helped the Dance Theatre of Harlem develop new audiences by sponsoring a national advertising and direct mail campaign which included the insertion of donation envelopes with checking account statements. In 1992 Chase became the first company to develop an international sponsorship collaboration by joining forces with Kirin Brewing Company, Limited in Tokyo, Japan, to support a tour of Twyla Tharp and Dancers in Japan. Three years later, Chase collaborated with Japan's Ministry of Post and Telecommunications to present the Paul Taylor Dance Company's tour of Japan.

Additionally, Chase has underwritten a wide range of major visual arts exhibitions including: *Man Ray/Bazaar Years: A Fashion Retrospective,* organized by the International Center of Photography in New York; *Helen Levitt,* organized by the San Francisco Museum of Modern Art; *Fifty Years of Collecting: An Anniversary Selection,* in the Solomon R. Guggenheim Museum in New York; *Edward Hopper and the American Imagination,* in the Whitney Museum of American Art in New

York; and *An Enduring Legacy: The Mr. and Mrs. John D. Rockefeller 3rd Collection,* in The Asia Society in New York.

"Since the merger we have signed on to support *The Chase Recital Series at Carnegie Hall.* Our grant of $750,000 — $250,000 for each of three years — is the largest business sponsorship in the history of Carnegie Hall," said Mr. Shipley. "To celebrate the 50th anniversary of the Bank's establishment in Tokyo, we're sponsoring a performance of the Alvin Ailey American Dance Theater in Tokyo. We are also sponsoring the Roundabout Theatre Company, The Chamber Music Society of Lincoln Center and The New Victory Theater, all in New York City. We are using our sponsorship of the arts to broaden audiences and to increase public awareness of the new Chase."

To provide assistance to small New York City community-based arts organizations that do not typically receive business

support, Chase also established two pilot programs. One, *SMARTS (Small Grants Program for the Arts) Regrants Program,* provides support to arts service organizations which in turn award grants and technical assistance to small arts groups. The other, the *SMARTS Impact Grants Program,* provides multi-year support to small and midsize arts organizations that benefit from sustained support. In an effort to increase understanding among the culturally diverse Caribbean community, as well as the non-Latino population of New York, Chase co-sponsored *The Taino Legacy* in El Museo del Barrio in New York, as well as community outreach programs created in conjunction with the exhibition.

"As a result of the merger, we now have about 15,000 works of art in the corporate collection. Chemical had about 2,000 pieces, and Chase about 13,000," said Mr. Shipley. The Chemical art program began in 1981 when Chemical moved to its new building at 277 Park Avenue. The Chase Collection began in 1959 — when Chase, under the direction of David Rockefeller, who was then the Bank's President, was about to move into its new headquarters in lower Manhattan. The purpose of both collections was to have art in the building to enhance offices and to stimulate creative thinking. Works from the Collection are shown in our facilities throughout the world and are loaned occasionally to museums.

"We support the arts for multiple business reasons. We are a global financial institution and we believe that the arts enrich the lives of our employees and customers worldwide and are vital to the health of the economy. We also support the arts because they help us reach existing and potential customers. And, we aim to provide leadership and encourage other companies to support the arts because we believe it is just as much the role and responsibility of business to do so, as it is to make money."

Top to Bottom: Brice Marden's "From Bob's House #1" (1970); Donald Judd's "Untitled" (1972), both in The Chase Manhattan Bank headquarters, New York. Opposite (Top to Bottom): Big Apple Circus; Twyla Tharp and Dancers.

Energizing Small Towns
with the Arts

"MUSIC HAS ALWAYS BEEN A PART OF MY LIFE. MY MOM INSISTED THAT I TAKE PIANO LESSONS, WHICH I DID FOR 10 YEARS, AND I STILL PLAY TODAY, ALTHOUGH NOT VERY WELL. I REMEMBER I COULD NOT PARTICIPATE IN SPORTS OR DO ANYTHING UNTIL I PRACTICED FOR AN HOUR EACH DAY. IT WAS GREAT DISCIPLINE WHICH HAS SERVED ME VERY WELL THROUGHOUT MY BUSINESS CAREER," SAID JAMES E. ROGERS, PRESIDENT AND CHIEF EXECUTIVE OFFICER OF CINERGY CORP., AN ENERGY SERVICES COMPANY BASED IN CINCINNATI, OHIO.

"BEYOND THOSE MUSIC LESSONS, I DID NOT HAVE VERY MUCH EXPOSURE TO THE ARTS AS I GREW UP. I WAS ONE OF THOSE POOR KIDS WHO WORKED HARD, TRIED TO CREATE VALUE AND POSITION MYSELF," CONTINUED MR. ROGERS, WHO WAS BORN IN ALABAMA AND GREW UP IN DANVILLE, KENTUCKY, A TOWN OF ABOUT 15,000. "WHILE STUDYING FOR A LAW DEGREE FROM THE UNIVERSITY OF KENTUCKY DURING THE DAY, I WORKED FULL-TIME AS A NEWSPAPER REPORTER AT NIGHT. BEING A JOURNALIST HELPED ME A LOT IN LAW SCHOOL AND IT'S HELPED ME THROUGHOUT

James E. Rogers
President and
Chief Executive Officer

my business career. Writing gives you a better ability to express your vision, your views. To this day, I write my own things and I enjoy doing it.

"My involvement with the arts really began when I joined PSI," recalled Mr. Rogers. "I married when I was very young. I had two children before I was out of college and three before I was out of law school. I worked very hard and was off to a fast start." Before joining PSI Energy, Inc., an Indiana-based energy company which merged with The Cincinnati Gas & Electric Company in the fall of 1994 to become Cinergy Corp., Mr. Rogers was Assistant Attorney General for the Commonwealth of Kentucky. In addition, he was Deputy General Counsel for Litigation and Enforcement of the Federal Energy Regulatory Commission and a member of the Washington, D.C., office of a Texas-based law firm that dealt with natural gas and electric utility interests. He also spent four years in Texas working for various divisions of Enron Corp. "During those years there wasn't much time for the arts. I did little more than work," he recollected.

"When I was 40 years old I became the Chairman, President and CEO of PSI. I took the job realizing that it was a tremendous opportunity to turn the Company around and a tremendous opportunity as CEO to really give back to the community through personal leadership. One of the things I did was to set up a company foundation. We started by putting one percent of our pre-tax earnings into the Foundation. We then reinvested these funds in different community organizations, especially the arts. I did this, in part, because I remembered what the arts had done for me and I wanted to do this for others. In this era, everything moves so fast. We have voice mail, computers, e-mail. Everything is so impersonal. The arts help us get in touch with our sense of humanity.

Cincinnati Ballet
"The Nutcracker."
Opposite: Cincinnati
Symphony Orchestra
"Home for the Holidays."

"I also realized that in order to be a leader, I had to get in touch with myself, as well as to create an environment for our 4,000 employees which would enable them to do this for themselves. They had to understand themselves — find joy in what they did — and then they could be creative. Artists do this well, and they help us understand how to do it. Seeing others express themselves in music or in any of the arts gives us license and freedom, as well as a sense of what can be done.

"At PSI, and now at Cinergy, we don't just give money, we try to get our employees involved. We serve a 25,000-square-mile area spanning Indiana, Ohio and northern Kentucky. The people who work for our Company come

"IN THIS ERA, EVERYTHING MOVES SO FAST. WE HAVE VOICE MAIL, COMPUTERS, E-MAIL. EVERYTHING IS SO IMPERSONAL. THE ARTS HELP US GET IN TOUCH WITH OUR SENSE OF HUMANITY."

from these areas. They are constantly balancing the demands of their families with the demands of work. I believe that people want to have as rich a life as possible. We work to make the arts accessible to them and to their children, and we encourage them to serve as volunteers for community organizations, including the arts. When our employees go out and volunteer — make a difference in an organization, make a difference in the community — we support their efforts by making grants to the organizations that they serve. It's a win-win situation. And we are sending our employees a very powerful message that we are not just urging them to do something, we are backing them.

"When we invest in the arts, we try to leverage and build for the arts and for the Company. We support all the major arts organizations in our operating area and we focus on those that need extra assistance. Cinergy sponsored the 1996-1997 season of the Cincinnati Ballet. We also sponsor productions each year of the Cincinnati Opera. We try to build an educational component into everything we support. For example, in 1995 we underwrote the entire dedication week of the new Aronoff Center for the Arts in Cincinnati. We arranged to have children admitted free-of-charge to a number of events during the opening week."

Additionally, Cinergy sponsors many of the major exhibitions in the Cincinnati Art Museum including *Mistress of the House, Mistress of Heaven: Women in Ancient Egypt,* the first major American exhibition which explored the role of women in ancient Egypt, and *Gauguin and the School of Pont-Aven.* Both exhibitions traveled to museums throughout the United States. To showcase Cincinnati's cultural organizations on the national level, Cinergy sponsored the 1995 performance of the Cincinnati Pops and Hoosier Singers of Indiana University in Carnegie Hall in New York.

"We also create innovative community-based programs to provide performance opportunities for young artists and to offer visual and performing arts experiences to people who might not otherwise have them," continued Mr. Rogers. *Powerful Performances,* created in 1992 under the PSI banner, enabled community organizations in small Indiana towns to present concerts and in-school workshops featuring Indiana college music groups. The Company produced and distributed a catalogue that profiled the

the artistic talents of Indiana, Kentucky and Ohio high school students. Each winner receives a $5,000 college scholarship and their schools each receive a $1,000 grant earmarked to enhance arts education programs. "We made this a community project and we encourage other companies to join us," said Mr. Rogers. The awards are presented during a special dinner attended by individuals representing the arts, business and government.

"Good ideas don't come just from New York, San Francisco or Los Angeles," commented Mr. Rogers. "Some of the greatest creativity in this country comes from small towns and rural areas. We have the ability to create a rich cultural environment in our Company and in the communities we serve. I believe our programs create an appreciation of the arts and create an understanding about how the arts create value within our Company and the community."°

Top to Bottom: Cinergy Collection at Indiana University at Kokomo; children participating in a program of The Children's Museum of Indianapolis. Opposite (Top to Bottom): Cincinatti Opera, "The Barber of Seville;" University of Cincinnati College - Conservatory of Music Jazz Ensemble, "Powerful Performances."

participating groups and underwrote all performance, advertising and promotional costs for each performance. The community organization presenting the concert kept all profits from the performance with the provision that these funds were to be used to present future performances."

Another community program, the *Cinergy Collection,* a traveling juried art exhibition of works created by Indiana, Kentucky and Ohio artists, enabled individuals in small communities to view and purchase original works of art. Fifty percent of each sale was returned to the artists, 40 percent supported the local not-for-profit organization that hosted the Collection and 10 percent was earmarked for administrative costs. In 1995 the Collection traveled to more than 40 communities and generated funds for 70 not-for-profit organizations.

In 1996 Cinergy made a $425,000 grant over three years to underwrite Cincinnati's first annual holiday program — *Home for the Holidays* — presented in the Aronoff Center for the Arts. This program featured the Cincinnati Symphony Orchestra and other performing arts groups. The following year the Company took a leading role in establishing the *Overture Awards,* an annual competition which showcases

Partnering with the Arts
to Serve Communities

" MY FIRST SERIOUS EXPOSURE TO THE ARTS WAS ON A SCHOOL OUTING TO THE MINNEAPOLIS

INSTITUTE OF ARTS WHEN I WAS ABOUT EIGHT YEARS OLD. IT WAS ONE OF THOSE SCHOOL VISITS THAT

ARE EXTRAORDINARILY IMPORTANT IN ONE'S DEVELOPING YEARS BECAUSE OF THE NEW HORIZONS

THAT EXPOSURE TO THE ARTS SUDDENLY OPEN UP. IT WAS AN AWESOME EXPERIENCE," RECALLED

ROBERT J. ULRICH, CHAIRMAN OF THE BOARD AND CHIEF EXECUTIVE OFFICER OF DAYTON HUDSON

CORPORATION, A GENERAL MERCHANDISE RETAILER HEADQUARTERED IN MINNEAPOLIS, MINNESOTA.

"AS A YOUNG BOY, I WAS ALSO INTERESTED IN MUSIC," HE CONTINUED. "I LISTENED TO MUSIC MORE

THAN OTHER YOUNGSTERS BECAUSE MY FATHER HAD A BIAS AGAINST TELEVISION."

AT ABOUT THE SAME TIME THAT ROBERT ULRICH BECAME INTERESTED IN THE ARTS, DAYTON

HUDSON CORPORATION ESTABLISHED AN INNOVATIVE PHILANTHROPIC PROGRAM WHEREBY THE

COMPANY ALLOCATES FIVE PERCENT OF ITS ANNUAL FEDERALLY TAXABLE INCOME TO NOT-FOR-PROFIT

ORGANIZATIONS. BY 1997, THIS PIONEERING CONCEPT, STARTED 50 YEARS EARLIER, PRODUCED

Robert J. Ulrich
Chairman of the Board and
Chief Executive Officer

more than $135 million for the arts, and more than $350 million in total philanthropic contributions to Dayton Hudson communities.

Two of the original art grantees of this program — The Minneapolis Society of Fine Arts and the Minnesota Orchestra — continue to receive major support from Dayton Hudson. In 1974, for example, Dayton Hudson gave $1.9 million to The Minneapolis Society of Fine Arts to help finance the construction of a $38.5 million complex that included The Minneapolis Institute of Arts, The Minneapolis College of Art and Design and the Children's Theatre Company. In 1973 the Company made a $1 million grant toward the construction of the Minnesota Orchestra's new concert hall.

"My interest in art is very much in the tradition of Dayton Hudson," explained Mr. Ulrich. "For 50 years the Company has encouraged its executives to get involved in the community, and it has always been a very strong supporter of the arts. Bruce Dayton is extremely generous to The Minneapolis Institute of Arts. Kenneth Dayton is a very generous supporter of the Walker Art Center, and a leading supporter of the Minnesota Orchestra. Judy Dayton co-chairs the Artistic Development Campaign of The Minnesota Opera. All have done an extraordinary job of providing leadership and serving as role models for their employees in the area of business support of the arts. This includes traveling around the country and giving speeches to encourage other businesses to become involved with the arts in their communities.

"Museums have always been of special interest to me. They touch the lives of a diverse segment of the population — different cultures and ethnic groups and all age groups. They can exert a very, very positive influence on learning and creativity," remarked Mr. Ulrich, who serves as the Chairman of the Board of The Minneapolis Institute of Arts.

"I am a collector. I focus on African art, especially masks and sculptural pieces used in village life, primarily from Zaire," he continued. "There is a fascinating story behind each of these pieces. In many cases they were used for magic, and sometimes one can almost feel a primitive strength in them. I am also drawn to sculpture from the late 1800s to early 1900s that is constructive or cubist in character, as well as to architecture — that too is very sculptural, and I am fascinated by it."

Over the years Dayton Hudson and its subsidiaries — Dayton's, Hudson's, Marshall Field's, Mervyn's and Target Stores — have sponsored a variety of exhibitions in museums in their operating communities including *Made in America: Ten Centuries of American Art, The People Yes: Photographs of Jerome Liebling,* and *James L. Tanner: Unrolling Reflection* in The Minneapolis Institute of Arts; *Painting the Maya Universe: Royal Ceramics of the Classic Period* in the Los Angeles County Museum of Art; and *Human Nature/Human Form: Figurative Dimensions in Clay, Metal, Stone and Wood* and *Contemporary Mexican Photography* in the Austin Museum of Art at Laguna Gloria in Austin, Texas.

Dayton Hudson is also a long-term sponsor of the performing arts. Mr. Ulrich has served as a Director of both The Guthrie Theater and the Minnesota Orchestra. Other Dayton Hudson executives serve on the boards of nearly all performing arts organizations in the Twin Cities. In recent years the Company has supported the San Francisco Ballet's production of *The Nutcracker,* the Evansville Philharmonic Orchestra's *Fiesta! Latin at the Pops* and The Greater Lansing Symphony Orchestra's *Holiday Pops Concert* and *Dance/Africa Festivals* presented in Minneapolis, St. Paul and Chicago.

"To encourage broad participation in the arts, Dayton Hudson and its subsidiaries have created several model programs," explained Mr. Ulrich. "One of our most visible cause marketing programs is *Treat Seats*. Through this program we offer coupons — in kiosks in our stores — for reduced-price admission to the arts and other forms of family entertainment. People don't have to buy anything to take advantage of these coupons. This is our way of doing something that our customers like, and it gives them another reason to come to our stores. This program also offers the arts invaluable exposure and has substantially increased attendance."

Many of the Dayton Hudson subsidiaries support programs to encourage family participation in the arts. In Santa Ana, California, for example, Mervyn's Department Stores sponsors

Left to Right: Minnesota Orchestra, "The Rake's Progress;" Pacific Symphony Orchestra Ballet performance. Opposite: Minnesota Orchestra, Eiji Oue, Conductor.

the *Family Series* of the Pacific Symphony Orchestra. This is a special concert series which includes a question and answer session to encourage children, aged four to thirteen years, to learn about music with their families.

To increase multicultural understanding through the arts, Dayton Hudson and its subsidiaries have created and underwritten a wide range of initiatives including the sponsorship of a PBS series, *Heritage*. Produced by KLRN-TV, San Antonio, Texas, this series showcases the arts and cultural heritage of the Latino community. And, in 1990 Mervyn's developed *Expressions '90,* a program designed to build audiences for the arts and to preserve the cultural heritage of the Asian, African-American and Hispanic communities.

"WHILE WE KNOW THAT DOLLARS ARE IMPORTANT TO THE ARTS, WE ALSO KNOW THAT FORMING A PARTNERSHIP WITH THE ARTS IS MULTIDIMENSIONAL AND DRAWS ON STRENGTHS OF THE DAYTON HUDSON FAMILY THAT GO BEYOND JUST MONETARY GIFTS."

One of the Company's objectives is to broaden the horizons of Twin Cities artists and arts administrators. In order to achieve this, Dayton Hudson collaborated with General Mills and the Jerome Foundation to establish *The Travel Study Grant Program.* Since the program's inception in 1986, Dayton Hudson has provided more than $350,000 in support. The Company also has a special fund, *The Dayton Hudson Artists Loan Fund,* begun in 1991, to provide low-interest loans to Twin Cities artists for artistic and business development.

Concern about helping the arts strengthen their management structures led Dayton Hudson to develop a number of innovative initiatives such as the *Comprehensive Arts Support Program (CASP).* Through this program, established in Minneapolis and St. Paul in 1979 and in Chicago in 1990, the Company works with participating arts organizations on an individual basis to help them set annual operating goals and to measure results. An annual self-evaluation helps determine the level of support the arts organization will receive from Dayton Hudson the following year.

"Dayton Hudson has historically given about 40 percent of its annual philanthropic budget to the arts," noted Mr. Ulrich.

Minneapolis Sculpture Garden, Walker Art Center, "Babu's Magic," Chuck Davis. Opposite: Walker Art Center, Minneapolis.

"This is considerably more than most companies. It's incredibly important to maintain our policy, especially when there is diminishing support for the arts and many children no longer have arts courses in their K-12 education. We need the arts to inspire us. That's why our Company's contribution guidelines encourage quality art, accessible to a wide range of people, particularly families, our primary customers.

"In addition to direct support, we also do cause-related marketing involving the arts. We think it is good for both the arts and business. For example, when we sponsor a major art exhibition, we work with the arts organization to generate media coverage and to design ads that include a small Target or Dayton Hudson credit line for our stores. We also put together a package of promotional material. Over time this helps us become known as a company that cares, and it gives our 165,000 employees a sense of pride in working for the Company.

"Cultural institutions understand the value of audience building, and appreciate what we are doing for them," continued Mr. Ulrich. "Whenever possible, we go beyond grant-making by using our professional expertise to help further the goals of arts organizations. When we make a contribution, we enclose the check in a small brochure that states, 'Here's what we can do for you, and here's what you can do for us.' On one side of the brochure we describe what we can do for the arts, including programs like *Treat Seats,* messages that we print on shopping bags and volunteer assistance. On the other side we describe the things that we would like the arts to do for us. For instance, every year during the holiday season, we close many of our stores for several hours and give a special shopping party for senior citizens and people with disabilities. Often, we invite a musical group that we've supported to perform during this party.

"We think the arts are a very important part of every community. While we know that dollars are important to the arts, we also know that forming a partnership with the arts is multidimensional and draws on strengths of the Dayton Hudson family that go beyond just monetary gifts. We invest a great deal in these partnerships because we believe that working together is best for the arts, best for our Company and best for the community."

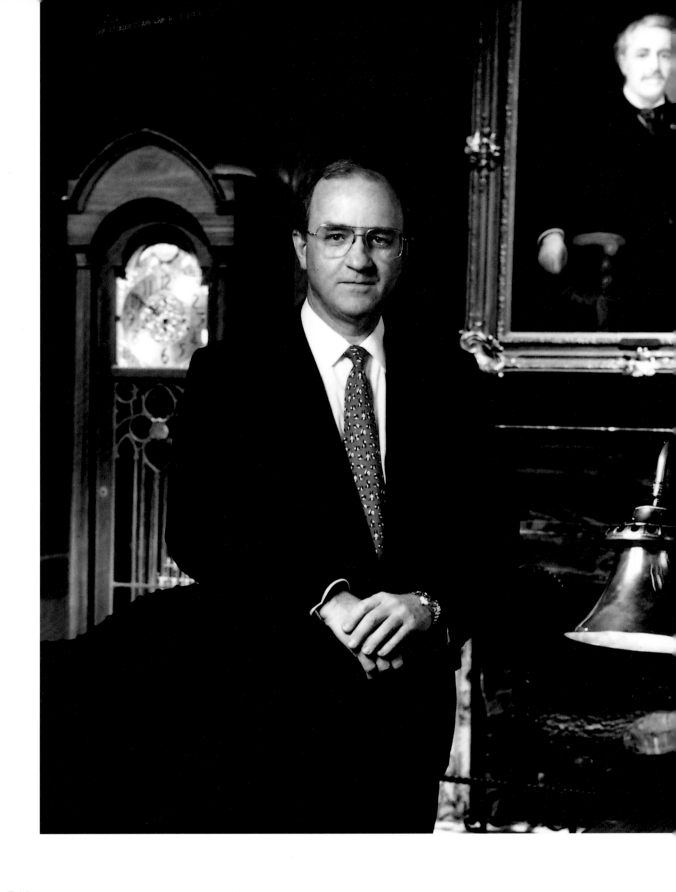

Randall L. Tobias
Chairman of the Board and
Chief Executive Officer

ELI LILLY AND COMPANY

Creating a Global Dialogue
with Culture

"GROWING UP IN A SMALL TOWN IN THE NORTHWEST PART OF INDIANA — REMINGTON, POPULATION 1,200 — I HAD A LOT OF OPPORTUNITIES THAT EXPOSED ME TO THE ARTS EARLY ON," SAID RANDALL L. TOBIAS, CHAIRMAN OF THE BOARD AND CHIEF EXECUTIVE OFFICER OF ELI LILLY AND COMPANY, A PHARMACEUTICAL COMPANY BASED IN INDIANAPOLIS, INDIANA. "I PLAYED THE TRUMPET IN THE HIGH SCHOOL BAND AND I SANG IN BOTH THE HIGH SCHOOL AND CHURCH CHOIRS. OCCASIONALLY, MY FAMILY AND I WENT TO THE ART INSTITUTE OF CHICAGO AND OTHER MUSEUMS IN CHICAGO. ALL OF THIS GAVE ME AN EARLY APPRECIATION OF THE ARTS."

AFTER GRADUATING FROM INDIANA UNIVERSITY WITH A DEGREE IN BUSINESS, MR. TOBIAS WORKED FOR INDIANA BELL, A SUBSIDIARY OF AT&T, AS ASSISTANT TO THE PRESIDENT. NOT LONG THEREAFTER, HE HAD THE OPPORTUNITY TO LINK HIS INTEREST IN THE ARTS TO BUSINESS. IN 1971 J. IRWIN MILLER, AN AT&T DIRECTOR AND CHAIRMAN OF CUMMINS ENGINE COMPANY, INC., OF COLUMBUS, INDIANA, CONVINCED THE PRESIDENT OF INDIANA BELL TO CHAIR A CONFERENCE

held at the Indianapolis Museum of Art to help business explore what it might do for the arts beyond writing a check. "I spent two months organizing this conference," recalled Mr. Tobias. "We talked about everything from developing architecturally pleasing buildings, to leaving green space, to sharing corporate art collections so that employees and the public could view the works in these collections. It was a great learning experience for me, and it generated a number of good partnerships between business and the arts."

Mr. Tobias spent 30 years with AT&T, where he was named Vice Chairman of the Board in 1986. In that capacity he presided over a number of arts events sponsored by the Company, including *The New Painting: Impressionism 1874-1884,* which traveled to 33 museums in the United States. Another exhibition, *An American Vision: Three Generations of Wyeth Art,* organized by the Brandywine River Museum, was shown throughout the United States and in Moscow. "It was a wonderful educational opportunity," said Mr. Tobias.

Throughout his career with AT&T, Mr. Tobias maintained

connections to his Indiana roots. "My grandfather settled in Indiana in 1849 and built a mill on a river," he explained. "When steam came along, the mill became obsolete so the family started farming. My father grew up on a farm. A teacher who took an interest in him helped him obtain a scholarship to DePauw University. He graduated in 1929, the year that marked the beginning of the Great Depression, and went to work for a bank in Remington. He was with that bank for 45 years, 25 of which he served as Chief Executive Officer. My mother was also from Indiana. She worked and put herself through college and then taught in public schools in the State. When Eli Lilly and Company was seeking new directors in the 1980s, they invited me to join the Board. I suspect the fact that I had maintained my ties with Indiana contributed to their invitation.

"I joined the Lilly board because of what the Company represents — its excellent values and qualities, beyond its superb performance in its markets. Lilly's values and culture are reflected in the Company's support of the arts. Yet, at this time when all American businesses are experiencing

increased scrutiny by the public, it is no longer good enough to say that we support the arts because we have been doing so for 120 years. Managements of publicly-held companies are forced to recognize that they don't own their company, and shareholders' interests must be a first priority. There must be business reasons for what a company does. It's definitely fair to say that we have a business interest in supporting the arts, especially in locations where we have customers and employees."

In 1993 Mr. Tobias assumed the chairmanship of Eli Lilly and Company — the largest company in Indiana, founded in 1876 by Colonel Eli Lilly. The Colonel, his son and two grandsons, who each served as CEO of the Company, were strong supporters of the arts. They expressed their commitment and support through both personal and Company philanthropy. Colonel Lilly's son, Josiah Kirby (J.K.) Lilly, Sr., assembled one of the finest collections of memorabilia related to composer Stephen Foster. The son of J.K. Sr., Eli Lilly, gathered a large collection of Chinese art, which is now part of the permanent collection of the Indianapolis Museum of Art, located on the grounds of the former home of J.K. Lilly, Jr.

"Even after the Lilly family was no longer involved with the business, the Company continued its involvement with the arts because of the interest of senior management," explained Mr. Tobias. Over the years, Lilly has supported all

the major cultural institutions in the City, including the Indianapolis Museum of Art, the Indianapolis Symphony Orchestra, the Indianapolis Opera Company, The Children's Museum of Indianapolis, and the Indianapolis Zoo, as well as emerging arts organizations. In 1987 Lilly began matching the gifts of its employees, board members and retirees to cultural organizations. The Company gave 375 cultural groups in Lilly operating areas a total of $1.9 million in matching gifts during 1996. Much of the growth of this program is attributed to the *Patrons Program*, an initiative created to encourage upper-level executives to pledge a percentage of their salary to the arts. In 1995 the Company began a month-long *Arts Awareness Series* — workplace performances presented by Indianapolis arts groups — to broaden employee participation in arts organizations in the community. The Company also promotes employee participation on the boards of cultural organizations and organizes an annual *Volunteer Fest* to encourage employees to offer volunteer assistance to community organizations, including the arts.

Each year the Company works with the Indianapolis Symphony Orchestra to present a "thank-you for your

Top to Bottom: Indianapolis Museum of Art; Indianapolis Opera Company, "La Traviata." Opposite: Indianapolis Symphony Orchestra performance at the Lilly Corporate Center, Indianapolis.

"THE ARTS FOSTER CREATIVITY, AND CREATIVITY IS CENTRAL TO OUR BUSINESS STRATEGY. INDEED, WE BELIEVE THERE IS A STRONG LINK BETWEEN THE CREATIVITY NURTURED BY THE ARTS AND SCIENTIFIC CREATIVITY. IF OUR SCIENTISTS ARE STIMULATED THROUGH THEIR INVOLVEMENT WITH THE ARTS, THEN IT'S ULTIMATELY GOOD FOR OUR BUSINESS — AND THE COMMUNITY."

support" concert for employees and their families on the grounds of the Lilly Corporate Center. Additionally, Lilly makes tickets for Symphony performances available to its employees and customers, and sells the Symphony's compact discs in the Company store. Lilly also supports an employee Arts and Crafts Club and a Drama Club.

"Indianapolis is a wonderful place to live. The lifestyle is terrific," remarked Mr. Tobias. "When it comes to recruiting some of the top scientific talent in the world, the job is never the issue — Lilly has some of the best opportunities in the world for leaders in numerous scientific fields — rather, it's often a question of the spouse and family wanting to know what there is to do in Indianapolis. Once we introduce them to the Indianapolis Symphony Orchestra, the Indianapolis Museum of Art and The Children's Museum, plus other cultural organizations in the community, this concern melts away. And, once they are here, we could not pay them to leave. The arts, as well as everything else the community offers, are very important to our recruiting efforts.

"The arts are truly one of the common languages of the world. Currently, we operate in more than 150 countries and our international markets are expanding. As we do business abroad, we want to be thought of not only as a company that seeks opportunities to meet business goals, but also as a company that is interested in being a good corporate citizen of a country, becoming a long-term part of its fabric and contributing to its well-being. For example, we recently opened an office in Vietnam. Shortly after it opened, my wife, Marianne, and I visited this office. Marianne has a doctorate in musicology and is a concert pianist. She writes program notes for the Indianapolis Symphony Orchestra and

The Children's Museum of Indianapolis. Opposite: Indianapolis Zoo.

reviews classical music on the PBS station in Indiana. She conducted a master class in Vietnam for students attending a conservatory of music. She also met with faculty members of the conservatory, all of whom were hungry to learn about music curricula in the West. It was a wonderful experience for everyone."

In the fall of 1997 Eli Lilly sponsored the European tour of the Indianapolis Symphony Orchestra which included performances in England, Spain, Germany and Austria. "This was a very good experience for the Orchestra," said Mr. Tobias. "The Symphony made many recordings while in Europe. And we entertained individuals who are important to Lilly. Everybody wins."

Like the Company itself, Mr. Tobias has acquired a good deal of art. "I certainly don't consider myself a collector, as much as an accumulator," he said. "I've picked up a lot of interesting things over the years from around the world as I traveled. I also have a number of paintings by Hoosier School artists such as T.C. Steele and Forsythe, Williams and Border, as well as some works by nineteenth and twentieth-century artists who painted in Brown County, Indiana."

Most of the art that Lilly has acquired for its corporate art collection is the work of regional artists, among them T.C. Steele, James Cunningham, Marilyn Price, Nancy Noel and Wilbur Meese, a Lilly retiree. In 1984 Willie Faust was

commissioned by the Company to create a work about the scientific discovery process. In 1996 Lilly began a collaboration with the Indianapolis Museum of Art to display works from the Museum's collection in the Company's headquarters that link to the Company's business interests.

"As the leading company in the State, we believe we have a responsibility to support the arts and to encourage other companies to follow our lead," explained Mr. Tobias. "In 1995, for example, Lilly made a $45,000 challenge grant to the Indianapolis Opera Company. This grant led to assistance from more than 40 other businesses, many of which had never previously supported the Opera.

"The arts foster creativity, and creativity is central to our business strategy. Indeed, we believe there is a strong link between the creativity nurtured by the arts and scientific creativity. If our scientists are stimulated through their involvement with the arts, then it's ultimately good for our business — and the community."

Building the Arts Into its Business

"GROWING UP IN ANDERSON, A SMALL TOWN IN THE LOW COUNTRY OF SOUTH CAROLINA, I WAS ENCOURAGED TO APPRECIATE THE ARTS OF THE REGION. PROFESSIONAL PERFORMING ARTS GROUPS SELDOM COME TO THE AREA, BUT WE HAVE A LITTLE THEATER IN TOWN THAT I OFTEN WENT TO," SAID LESLIE G. MCCRAW, FORMER CHAIRMAN OF THE BOARD AND CHIEF EXECUTIVE OFFICER OF FLUOR CORPORATION, A GLOBAL ENGINEERING, CONSTRUCTION AND DIVERSIFIED SERVICE COMPANY HEADQUARTERED IN IRVINE, CALIFORNIA.

"I BECAME INTERESTED IN THE ARTS MUCH LATER IN LIFE, AFTER GRADUATING FROM CLEMSON UNIVERSITY WITH A DEGREE IN CIVIL ENGINEERING," CONTINUED MR. MCCRAW. "I WOULD SAY MY FORMATIVE INTEREST IN THE ARTS — AND MY WIFE'S — BEGAN DURING THE TIME I WORKED FOR DUPONT IN DELAWARE. ONE OF MY MOST MEMORABLE EXPERIENCES WITH THE

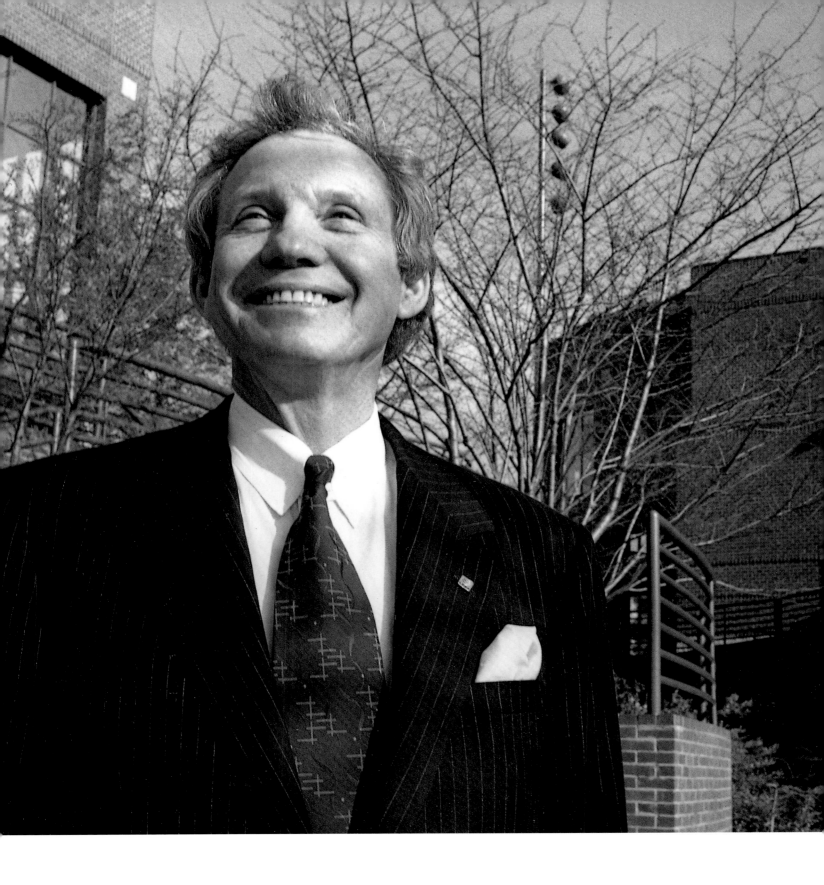

Leslie G. McCraw
Former Chairman of the Board
and Chief Executive Officer

arts was a Wyeth exhibition in the Brandywine River Museum in Pennsylvania. I remember going to this exhibition and others sponsored by the Company. We also visited Longwood Gardens and Winterthur often when we lived in Delaware."

In 1975 Mr. McCraw joined Daniel International, a construction company based in Greenville, South Carolina. Two years later, it was purchased by Fluor Corporation. In 1984 he was named Chief Executive Officer and a Director of Fluor after serving as President of Daniel for two years.

"Our support of the arts at Daniel was a legacy from our founder, Charlie Daniel," he explained. "He and his wife lived in Greenville. They had a private foundation and were involved with the arts on a personal level. Mrs. Daniel was also very active with the universities in the area. Their interest in traditional art was reflected in their home, which was a replica of the Governor's mansion in Williamsburg. It's now the home of the President of Furman University — a wonderful liberal arts university with about 2,500 students and a strong arts and music program. There are a number of places in Greenville that are named for the Daniel family, among them the Daniel Theatre, also called the Greenville

Little Theatre, as well as several venues at Furman. The Daniels' strong personal involvement and commitment to the arts had an influence on the Company. When the Company went public and Fluor bought Daniel in 1977, Buck Mickel, who was Chairman of the Board of Daniel and on the Board of Fluor, carried on the tradition that Mrs. Daniel began."

The new entity in Greenville, now known as Fluor Daniel, is one of the leading supporters of the arts in the city. In 1989 the Company made a leadership grant of $500,000 toward the construction of The Peace Center for the Performing Arts, which includes a 2,000-seat concert hall and a 400-seat theater. The Company also provided a construction manager for the project and an additional $250,000 endowment grant. Mr. McCraw and other Fluor Daniel executives serve on the Center's Board of Directors, and the Company supports a number of the Center's programs, including the *Peace Outreach Program (POP),* an arts education initiative that serves 45,000 students and teachers annually by bringing them to The Peace Center for live performances. Fluor Daniel is also a major supporter of the Greenville County Museum of Art. In addition to underwriting the Museum's annual antique show, which raises

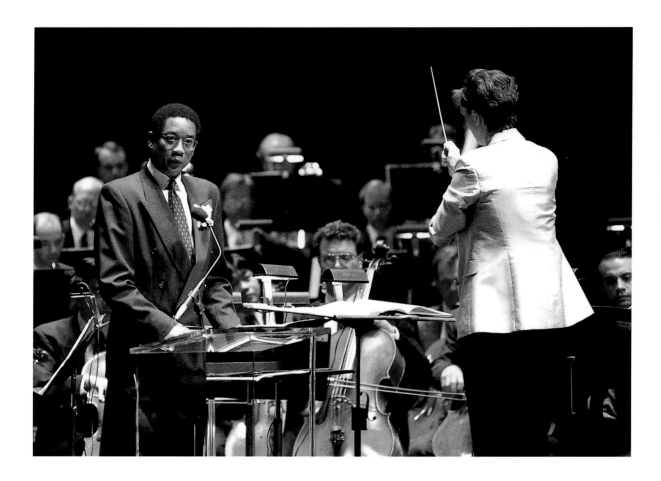

funds to purchase works for the Museum's permanent collection, the Company has also sponsored an exhibition of regional American art, and helped the Museum acquire the painting, *Benjamin Hawkins and the Creek Indians.*

Greenville's two annual arts festivals — *Art in the Park,* a two-day visual arts event featuring the works of 200 artists and attended by more then 8,000 persons, and the *Riverplace Festival,* an arts and entertainment event attended by more than 20,000 persons each spring — are also supported by Fluor Daniel. In 1996 the Company sponsored the creation of a canvas mural designed by *Festival* visitors which hangs in the Fluor Daniel Gallery. The Gallery, established in 1989, showcases the work of local students, as well as aspiring and established artists.

For four years, beginning in 1989, Fluor Daniel underwrote *Get Comfortable with the Arts Day,* organized by the Metropolitan Arts Council of Greenville, to encourage employees to attend performances and exhibitions. To further encourage employees to take an interest in the arts, the Company allocates space near its food facilities where employees may view and purchase works created by local artists. Additionally, Fluor provides general operating support for nearly all the arts organizations in the city, including the Greenville Symphony Orchestra, the Fine Arts Center of Greenville County School District, the Greenville Little Theatre, the South Carolina Children's Theater, The Warehouse Theatre, Centre Stage - South Carolina! and the

South Carolina Governor's School for the Arts, a pre-professional summer training school for high school art students. Fluor Daniel also underwrote a literary program, *Let's Talk About It,* initiated by the Greenville County Library, which featured poets and authors reading and discussing their works in local libraries. In 1990 Fluor Daniel received the Governor's Award for Business Support of the Arts.

"Commitment to the arts has been a tradition in both companies prior to the merger," observed Mr. McCraw. "The Fluor family, like the Daniel family, has a strong interest in the arts. When Fluor built its new office building in Orange County, California, it bought a lot of art for the building. J. Robert Fluor, former CEO and an ardent supporter of the arts, was on the Board of the Orange County Performing Arts Center. David Tappan, who succeeded Bob Fluor as CEO, continued Fluor's strong commitment to the Performing Arts Center. Additionally, he founded the Orange County Business Committee for the Arts in 1980 and served on the Board of the Newport Harbor Art Museum. When I lived in Orange County I served on the Board of the Performing Arts Center for six years and we supported a variety of programs including Stop-Gap and Art Reach."

The Fluor Foundation made a leadership grant of $2 million toward the construction of the Orange County Performing Arts Center, plus a multi-year gift totaling $500,000 designated for the Center's Endowment Fund. In addition to general operating grants to a variety of arts

"WE THINK THAT EXPOSURE TO AND KNOWLEDGE OF THE ARTS CERTAINLY MAKES FOR A MORE ROUNDED INDIVIDUAL.... WE HOPE THAT OUR SUPPORT OF THE ARTS PROVIDES A BACK-DROP TO BETTER ROUNDED EMPLOYEES AND TEAM MEMBERS."

organizations in Orange County, including The Orange County Museum of Art in Newport Beach, Opera Pacific in Laguna Beach and the Pacific Symphony Orchestra in Santa Ana. Fluor sponsors workplace performances for its employees through the Orange County Performing Arts Center program called *Informally Yours*. And employees volunteer their services to arts organizations as members of the Fluor Community Involvement Team. In 1995, for example, Fluor employee volunteers helped Ballet Pacifica rebuild its rehearsal facilities and offices, which were destroyed by a fire.

"Because of the nature of our Company, we do a lot of projects in a lot of different places — California, Houston, Greenville, Chicago, as well as in Amsterdam, Düsseldorf, Warsaw, Beijing, Singapore and Jakarta. If you go through these different offices, you will see indigenous art in all of them. Because we move people around to many communities, we're interested in the quality of life in the communities where our employees live. And, because the nature of our

business is serving people, we encourage our employees to join the boards of arts organizations and to participate in their community.

"We have a foundation — The Fluor Foundation. I chair its Board. We have a defined annual budget target, so it's not catch as catch can. We start with a budget for both The Foundation and the Company's contributions program, which is about two percent of our earnings. We then divide it into categories. About eight to ten percent goes to the arts. Our regional offices have local autonomy to recommend contributions to The Foundation.

"We are inclined to support those activities that our employees are involved in. If the symphony comes in and wants support, and our people are not contributing time and resources to the symphony, we are not inclined to support it. This, we find, is an effective indirect means of getting our employees involved. Why do we do this? We think that exposure to and knowledge of the arts certainly makes for a more rounded individual. Because we're so technically oriented, there's a tendency for us to be left-brained, rather then right-brained. And, there's a tendency to be less creative than we would like to be.

"We're a service company. We don't sell a product. Our support is directed to improving the quality of life in the communities in which we're involved. We hope that our support of the arts provides a backdrop to better rounded

employees and team members. As part of our business operations, we have a site selection group to help companies that are relocating go beyond the engineering and construction we provide. A certain part of the site selection matrix concerns quality of water, rail service, highways and golf courses. While another very important part involves cultural and other life enriching type activities. I see more and more companies making decisions based on these issues.

"The Chamber of Commerce recently asked me to talk about the quality of life in Greenville with executives from a company that was considering relocating from Delaware. They were looking at three locations — Greenville, Charlotte and Nashville. The Chamber flew some of this company's families to Greenville. They visited The Peace Center for the

Performing Arts, the Greenville County Museum of Art and they saw some of our theaters. After this visit, I am pleased to say, they chose Greenville.

"I've lived in nine states, and I find Greenville is a really wonderful place to live. You have the basics, the fundamental cultural outlets, and then there is a kind of double bonus. You have the universities with their arts activities. Bob Jones University has a wonderful collection of religious art. Furman University has a variety of cultural activities. Clemson University also has a very rich program. One might think, well, there is not much going on in a place like Greenville. That's a mistake. Our strong commitment to the arts in Greenville and in the university communities nourishes a healthy intellectual and cultural environment."

Orange County Performing Arts Center, Costa Mesa. Opposite (Left to Right): Greenville Little Theatre, The Peace Center for the Performing Arts, The Greenville County Museum of Art.

Christopher Forbes
Vice Chairman

Carrying on a Family Tradition

"PA WAS A COLLECTOR OF A WIDE RANGE OF THINGS. MY THREE BROTHERS, SISTER AND I TAKE AFTER OUR FATHER IN THAT ALL OF US HAVE BEEN BITTEN BY THE COLLECTING BUG. EACH OF US COLLECTS SOMETHING DIFFERENT," SAID CHRISTOPHER FORBES, VICE CHAIRMAN OF FORBES INC., A MAGAZINE PUBLISHING AND MEDIA COMPANY, LOCATED IN NEW YORK, NEW YORK. "MY BROTHER, STEVE, SPECIALIZES IN MATERIALS ON WINSTON CHURCHILL, JOHN GALSWORTHY AND IN AUTOGRAPHS AND MEMORABILIA," HE EXPLAINED. "TIM HAS AN IMPORTANT ANTHOLOGY OF NINETEENTH-CENTURY AMERICAN FURNITURE FROM DUNCAN PHYFE TO GUSTAV STICKLEY. BOB HAS EXPERTISE IN PHOTOGRAPHS AND VINTAGE WINE.

"AUTOGRAPHS WERE MY FATHER'S FIRST LOVE," HE CONTINUED.

"He started collecting them when he was very young. By the time my brothers and I were old enough to be aware of what he was collecting, he was buying American paintings — mostly work by living artists. He began a personal collection of Fabergé in the early 1960s. When he was a young boy, he learned about Fabergé while reading a book about World War I. Years later he bought a Fabergé cigarette case and gave it to my mother. In 1964 he purchased a Fabergé egg at an auction for his personal collection, not the Company's. He and his older brother were running the Company at the time. They each received an equal number of shares from their father, B.C. Forbes, our Founder. They were both very bright and sometimes they did not agree on things. So, it was only when his brother died that my father decided that The Forbes Magazine Collection should focus on Fabergé.

"Growing up we always had art and objects around. My mother had a degree in interior design and painted rather beautifully — both watercolor and oil. I began my education in local schools in New Jersey and then I was trundled off to St. Marks in Massachusetts for four years. At the end of my ninth year of school I was sent to École Nouvelle de la Suisse Romande, just outside of Lausanne, Switzerland, and from there I went on to Princeton University.

"When I asked my father if I could major in art history, at Princeton, rather than economics, he said, 'Sure, whatever you learn in school, you never much use, so majoring in economics would be a waste of time. Do what you enjoy and you will do well.' And then he said, 'By the way, as the Curator of The Forbes Magazine Collection, you can pay your own tuition!'"

The third youngest of the four brothers, Christopher Forbes, or Kip as he is known to family, friends and business associates, joined the family-owned company in 1970, while he was still a student at Princeton. His eldest brother, Malcolm S. Forbes, Jr., called Steve, began his career as a reporter for *FORBES* in 1969. Currently, he is President and Chief Executive of Forbes Inc., Editor-in-Chief of *FORBES* and Chairman of the American Heritage Division. Bob, the second eldest, joined the Company in 1971, and left four years later to pursue a career in photography. He returned in 1980 and became Vice President of the Company's subsidiary, Sangre de Cristo Ranches. In 1989 he was named President of *FORBES FYI,* a supplement published by Forbes,

and he is currently Vice President of Forbes Inc. Tim Forbes joined Forbes in 1981 and was named President of the American Heritage Division in 1986. In 1996 he was named Chief Operating Officer of Forbes Inc.

"When I was the Curator of The Forbes Collection, I persuaded my father that we should assemble the largest collection of English nineteenth-century paintings in North America," recalled Mr. Forbes. "To do this, I also had to convince him to sell what I called his third-rate Monet, *Water Lilies,* which he did. As I was putting the Collection together, I also persuaded the Art Department of Princeton to allow me to write a catalogue about the Collection and to exhibit the works at Princeton, instead of writing a conventional thesis. The Metropolitan Museum of Art heard about the project and asked if it might have the exhibition before Princeton. Based on this request, Princeton decided I was a genius, so I did very well!" In 1975, an exhibition of works from our Collection, tilted, *The Royal Academy Revisited,* opened in The Met.

"By the early 1960s, around the time we bought the building on lower Fifth Avenue in New York that serves as our headquarters, Pa already had a collection of Fabergé. He loved the coincidence that our magazine was founded at nearly the same time as the Russian Revolution in 1917," explained Mr. Forbes. "In a sense, my father was a pioneer. He knew the pleasure he derived from having original art around him. He felt that it was an experience others would enjoy and that it would enrich the work environment.

"In 1977, when we celebrated the 50th anniversary of *FORBES* Magazine, we had a number of cases installed in the lobby of our headquarters to display our then-modest

The Picture Gallery, The Forbes Magazine Galleries, New York. Opposite: Entrance to The Forbes Magazine Galleries.

Fabergé collection and some of the historic autographs that my father collected and just loved. I will always recall my father joking that by putting Fabergé in our lobby, visitors coming for lunch and meetings would know we were solvent! It's hard to believe, but in those days *Forbes* was an also-ran among the three major business magazines.

"In 1983 we decided to turn the entire ground floor of our building into a gallery. This set us apart. It gave us a distinct identity and it's part of the reason we are now the number one business magazine," said Mr. Forbes. The Forbes Magazine Galleries began operating in 1985 and feature permanent exhibitions — admission free — of Fabergé objets d'art, including 12 Easter eggs made for the Czars of Russia; selections from the Magazine's more than 4,000 historical documents, related memorabilia and historic autographs; a display of more than 10,000 military miniatures; an exhibition of more than 500 toy ocean liners, pleasure crafts and warships; *The Mortality of Immortality,* a collection of some 160 trophies; and a rotating exhibition of paintings,

photographs and other visual works from The Forbes Magazine Collection. "The Galleries and Collection are part of my responsibility," noted Mr. Forbes. "But we have an entire department of individuals far more knowledgeable than I am handling curatorial and operational matters. In addition to showing art and objects, we also use the Galleries for business functions and we frequently host special events in the space for not-for-profit organizations.

"Each year we make the Galleries available to several not-for-profit organizations to use for their events. I serve on the boards and national committees of a number of not-for-profit organizations, among them, The Victorian Society, the Business Committee for the Arts and The National Museum of Women in the Arts, all of which have held events in the Galleries. I am also on the Board of The New-York Historical Society, the Brooklyn Museum of Art and The Newark Museum. They're all good institutions. None of these three organizations has it easy, considering that each is located so close to The Metropolitan Museum of Art.

"Carrying on a tradition established by our father, we lend works from our Collection to museums throughout the world. For example, we lent 80 works to *Fabergé in America* and we toured *The Royal Academy Revisited* to five cities. When we do this, we try to link it with our business interests by entertaining and offering private showings. We also use art, but not aggressively, in our publications. We used the Fabergé early on in an advertising campaign and once in a while we use images from the Collection on holiday greeting and gift subscription cards.

"We believe it's essential for business to support the arts. Rather than run around and hit people over the head with

the idea, we decided to sponsor the Business in the Arts Awards. We started co-sponsoring these Awards with the Business Committee for the Arts in 1977 because we wanted to draw national attention to companies that formed exemplary alliances with the arts. We believed this was the best way to propagate the idea.

"Our Collection is alive, well and evolving. My father was a great believer in change, especially when it came to the Collection. He always said, 'If something doesn't turn my children on, I hope they will let other collectors have a chance at getting it. So by all means they should put things on the block that they are not interested in.' We have done this in some areas and expanded in other areas. We recently purchased a wonderful life-size marble sculpture by Frederick Lord Leighton that has an interesting story. It depicts an athlete strangling a python. In 1887 Carl Jacobson, owner of the Carlsberg Brewery in Copenhagen, commissioned the marble sculpture for the Ny Carlsberg Glyptotek, a sculpture museum he founded in 1882. This upset Leighton because the piece was originally intended to be cast in bronze. With a change in medium, Leighton had to find a way to stabilize the athlete. He did it by placing it artfully against a tree trunk. In 1977 when The Minneapolis Institute of Arts was organizing the exhibition entitled *Victorian High Renaissance,* the Ny Carlsberg Glyptotek was asked to lend this piece. The Glyptotek replied that it did not have such a piece, but the Museum was welcome to send a representative to explore the storage area, which it did. The representative scoured the area, found nothing. And then, while walking up a steel staircase to leave, spotted a crate in a corner. It was opened and there was Leighton's marble sculpture. It had been delivered to the Museum in 1891 and it had never been uncrated. After the 1977 exhibition, it was sold to an English gentleman who in turn sold it to the collector from whom we purchased it.

"Fairly recently my brothers and I agreed to make a stretch to acquire John Martin's masterpiece, *Pandemonium.* To make this one purchase we agreed to sell about 30 paintings. It was very painful, but it was the only way we could add this seminal work to the Collection. It is really dazzling and we are all happy we did it.

"My personal collection focuses on Napoleon III. It's the contrarian play. I couldn't afford Napoleon I. I also collect furniture and decorative objects from the American Arts and Crafts Movement. My interest in these works began as a functional project. We were running a nineteenth-century publication around the time we were building a new lodge at our ranch in Colorado. One of the advertisements in this publication was for Mission furniture. I tried to persuade my father to buy this furniture for the lodge. I remember saying to him, I agree it's hideous, but remember what happened to the value of our Victorian art. This furniture will pay for the lodge within 10 years. I didn't succeed. Instead my wife and I decided to use this furniture in one of the older buildings on the ranch that we were restoring. We agreed, it's an ugly house and ugly furniture and they complement each other beautifully. We enjoy it. Now we have a house and guest house full of Roycroft.

"I really think the desire to collect is something you are born with. It's a passion that spills over into everything," commented Mr. Forbes. "So many great businessmen are passionate collectors. For example, Walter Annenberg built a very successful business and he developed one of the greatest collections in the world of works by the Impressionists. He believed, as did my father who taught us, 'If you are lucky enough to have works of art, it is important to share them with others.'"

Integrating the Arts
Into the Workplace

"WE DIDN'T HAVE MANY WORKS OF ART IN OUR HOME WHEN I WAS A CHILD, ALTHOUGH I DO REMEMBER MY FATHER COMING HOME WITH AN OIL PAINTING THAT HE BOUGHT FOR $10, WHICH HE FELT WAS A GREAT BARGAIN AND MADE HIM VERY HAPPY," RECALLED GERALD L. GOLUB, MANAGING PARTNER, GOLDSTEIN GOLUB KESSLER & COMPANY, P.C., AN ACCOUNTING AND CONSULTING FIRM BASED IN NEW YORK, NEW YORK. "IT WAS A PAINTING OF A GOD-LIKE STATUE ALONG WITH A COUPLE OF URNS, SET AGAINST A DARK BACKGROUND. IT STILL HANGS IN MY PARENT'S HOME."

"MY MOTHER WAS A BOOKKEEPER AND MY FATHER WANTED TO BE A DOCTOR, BUT HE SPENT HIS LIFE DRIVING A TRUCK FOR A BREAD COMPANY BECAUSE HIS FATHER DIED WHEN HE WAS YOUNG AND HE DECIDED TO LEAVE SCHOOL TO SUPPORT HIS MOTHER AND YOUNGER BROTHER. IN HIS SPARE TIME,

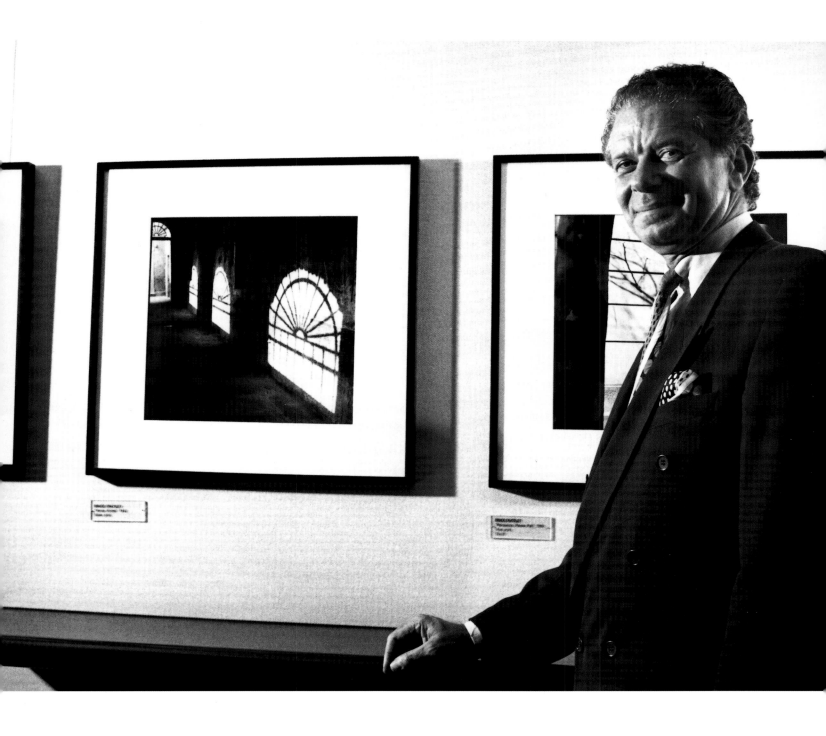

Gerald L. Golub
Managing Partner

GOLDSTEIN GOLUB
KESSLER & COMPANY, P.C.

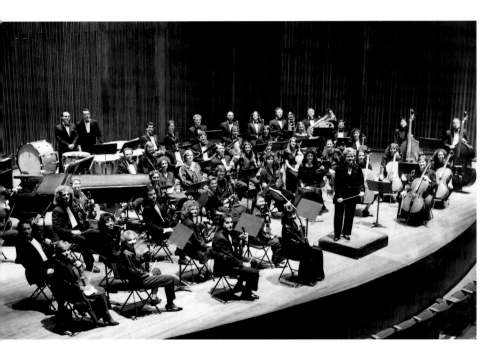

Chorus, but when there was a scheduling conflict between glee club and baseball, you know which one I chose!

"After graduating from Stuyvesant High School, I was obviously on course to enter the engineering world at Brooklyn College. After about a year and a half into my studies, I had a concept problem in physics, so I asked my physics teacher to explain certain criteria and assumptions relating to the concept. He couldn't. This really upset me because I thought, how can I be expected to build bridges, based on an assumption that a teacher couldn't explain. I decided right then and there to change my major to something else. I was very capable in math and a number of my fraternity brothers were accounting majors, so I switched to accounting.

"My wife, Bonnie, introduced me to the arts. Her family was very interested in the arts. In fact, they supported the creative works of a number of artists and they began taking her to museums when she was about six years old. We met at Brooklyn College. My fraternity and her sorority teamed up to present a musical spoof of *Alice in Wonderland*. She was directing the show and needed a Tweedledee and Tweedledum. I volunteered!

"When we had our own children, we did what my wife's parents did for her — we took them to performances and museums at an early age. Now, we do this with our grandchildren. I think it is very important to give children opportunities to experience the arts when they are young.

"In 1961, right after graduating from college, I worked for a small accounting firm that had writers and producers, involved with theater and film, among its clients, so I had exposure to the arts early in my career," explained Mr. Golub. "During the summer of 1968 I started my own firm and two and a half years later I merged it with that of Stan Goldstein and Stu Kessler. In 1971 we put it all together as Goldstein Golub Kessler & Company with a total of 20 persons. Today, within our overall roster of clients we have more than 200 not-for-profits. We work with these organizations because they are doing something that is very important. In many instances they are small organizations, so we greatly reduce our fees and provide in-kind professional services in an effort to help them." Among GGK's cultural not-for-profit clients are the Brooklyn Philharmonic

and even more seriously after he retired, he enjoyed photography. He took wonderful pictures by dropping water on flowers and then photographing them from different angles. My parents felt that education was the prime criteria for success, so they gave up whatever luxuries they might have been able to afford to pay for my education and my brother's. I grew up in Brooklyn and went to Stuyvesant High School and Brooklyn College. In high school I sang in the glee club and played baseball. In fact, I was offered a position in the All-City

"THE ARTS AND CULTURE ARE FOR EVERYONE, NOT JUST THE WEALTHY. THE BUSINESS COMMUNITY MUST CONTINUE THE TRADITION OF SUPPORTING THE ARTS BY HELPING CULTURAL ORGANIZATIONS PRESENT PROGRAMS THAT REACH EVERY MEMBER OF THE COMMUNITY."

Orchestra, The China Institute Gallery, The China Institute in America, The Concordia Orchestra, the Museum of American Financial History, the International Jazz Museum, the Russian American Cultural Foundation, theater companies, including The Pearl Theatre Company, Inc. and The American Place Theater, as well as several art galleries.

"For years accountants were known as number-crunchers, but this has really changed," commented Mr. Golub. "Frankly, I think the creative mind was always there, but now it's become more evident. Today, the accountant has to be a consultant, has to be industry smart, and has to be innovative in order to help people run their businesses. As a firm, we appreciate and understand the arts and I think we have

an important role to play by guiding, advising and helping arts organizations reach their potential. Typically, accountants are not on boards of not-for-profits, but we do a lot of professional volunteer work with boards and staffs to help them enhance their management skills," noted Mr. Golub. "We also run seminars and workshops to make these groups aware of issues and trends affecting their operations. These include current trends in financial reporting, new tax legislation affecting not-for-profits, planned giving techniques to improve future revenue streams, and tips on how to control cash flow and manage the business side of the operations more effectively.

"I firmly believe it is important to integrate the arts into the workplace," explained Mr. Golub. "When we moved to our

Brooklyn Philharmonic Orchestra, Robert Spano, Conductor. Opposite: The Concordia Orchestra, Marin Alsop, Conductor.

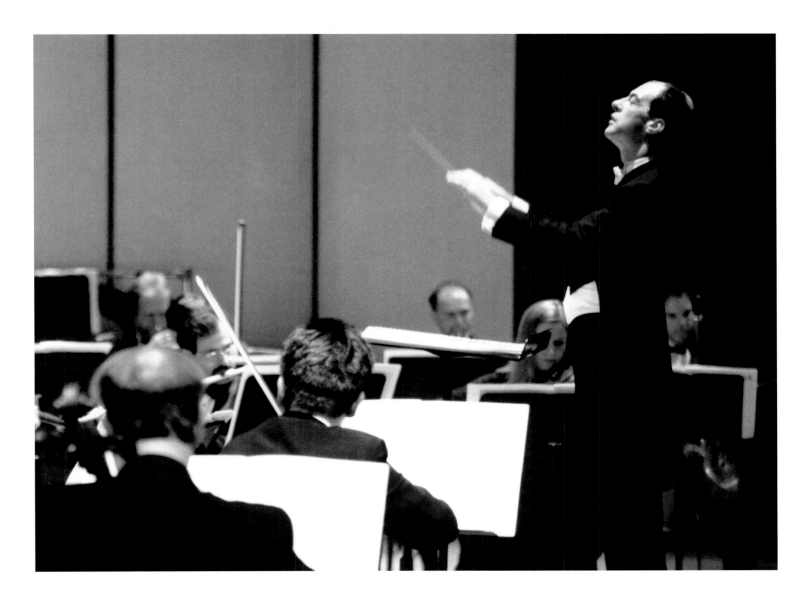

current offices in midtown Manhattan, we made a conscious decision to develop a consistency in the design throughout our space and to assemble and display a collection of fine black-and-white photography. We were one of the first in our field to do this. We receive many compliments about our collection from our clients when they visit our office. In fact, some arrive a half hour before an appointment to walk through our offices and look at the photographs. In 1988 we began working with Betty Levin of Corporate Art Directions Inc. to assemble the GGK collection of photography. We acquired our first works — a series of Ansel Adams photos depicting some of the natural wonders of the West — from Bob Feldman of Parasol Press, Ltd. Our collection now includes more than 140 photographs by 75 photographers, including George Tice, Helen Levitt, Linda Butler, Jerry Elsmann and Zeke Berman.

"I enjoy being surrounded by art at the office and at home, and visiting museums. I go to the International

Center of Photography quite often. And, while it changes exhibitions, and we do not, I think we have a really outstanding collection," remarked Mr. Golub. "It gives me, our staff and our clients great pleasure, and it is a clear signal that our firm appreciates the arts."

To enhance its reception area, GGK commissioned Alexander Jankowski in 1990 to create a free-form painted fabric work titled, *Solarwind*. "I think art is to be enjoyed and art is to be questioned," suggested Mr. Golub. "When we installed *Solarwind,* there was a mixed reaction from my partners, and reactions continue to change. Some liked it and now they don't, and some who didn't like it at first, now do. Others have grown accustomed to it. It's an interesting process to observe. Over time, I think works of art become part of a company's culture. I don't believe that companies that bought works for relatively little money years ago, should now liquidate them because they have greatly escalated in value.

"I give the younger generation a lot of credit for their capabilities and their achievements. The generation just coming into business and the generation that will soon assume leadership positions, probably have more going for them than my generation. They are better educated than their predecessors and they have more exposure and more opportunities to be involved with the arts," said Mr. Golub.

"I also think that inner city children are far more exposed to the arts and culture today than ever before," he continued. "Just think about all the theater, dance and music performances that arts organizations present for children in the inner cities. I will always remember when Jacqueline Kennedy took us through The White House on television. It gave so many of us a chance to see something that we might not have seen otherwise. Today, there are so many wonderful opportunities for everyone to experience the arts and culture on television and through other technologies. The arts and culture are for everyone, not just the wealthy. The business community must continue the tradition of supporting the arts by helping cultural organizations present programs that reach every member of the community."

Top to Bottom (Left to Right): Alexander Jankowski's "Solarwind;" Lobby; Corridor, GGK offices, New York. Opposite: Conference Room, GGK offices, New York.

Making the Arts Available to All

"I BEGAN COLLECTING ART BY PURCHASING A MODIGLIANI PRINT FOR $1 AT A MEMPHIS DEPARTMENT STORE WHEN I WAS JUST OUT OF HIGH SCHOOL. MY ART COLLECTION GREW FROM THERE AS I PURSUED RARE AND BEAUTIFUL WORKS, NOTABLY THOSE BY TOULOUSE-LAUTREC, MATISSE, BONNARD AND VUILLARD," SAID IRA A. LIPMAN, FOUNDER AND PRESIDENT OF GUARDSMARK, INC., A PRIVATELY-OWNED NATIONAL SECURITY SERVICES FIRM LOCATED IN MEMPHIS, TENNESSEE.

"I GREW UP IN LITTLE ROCK, ARKANSAS. IN FACT, I WAS A SENIOR AT HALL HIGH SCHOOL AT THE TIME OF THE CENTRAL HIGH SCHOOL DESEGREGATION CRISIS," RECOUNTED MR. LIPMAN. "I HELPED JOHN CHANCELLOR, THE TELEVISION REPORTER AND ANCHORMAN, SCOOP OTHER REPORTERS BY SECRETLY FEEDING HIM INFORMATION ABOUT

Ira A. Lipman
Founder and President

G U A R D S M A R K , I N C .

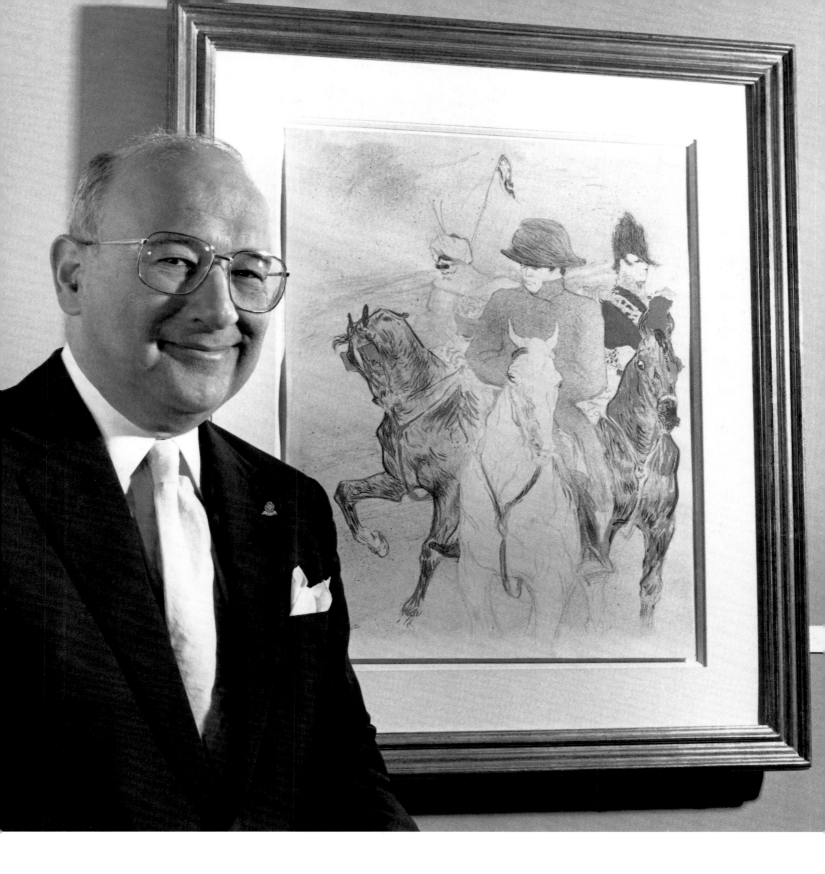

the situation, which I got from Ernest Green, a locker room attendant at the Jewish Country Club where my parents were members. Ernest, whom I had befriended, was a member of the Little Rock Nine — the group of students who entered Central High. This episode is chronicled in David Haberstam's book, *The Fifties*."

In 1975 my wife, Barbara, and I were married, and I purchased the first piece for The Guardsmark Collection — Toulouse-Lautrec's poster, *Divan Japonais*. Shortly, thereafter,

I bought a second piece, *Babylone d'Allemagne*," continued Mr. Lipman.

"My interest in art is untrained — like a person who plays the piano by ear. I continued to pursue Toulouse-Lautrec's works through the years, until I collected one of each of his posters — always selecting the perfect, the unfaded, the unblemished. With our collection, we are guided by the same principles we use in our business. We concentrate on quality and perfection — the best.

"I admire Lautrec's work for its colors and brilliance, and for his social commentary on his world. I do not, however, admire the artist's lifestyle. His work is admirable, but it is sad that he became an alcoholic and succumbed to an early death because of his drinking.

"What impresses me most about Lautrec's posters is how

Henri de Toulouse-Lautrec's "Divan Japonais" (1892-1893). Opposite (Left to Right): Pierre Bonnard's "Maison dans la Court;" Henri de Toulouse-Lautrec's "Moulin Rouge La Goulue" (1891).

extremely historical they are," commented Mr. Lipman. "He was truly great because of his insights into life. He really shows you different worlds. He is also the father of modern lithography.

"One of my favorite Lautrecs, and one of the rarest in our Collection, is *Napoleon*. Lautrec and other artists had been invited to produce illustrations for a book about Napoleon to be published in the United States. The producers of the book did not realize who Lautrec was, and they rejected his work. Disappointed, Lautrec printed 100 posters himself and signed them. The Guardsmark Collection contains number 47. While the book was never published, the fame of *Napoleon* goes on and on.

"Another of my favorites is *The Troupe of Mademoiselle Églantine*," continued Mr. Lipman. "The yellow in this work is fantastic. I also prize *The Irish and American Bar*. This is the one that depicts the bar where Lautrec met interesting characters, among them the Rothschild's footman. It's close to my heart. *La Vache Enragée* is a fun thing. It shows a bull running down the street being chased by a policeman and a shopkeeper. *Moulin Rouge* is the biggest, the oldest and one of his first posters. It's what you think of when you go to the movies and see the can-can performed."

The Guardsmark Collection contains more than Toulouse-Lautrec's work. Over the years, Mr. Lipman has collected pieces by a number of artists including Edouard Vuillard, Pierre-Auguste Renoir, Pierre Bonnard, Helen Frankenthaler, Andy Warhol, and a Swiss artist named Valenti. The Collection also includes two complete sets of Matisse's *Jazz*. These works hang in a special gallery in Guardsmark's headquarters.

"My search for art continues," said Mr. Lipman. Every weekend my secretary packs a briefcase of mail from the Art Dealers Association of America which I read on Sunday afternoons while listening to Beethoven and Tchaikovsky. It's a wonderful way to relax and rejuvenate."

Works from The Guardsmark Collection are often loaned to museums and galleries for special exhibitions, and tours are given to visitors who come to Memphis. In 1985 *Jane Avril* was one of the pieces loaned to The Museum of Modern Art in New York for its exhibition, *Henri de Toulouse-Lautrec*. The entire Toulouse-Lautrec Collection was shown in The Dixon Gallery and Gardens in Memphis for a special 1989 exhibition entitled, *The World of Toulouse-Lautrec Featuring The Guardsmark Collection*. Pieces were also loaned to the Memphis Brooks Museum of Art, and works by

Left to Right: Henri de Toulouse-Lautrec's "Babylone d'Allemagne" (1894); Henri de Toulouse-Lautrec's "Le Jockey" (1899). Opposite: Henri Matisse's "Le Cheval."

Matisse, Bonnard and Vuillard were shown in an exhibition entitled *Selections from The Guardsmark Collection* held in The Dixon in 1997.

Over the years, Mr. Lipman has supported a number of efforts to encourage grade school students, especially those underserved, to visit museums. "These magnificent buildings housing art are theirs, and underprivileged students should have an opportunity to go to museums," explained Mr. Lipman. "On one occasion, I asked the Superintendent of Schools, Dr. W. W. Herenton, who was later elected Mayor

of Memphis, to greet students at the front door of a museum. I have also arranged to have a number of outstanding artists visit the local public schools to teach the students about the arts.

"Art is our civilization. Everyone should have an opportunity to be touched by the arts. We should all work to help a cross-section of individuals increase their understanding of the arts," he continued. "My focus is on minorities in this respect. Making the art accessible to everyone is a challenge that business must address."

Irving W. Marks
President

Showcasing Cultural Gems
in the Community

"MY APPRECIATION OF THE ARTS REALLY STARTED IN THE MID-1950S WHEN I BOUGHT MY FIRST AUTOMOBILE AND BEGAN TO LISTEN TO CLASSICAL MUSIC ON THE CAR RADIO," RECALLED IRVING W. MARKS, PRESIDENT OF I.W. MARKS JEWELERS, INC., A FINE JEWELRY STORE IN HOUSTON, TEXAS.

"MY FATHER WAS FROM CONNECTICUT AND MY MOTHER WAS A POLISH IMMIGRANT. I REMEMBER HOW MUCH THEY ENJOYED LISTENING TO MUSIC, ESPECIALLY CLASSICAL MUSIC AND OPERA. THEIR LOVE OF MUSIC LED THEM TO NAME ME AFTER IRVING BERLIN, WHO WAS A HERO IN THIS COUNTRY DURING THE 1930S," RECOUNTED MR. MARKS. "MY PARENTS TOOK ME TO PERFORMANCES IN THE CHICAGO AREA WHERE I GREW UP, BUT I BARELY REMEMBER THIS.

I do remember taking piano and violin lessons but, like most kids, I had little interest and never wanted to practice.

"My late wife, Diane, and I started our jewelry business in Houston shortly after we were married. Like anyone who starts small, I was a jack-of-all-trades. I would stay at the store nearly all night doing paperwork, repairing jewelry and doing whatever else was necessary to open the next day. My companion during the night was a classical music station. As our business grew, we began to advertise on this station. One day the station manager told me the station was going off the air from midnight until six the next morning because they could not afford to pay the all-night engineer. I didn't want this to happen so I paid the engineer's salary — which in the 1970s was about $125 a week — and the program was named, *Midnight 'Til Dawn,* sponsored by I.W. Marks Jewelers. People came into the store and thanked me for

keeping this program on the air. It turned into a great business investment." Since 1979 I.W. Marks Jewelers has sponsored *Midnight 'Til Dawn,* as well as other classical music programs on KRTS-FM in Houston.

"As a result of this experience I became more interested in music and more aware of the arts in Houston," admitted Mr. Marks. "Diane and I first went to performances of the Houston Symphony as single-ticket buyers, and then decided to buy a season subscription because we enjoyed the performances so much." Since the mid-1980s, I.W. Marks has sponsored Houston Symphony concerts and on occasion has underwritten the Symphony's Opening Night Ball.

"Not long after we began going to Symphony concerts, we went to several performances of the Houston Grand Opera. And, as with the Symphony, we enjoyed the experience so much that we became season ticket-holders. We joined the patrons group of the Opera, and the Company began to underwrite at least one performance a year, plus the annual Opera Ball — the Opera's primary fundraising event and the major social event of the year in Houston. Over the years we have also hosted a number of cast parties for world-famous opera stars, among them Plácido Domingo. To help the Opera thank individual and business patrons and to cultivate new supporters, we also underwrite special events such as *Diamonds & Divas.* This event, held in our store, included a private viewing of the $6 million collection of the winning pieces of jewelry from the De Beers Diamond International Awards, as well as performances presented by members of the Houston Opera Studio who modeled some of the pieces from the De Beers collection. Guests also had an opportunity to talk with Daniel Catan, who wrote *Florencia en el Amazones* which was premiered by the Houston Grand Opera.

"I enjoy introducing people to the Symphony and the Opera and helping both expand their business horizons. Over the years we have worked with local advertising agencies and the media to encourage them to provide pro bono services and space for all of the arts organizations in Houston. Several years ago I remember looking at the back of my Symphony ticket and wondering why it did not carry an advertising message as many sports tickets do, so I

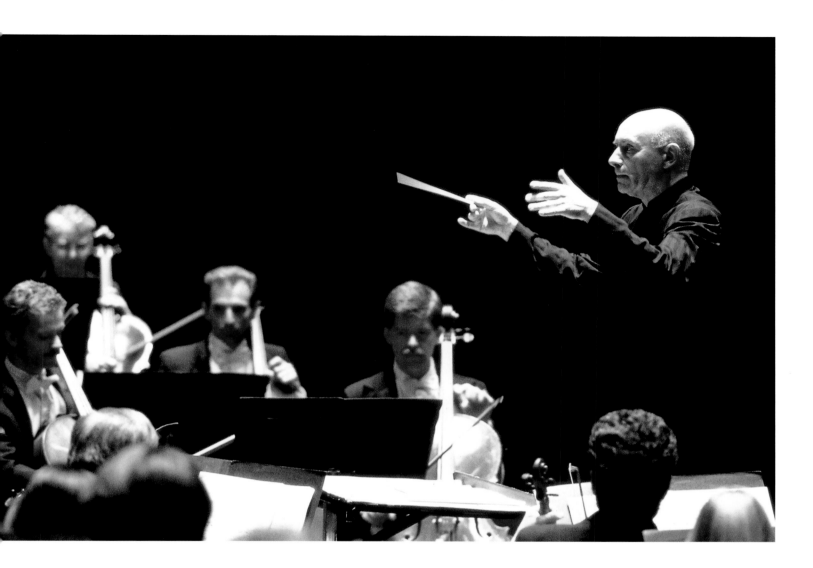

asked the Symphony management if we could underwrite the printing cost of the tickets each season in return for putting our Company's name on the back of all 250,000 tickets. They thought this was a fine idea and we have been doing this ever since. We have a similar arrangement with the Da Camera of Houston and the Society for the Performing Arts for its *Broadway Series.*

"I think it is very important to interest young people in the arts, especially now with so many schools eliminating or reducing the arts in K-12 curricula. As our two sons were growing up, we wanted them to take an interest in classical music, so I made a point of developing their interest by asking them questions such as, Who is the conductor of The Cleveland Orchestra? and I promised them a monetary reward for the right answer. My younger son, Brad, took a few music appreciation classes in college and

then began asking me questions such as, 'Where did Gregorian Chant come from? 'Or, 'Who wrote the first opera?' He took great pleasure in finding questions that stumped me. Today, he goes to concerts and operas, as does my older son, Daniel, who has a fine collection of classical music."

To encourage young people in Houston to formulate an appreciation for the arts, I.W. Marks Jewelers underwrites a variety of educational programs. Among these are *Opera-to-Go,* an educational outreach program for elementary school students designed to cultivate an interest in opera; *Shakespeare-by-the-Book,* a program which presents Shakespearean works in libraries throughout Fort Bend County, Texas; and the *I.W. Marks Master Class Series,* a community program of demonstrations and lectures for young people conducted by professional guest

artists appearing with the Society for the Performing Arts in Houston.

"I derive great enjoyment from attending opera and symphony performances featuring young artists and watching the careers of artists such as Denyse Graves, Robert McFarland and John Paul Fink takeoff," admitted Mr. Marks. To foster the talent of promising young singers and to provide them with opportunities to perform and work with the Houston Grand Opera, I.W. Marks Jewelers has co-sponsored the Eleanor McCollum Auditions and Awards with the Houston Grand Opera.

In addition to attending performances and arts-related events, Mr. Marks serves on the boards of many cultural, business, education and humanitarian organizations in Houston. He is Vice President of the Houston Grand Opera's Board of Trustees, a member of the Houston Symphony Board of Directors and is on the Executive Committee of the Society for the Performing Arts. The Company has received many awards for its involvement with the arts, including the Houston Symphony's Ovation for Excellence Award, given to recognize the Company's extraordinary contributions to the Symphony and to Houston. Additionally, I.W. Marks Jewelers has received Business in the Arts Awards in 1990, 1991 and 1993, presented by the Business Committee for the Arts and *FORBES* Magazine, to recognize the Company's exemplary partnerships with the arts. In 1994 and 1996 I.W. Marks

*Houston Grand Opera,
"Boris Godunov." Opposite
(Left to Right): Houston
Grand Opera performance in
the Wortham Theater Center,
Houston; "Diamonds &
Divas," featuring Houston
Opera Studio performers.*

Jewelers received the Houston Award for Quality, sponsored by the Better Business Bureau Education Foundation and the University of Houston College of Business Administration.

"We support the arts because we love them," said Mr. Marks. "Our employees are very supportive of our involvement in the community. They think what we do is great. I encourage them to attend performances, and, in fact, we purchase many tickets to cultural events and give them to our employees.

"We did not decide to become involved with the arts because it promoted our business, however, it has definitely been an added benefit for which we are grateful. We have clearly found a way to make our genuine interest in the arts help our business, and we hope that owners of other small businesses will discover that there is both personal satisfaction in supporting the arts and added value for their companies. We know that our involvement is good for the arts, and what is good for the arts is good for Houston. And, what is good for Houston is good for I.W. Marks Jewelers."

"WE HAVE CLEARLY FOUND A WAY TO MAKE OUR GENUINE INTEREST IN THE ARTS HELP OUR BUSINESS, AND WE HOPE THAT OWNERS OF OTHER SMALL BUSINESSES WILL DISCOVER THAT THERE IS BOTH PERSONAL SATISFACTION IN SUPPORTING THE ARTS AND ADDED VALUE FOR THEIR COMPANIES."

Investing in Children
to Assure the Future

"As a little boy growing up in Cincinnati I recall going to the open air opera at the zoo during the summer. Sometimes we heard the birds and animals, along with the opera," recollected Irwin J. Jaeger, President and Chief Executive Officer of Jaeger Management Company, a real estate management company located in Beverly Hills, California. "I inherited my love of opera from my mother. Aside from summer performances at the zoo, during the winter we listened to the Met radio broadcasts. Today, when my wife, Patti, and I travel to New York during the opera season, we try to see several performances. We also enjoy going to the theater and museums — The Met, the Guggenheim, The Jewish Museum and The Frick. The Frick is a jewel — there's not a bad piece of art in that museum. We feel the same way about The Morgan Library. I served as the Chair of the Far Eastern Art Council of the Los Angeles County Museum of art, and my wife and I collect art from Asia — jade and cinnabar

Irwin J. Jaeger
President and
Chief Executive Officer

Inner-City Arts music class.
Opposite: Irwin J. Jaeger with
Los Angeles Mayor Richard
Riordan in the Inner-City
Arts Center, Los Angeles.

from the Ming Dynasty and earlier.

"After completing my undergraduate work at both the University of Michigan and the University of Cincinnati and earning a now-extinct degree, a Master of Science in Retailing — it has since been merged into the MBA Program — from New York University, I worked for a few years in Cincinnati. Subsequently, I moved my management consulting practice to Los Angeles. Not long after, real estate piqued my interest and I bought an industrial park in San Diego, some buildings in the downtown area of the City and some commercial properties in Orange County, all of which demanded my full-time attention, so I moved from management consulting to real estate investment and management.

"A number of years ago, when I realized there was more to life than business, I started doing volunteer work. For a couple of years I taught a math class at my son's school in Beverly Hills. I loved it, but I realized it was like taking coal to Newcastle. So I decided to volunteer in the inner city.

"I went down to one of the inner city schools in the heart of Skid Row with the intention of teaching the children how to play baseball. I was so naive. Many of the children in these schools were Hispanic and they didn't know anything about baseball. They knew about soccer and I didn't, so I ended up helping an artist, Bob Bates, who was teaching art on a volunteer basis. In one session, he gave the children scraps of wood and encouraged them to build things using their imagination. It was my job to hold the hot glue gun, which was difficult for the children to use. Frankly, it was all I was qualified to do!

"During one of my visits, Bob asked the children to work together to build an imaginary city," recalled Mr. Jaeger. "I was still the glue gun holder! I began talking with some of the children, and I learned that one of them was building a basketball court for the city. Then I asked the teacher to ask another child who only spoke Spanish — which I don't — what he was building. He said that he was building a podium for a speaker. Obviously, these children were communicating and working together through the medium of art, even though they could not speak one another's language. I thought it would be terrific for them to have a place to go to all of the time. I did a lot of soul searching and then said to

my wife, I'm going to give Bob Bates $25,000 to find a space where he can teach and work with these kids on a regular basis. When I realized that Bob was too busy working with the children to spend time looking for space, I investigated and found a loft close to the school that most of the children attended, so they could walk over after school and create more art, beyond what they created in school.

"When we began the program, more than half of the children were homeless, most lived on Skid Row, and they spoke many languages. Before long we could see that art was bridging the language barrier, as well as cultural and ethnic differences. The language barrier is tough and is often the reason that many of these children drop-out of school. It was clear to me that the arts build self-esteem, because the children are proud of their creations. Without self-esteem, there is little chance to learn. Unlike math, where you are either right or wrong, this is not the case with art. Art is your own creation and expression, and whatever you do is right. Art develops a child's capacity to learn.

"At first, the studio had its ups and downs. Soon after it

opened, it was closed down because it was above a denim dying facility and there was the possibility of toxins and flammable chemicals from the operation pervading the building. Looking for another space turned into a very positive experience," recalled Mr. Jaeger. Under his leadership a partnership was formed between the City of Los Angeles, the Community Redevelopment Agency and the Los Angeles Unified School District. As a result, an old auto body shop in the heart of Skid Row was acquired and transformed into the Mark Taper Center Inner-City Arts.

"Through a series of introductions we put together a wonderful group of individuals to help us develop the Center, " said Mr. Jaeger. "Al Nodal, the Director of Cultural Affairs for the City of Los Angeles, liked what we were doing and introduced me to Peter Sellars. When I talked with Peter, I explained that I had just purchased a garage and I didn't know how we were going to fix it up. He, in turn, introduced me to Michael Maltzan, an architect in Frank Gehry's office who, at the time, was the project designer for the Disney Concert Hall. Michael volunteered to design the Center for us

and the result is wonderful. He created a ceramics studio, a music area, a dance studio and other great spaces for all the visual and performing arts. He also brought in other designers who volunteered their services to create a very special oasis — a courtyard garden right in the heart of Skid Row.

"About the time we started to form a board, I met Itzhak Perlman in New York at a Business Committee for the Arts Awards ceremony. Knowing he loved children, I invited him to visit the Center when he performed in Los Angeles, which he did. He performed for about 500 children, many of whom had never before seen a violin. He was marvelous. It was a wonderful experience for the kids — and for the

"I THINK INNER-CITY ARTS IS AN ANSWER TO SOME OF THE CHALLENGES WE FACE IN LOS ANGELES. IT IS ALSO MY HOPE THAT THE CENTER WILL SERVE AS A MODEL FOR OTHER COMMUNITIES THROUGHOUT THE COUNTRY."

arts classes. He also organizes joint programs involving the Center and Los Angeles-area cultural institutions such as the Los Angeles County Museum of Art, The Museum of Contemporary Art (MOCA) in Los Angeles and the Otis Art Institute of Parsons School of Design. The Center also has strong ties to the California Institute of the Arts (CalArts), which provides graduate students who teach animation to elementary and high school students, and the UCLA Center for the Performing Arts which provides visiting artists who perform and conduct workshops. Additionally the Center offers a special program to help the children learn English, and is developing a plan to identify and assist artistically gifted children with additional educational opportunities.

"I am a firm believer in communities addressing their own challenges," commented Mr. Jaeger. "As the federal government pushes programs down to the states, and the states push them down to the cities, we must assume more responsibility at the local level. I think Inner-City Arts is an answer to some of the challenges we face in Los Angeles. It is also my hope that the Center will serve as a model for other communities throughout the country. Children are our future and we as adults must invest more effort in them — both time and money — to guide them in positive directions."

Top to Bottom: Art work created by students attending Inner-City Arts programs; student mural in the court-yard, Inner-City Arts, Los Angeles. Opposite: Children participating in an Inner-City Arts class.

project. We had some excellent media coverage of his visit, which helped us form an outstanding board of directors and people began volunteering to help."

In 1997 Inner-City Arts served about 11,000 children, ranging in age from 7 to 18 years. The Center's staff included eight full-time and 20 part-time teachers. In addition to raising funds for the project, Mr. Jaeger works with the staff to recruit artists to teach performing and visual

Harry P. Kamen
Chairman, President and
Chief Executive Officer

METROPOLITAN LIFE
INSURANCE COMPANY

Ensuring Broad Participation
in the Arts to Enrich Life

"IT WASN'T UNTIL I WAS OUT OF SCHOOL AND WORKING THAT I REALLY BECAME INVOLVED WITH THE ARTS," BEGAN HARRY P. KAMEN, CHAIRMAN, PRESIDENT AND CHIEF EXECUTIVE OFFICER OF METROPOLITAN LIFE INSURANCE COMPANY, AN INSURANCE AND FINANCIAL SERVICES COMPANY HEADQUARTERED IN NEW YORK. "I WAS BORN IN MONTREAL, LIVED IN NEW YORK CITY FOR A FEW YEARS AND THEN MOVED TO OHIO, WHERE MY FATHER WORKED AS A WHOLESALER OF CHINA-WARE," HE CONTINUED. "HE ENJOYED LISTENING TO OPERA ON RADIO, BUT LIKE ANY YOUNGSTER, I DIDN'T PAY MUCH ATTENTION. WHEN I WENT TO THE UNIVERSITY OF PENNSYLVANIA I TOOK A LOT OF PHILOSOPHY COURSES, AS WELL AS COURSES IN THE HISTORY OF ART AND THE HISTORY OF MUSIC, ALONG WITH THE COURSES I NEEDED TO GET A DEGREE IN ECONOMICS. I WOULD HAVE MAJORED IN PHILOSOPHY IF I THOUGHT I COULD HAVE MADE A LIVING AT IT. FOLLOWING MY STUD-IES AT THE UNIVERSITY OF PENNSYLVANIA, I WENT ON TO STUDY FOR A LAW DEGREE AT HARVARD UNIVERSITY. IT WAS DURING THIS TIME THAT I BEGAN TO TAKE A GREATER INTEREST IN THE ARTS.

The cultural offerings in Boston, Cambridge and the surrounding areas are very rich. I constantly went to museums, concerts and plays.

"Today, I'm involved with the arts for three reasons," said Mr. Kamen. "First, my family and I just simply enjoy the arts — especially music. Second, the arts let us see and understand different cultures, eras and schools of thought. And third, as a businessperson, I recognize that the arts enrich the communities in which our employees live and where we do business. So from my point of view, investing in the arts is a solid investment that enriches human experiences, enhances the workplace and inspires us to be more creative and better prepared to address the challenges we face in our daily lives.

"I will always remember one of my first experiences with the arts in business. It was during the late 1970s, when I was a young lawyer working for Metropolitan Life. I attended a holiday reception at Chase Manhattan Bank where I had the opportunity to see works of art from this renowned collection. At the reception, a gentleman came over and said, 'Hello, I'm David Rockefeller.' I introduced myself and we began talking about The Chase Collection and the collection we had started at Metropolitan Life. David asked what we were collecting. I told him, perhaps tongue-in-cheek, Impressionists — Van Goghs, Renoirs and Cézannes. But before he could say anything, I quickly added that they were copies. David said it was good that we were collecting, but

he suggested that we should not be buying copies. He told me we could purchase original prints, lithographs and engravings, for relatively little money. Just then, Dick Shinn, our President and Chief Executive Officer at the time, came along and joined the conversation, and I did a quick retreat.

In any event, Dick took David's advice and the Company began to acquire fine art. Several years later, under the leadership of John Creedon, Metropolitan Life's President and Chief Executive Officer from 1983 to 1989, the theme of our Collection — *American Landscapes* — evolved." Today, the MetLife Corporate Art Collection includes paintings and works on paper with an emphasis on American landscapes.

"Part of our Collection includes a series of murals that we commissioned N.C. Wyeth to create for our New York headquarters building," continued Mr. Kamen. "Wyeth proposed a series of historical paintings, *The Ballad of America*, which was to begin with the Pilgrims landing at Plymouth Rock in 1620 and was to continue through the gold-seeking California '49ers. Instead, he created a series of 14 paintings which focused on the Plymouth Colony and included scenes devoted to birds and deer, intended to convey the quietude of nature found by the Pilgrims in Plymouth. Before finishing these 14 works, N.C. Wyeth was killed in a car accident in Chaddsford, Pennsylvania. His son, Andrew Wyeth, and son-in-law, John McCoy, completed the murals, adhering to Wyeth's original concept. These works have been restored and now hang in the lobby of our New York City headquarters at One Madison Avenue.

"Occasionally, we loan works from our Collection, including the Wyeth murals, to museums. We do this, in part, because museums are great places to bring people together and to foster understanding of diverse cultures," explained Mr. Kamen who serves as a Trustee of the American Museum of Natural History and The Jewish Museum in New York. Since 1977 the Metropolitan Life Foundation has allocated substantial resources to support museums and has created several innovative museum programs. In 1984 the Foundation initiated the *Museum Grants for Minority Visual Arts* program, which it sponsored for five years to help museums advance the careers of Hispanic, Asian-American, African-American and Native American artists. A predecessor program, the *Multi-Cultural Initiatives,* which operated from 1990 to 1993, was designed to encourage interactions among museums, artists and art professionals involved with these four cultural groups.

"We also support museum exhibitions because we know that it is critical for a museum to frequently change its exhibitions in order to attract new audiences. By subsidizing the cost of bringing art work to museums, we hope we are helping museums increase their attendance each year," continued Mr. Kamen. "Metropolitan Life Foundation has underwritten 13 touring exhibitions since 1993, including *Ansel Adams, A Legacy: Masterworks from The Friends of Photography Collection,* organized by The Friends of Photography in San Francisco where it was on display before traveling to the Hunter Museum of American Art in Chattanooga, Tennessee; *Bridges and Boundaries: African Americans and American Jews,* organized by The Jewish Museum in New York; *Caribbean Visions: Contemporary Paintings and Sculpture; Gods, Kings and Tigers: The Art of Kotah,* which included works never exhibited outside of India; *In the Spirit of Resistance: African American Modernist and the Mexican Muralist School,* which opened in The Studio Museum in Harlem in New York; *The Latino Papers,* the first major

Top to Bottom: The Jewish Museum, New York, "Bridges and Boundaries: African Americans and American Jews," Robert Arneson's "Simon 'n Rastus" (1990); New York Philharmonic, Maxim Vengerov, violinist, and Kurt Masur, Conductor. Opposite (Top to Bottom): N.C. Wyeth's "Hunting Wild Turkey" (1940-45), from the Collection of the Metropolitan Life Insurance Company; "Live From Lincoln Center," New York.

"The Studio Museum in Harlem: 25 Years of African American Art," Romare Bearden's "Jammin' at the Savoy" (pre-1982). Opposite (Left to Right): Alvin Ailey Repertory Ensemble, "The Lark Ascending;" Ballet Hispanico, "Solo," Jose Costas.

traveling exhibition organized by El Museo del Barrio in New York; *Points of Entry,* a photography exhibition that includes photographs of, by and about immigrants; *Roy DeCarava: A Retrospective,* shown in The Museum of Modern Art in New York; *Still Life: The Object in American Art 1915-1995, Selections from The Metropolitan Museum of Art,* an anniversary exhibition; *The Studio Museum in Harlem: 25 Years of African American Art*; and *To Honor and Comfort: Native Quilting Traditions,* organized by the National Museum of the American Indian in New York.

"We devote about a fifth of our cultural giving to educational projects that encourage young people to become

involved with the arts," explained Mr. Kamen. "We do this because we believe arts education is essential to the educational process and critical to the process of building future audiences. Arts education also helps to develop creative thinking." Since 1988 the Metropolitan Life Foundation has committed more than $1.2 million through its *Partnerships: Arts and the Schools* program to support collaborative projects involving cultural organizations and public schools. As part of this initiative, schoolchildren have seen operas staged by The Atlanta Opera, the San Francisco Opera and the Houston Grand Opera, theater events offered by the American Conservatory Theater, the Trinity Repertory

Company and the Alliance Theater Company and they have learned about several museum collections including those of The Art Institute of Chicago, the Museum of Contemporary Art in Chicago and the High Museum of Art in Atlanta.

"We also support programs to help increase access to the arts and further our commitment to bring the arts to wide and diverse audiences," noted Mr. Kamen. "We recently agreed to underwrite the PBS telecasts of *Live From Lincoln Center* for three years. Beverly Sills, who serves as Chairman of Lincoln Center, was very persuasive when she came to my office to discuss this sponsorship. She told me that each telecast reached as many as 7 million individuals — some of whom might never have an opportunity to experience the arts without these broadcasts. Over the years, the Metropolitan Life Foundation has also underwritten many cultural programs on National Public Radio, including choral music, jazz and orchestral performances.

"While we are interested in educating people about the richness of the arts, we are also quite concerned about the future of arts organizations. Arts organizations need to maintain their creative vitality. So to help sustain artistic creativity our Foundation is involved with several programs designed to develop new works. For example, the *Theatre Communications Group/Metropolitan Life Foundation Extended Collaboration* program encourages theater professionals to collaborate in the development of new plays. Metropolitan Life Foundation's *Dance Collaborations Program* has enabled dance companies, including American Ballet Theatre, the Dance Theater of Harlem, the Parsons Dance Foundation, the Limón Dance Company and the Cunningham Dance Foundation to choreograph new works. And, to help dance companies showcase their new works, as well as favorites in their repertories, the Foundation has sponsored tours of the Alvin Ailey Repertory Ensemble, Ballet Hispanico and the Paul Taylor Dance Company.

"Our Company and our Foundation support many of the major cultural institutions in New York City. In fact, we made one of the first early grants to help build Lincoln Center for the Performing Arts," said Mr. Kamen, who serves on The Consolidated Corporate Fund Leadership Committee at Lincoln Center, and is a Trustee of Carnegie Hall, as well as Treasurer of the New York City Partnership, Inc. "The arts

certainly enrich the lives of those who live and work in a community. The arts are also an industry, especially in New York City, where they generate billions of dollars annually, attract millions of tourists and provide jobs," he added. "The New York City Partnership has been instrumental in developing this very concept of the arts as an economic engine.

"There is so much richness embodied in the visual and performing arts. I cannot imagine a healthy society without them, especially music which, to me, is the highest form of art and can reach almost spiritual perfection. As an involved corporate citizen, one of our major interests is the well-being of our communities," commented Mr. Kamen. "Through our support of the arts, we believe we are contributing to the well-being of communities throughout the country for current and future generations."

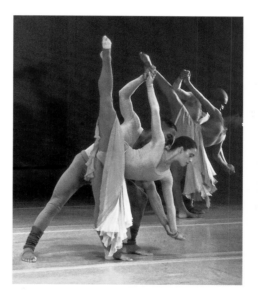

Raymond D. Nasher
Chairman of the Board

Turning a Passion Into a Public Asset

"In the 1890s my father and his family came to the United States as immigrants from Russia. My mother's family came here from Germany during the 1880s. Neither of my parents had any background in the arts. As an only child, my parents wanted to make certain that I was exposed to both art and music," said Raymond D. Nasher, Chairman of the Board of The Nasher Company, a real estate development company, based in Dallas, Texas, and Chairman of the Board of Comerica Bank-Texas. "When I was about five years old I began visiting museums with my parents," he recollected. "We constantly went to museums in the Boston area where I was raised and nearly each month we went to museums in New York when we visited my grandparents."

As a young boy, Mr. Nasher attended the Boston Latin School where he became steeped in classical studies that included Latin and Greek. "While studying economics as an undergraduate at Duke University, there was little time to study the arts," he

recalled. "After serving four years as a Naval Officer in World War II, I worked on a graduate degree in economics at Boston University at night and worked with my father during the day. He created an outlet chain of clothing stores called London Clothing Company. While I was working in Boston I met my late wife, Patsy, who was attending Smith College. She was from Texas and was very interested in and knowledgeable about art.

"During the time I was dating Patsy and working in New

"ART IS LIKE AIR OR WATER. IT IS NEEDED TO SURVIVE AND TO ENJOY LIFE TO ITS FULLEST, WITHOUT IT, WE CEASE TO SEE OURSELVES AS WE ARE, WE CEASE TO EXIST."

England, I developed a study and discovered that Texas, California and Florida were the states in the country with the most growth potential. Each state had a very progressive economic outlook about housing, urban policy, highway systems, water and sewer districts and public education. By 1951 Patsy and I were married and on our way to settle in Texas. Once there, I started my own company. At first I built houses, then expanded to warehouses, shopping centers, office buildings and banking.

"I decided early on that I wanted to incorporate art into my business," continued Mr. Nasher as he explained how he and his wife began collecting. "We also wanted to collect art so that our children would grow up with it and it would nurture their intellectual and aesthetic curiosity. We began by collecting pre-Columbian art, which we came across when we vacationed and went on archaeological digs in Mexico and Central America. However, we stopped collecting this form of art after I became involved with the UNESCO Treaty of 1971. This was the treaty that addressed the issue of international trade in art treasures and concluded that national art treasures of the sort we were collecting should remain in their countries of origin.

"Initially, we collected what we could afford — works by artists from Texas and the Southwest. I went to New York often on business and always headed to the galleries. It was there that I bought my first major painting, *The Tennis Player*, by Ben Shahn. I installed art in some of the first office buildings I built. My objective was to increase awareness among commercial tenants about how art can create an interesting and stimulating work environment, and how this can lead to job satisfaction and enhanced performance."

By the time Mr. Nasher was prepared to develop his first retail center in Dallas — NorthPark Center — he and his wife had made many trips to Europe and had expanded their knowledge of art by visiting many of the great museums throughout the Continent. "We had gotten to know many museum directors, as well as many artists, including Anthony Caro, Diego Rivera, Alberto Giacometti, Roy Lichtenstein, Henry Moore, George Segal and Frank Stella," explained Mr. Nasher. "I will never forget the time that Henry Moore visited our home in Dallas. We all stood

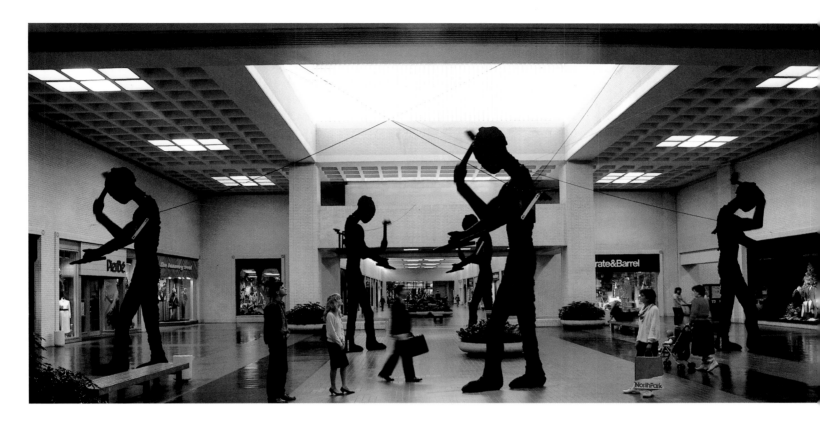

there watching as he, Henry Moore — the Michelangelo of our time — made a drawing of an Oceanic mask he saw in our bedroom. It was a truly fabulous experience.

"When I began the plans for NorthPark I decided to create a retail center unlike any that existed. I wanted art throughout the entire facility," explained Mr. Nasher. "To do this, we had to design a structure inside and out that met the needs of the retailers and had the space necessary to display large sculptures by Jonathan Borofsky, Alexander Calder, Mark di Suvero, Henry Moore, Beverly Pepper and George Segal. The landscape, interior water features, the walls and open spaces, the furnishings, lighting and signage — everything had to be just right to create a totally unified environment."

Since NorthPark Center and the adjacent NorthPark National Bank — now Comerica Bank-Texas, another project of The Nasher Company — opened in 1965, millions of persons have visited the facilities, including delegations from countries throughout the world, from Australia to China to Russia. "The success of NorthPark and the international visitors it attracts pleases me," admitted Mr. Nasher. "I believe that as a developer I can introduce people to the arts who might not otherwise have the opportunity to experience them. I also believe that the arts are an essential part of the total environment. Consequently, the arts are incorporated as design elements in all advertising and marketing campaigns for NorthPark Center."

NorthPark Center also hosts many special visual arts exhibitions and performances. From 1979 through 1981,

Jonathan Borofsky's "Five Hammering Men" (1982), NorthPark Center. Opposite: Claes Oldenburg's "Clothespin," NorthPark Center, Dallas.

a time when the Dallas Symphony Orchestra was on the verge of bankruptcy, NorthPark launched *Summerpops at NorthPark* to generate performance income for the Orchestra. From 1979 to 1992 the Center provided a home for the Dallas Repertory Theatre. The Nasher Company also provides general support for these two arts organizations, as well as all the major performing and visual arts organizations in Dallas.

By 1978 the Nashers had assembled a significant collection of twentieth-century art, and William B. Jordan, the Director of the Meadows Museum at Southern Methodist University, approached them about presenting an exhibition of works from their collection in the University gallery. "I remember Patsy telling Bill, 'You don't want to do that. We don't have a collection and we don't want you to get in trouble with your superiors at the

University,'" recounted Mr. Nasher. "He made us understand that we had assembled a collection, as opposed to just owning works of art, so we agreed to the exhibition."

That exhibition was the first of many. By 1987 The Nasher Collection had gained international recognition. It was the inaugural exhibition of the Dallas Museum of Art's new downtown building and it was later shown in the National Gallery of Art in, Washington, D.C., the Centro de arte Reina Sofia in Madrid, Spain, the Forte di Belvedere in Florence, Italy, and The Tel Aviv Museum in Israel. Today the Collection includes more than 700 works by some of the leading masters of the twentieth century including Arp, Brancusi, di Suvero, Duchamp-Villon, Ernst, Gauguin, Giacometti, Lichtenstein, Matisse, Moore, Picasso, Segal, David Smith and Tony Smith.

In 1995 Mr. Nasher and the Solomon R. Guggenheim Foundation established a long-term association which enables the Guggenheim to show works, on a rotating basis, from The Nasher Collection in the Guggenheim facilities in Venice, Italy. To mark this agreement, the sculpture garden of the Guggenheim's Venice location was named The Nasher Sculpture Garden. In October 1996 more than 70 works from the Collection were shown in the California Palace of the Legion of Honor in San Francisco and in February of the following year 105 sculptures and paintings from the Collection were exhibited in the Solomon R. Guggenheim Museum in New York. In 1997 Mr. Nasher announced plans to fund the development of a $32 million outdoor sculpture garden, called The Nasher Sculpture Garden, on two acres adjacent to the Dallas Museum of Art to display works from his collection.

Mr. Nasher has been a Director of the Dallas Museum of Art, The Dallas Opera, the Dallas Symphony Orchestra, the Dallas Theater Center, the Ballet Dallas and the Modern Art Museum of Fort Worth. He also serves on the Council of The Fine Arts Museums of San Francisco, the International Council of the Tate Gallery in London and as a member of the Trustees' Council of the National Gallery of Art in Washington, D.C.

To encourage other businesses throughout the Dallas Metroplex to support the arts, he founded the Dallas Business Committee for the Arts (DBCA) in June 1988, an affiliate of the national BCA. He has served on the national organization's Board of Directors since 1987 and has chaired the DBCA's Board of Directors since its inception. Through his efforts, the DBCA has increased business support to the arts in the Dallas Metroplex from $4.1 million in 1989 to $19.8 million in 1996. The organization has also designed and franchised a leadership training program for business executives to enable them to provide business expertise to Dallas area arts organizations. Through this program, the DBCA has placed 247 business executives on the boards of arts organizations. In 1995 the DBCA also formed a strategic alliance with four regional economic development agencies to centralize arts advocacy efforts in North Texas. In 1990 Mr. Nasher was appointed by President George Bush to serve on the President's Committee on the Arts and the Humanities. Two years later he was appointed to serve on the Texas Commission on the Arts. From 1988 to 1992 he was the Ambassador of Cultural Affairs for the City of Dallas.

"Art is like air or water. It is needed to survive and to enjoy life to its fullest," said Mr. Nasher. "Without it, we cease to see ourselves as we are, we cease to exist."

Left to Right: Pablo Picasso's "Head (Fernande)" (1909); Alberto Giacometti's "Bust of Diego (Buste de Diego)" (1954). Opposite: Magdalena Abakanowicz's "Bronze Crowd" (1990-91). These works are in the Patsy R. and Raymond D. Nasher Collection.

Gaining Momentum by Investing in the Arts

"After graduating from Duke, I worked in New York and I used to wander in and out of galleries," said David R. Goode, Chairman of the Board, President and Chief Executive Officer of Norfolk Southern Corporation, a Virginia-based holding company headquartered in Norfolk. "It was then that I met Sylvan Cole, the former Director of Associated American Artists, who interested me in collecting prints.

"I remember him telling me that a collection has to have a focus. Railroads intrigued me long before I knew I would work for one. I decided to collect prints — because these were what I could afford at the time — with railroads as the subject. One of my recent acquisitions is a wonderful Thomas Hart Benton print, *The Wreck of the Old '97*. Even though we work hard on safety at Norfolk Southern, this was a famous wreck of one of our predecessor companies, so it's an appropriate print to have.

"The walls, the attic and the storage bins in our home are full of prints, but I've

David R. Goode
Chairman of the Board,
President and
Chief Executive Officer

*Top to Bottom: Virginia
Waterfront International
Arts Festival performance;
The Chrysler Museum of
Art, Norfolk. Opposite: A
gallery in The Chrysler
Museum of Art.*

never been able to stop collecting these images because
they are so wonderful. They appeal to my sense of art and
history. Art tells us a good deal about the history, politics and
activities of a society. I am convinced that railroads — and
transportation in general — are a mirror of the industrial and
social development of our country, the opening of the West
and the building of great cities.

"In my youth I had very little exposure to the arts, growing
up in Vinton, Virginia, a town of about 4,000 people. My
mother forced me to take piano lessons which I suffered
through until I learned to play baseball, and that ended my

brief piano career! I owe most of my interest in the arts to my
wife, Susan," reflected Mr. Goode. "She also went to Duke
and was interested in the arts, particularly singing. When we
began dating, I used to sit in on her Duke chorus rehearsals,
and I gradually developed a love of choral music. Under her
tutelage, I also broadened my interest to include other forms
of music. Today, she is active in the Virginia Symphony, plus
The Chrysler Museum in Norfolk, and she keeps me very
active with both.

"From Duke I immediately went to Harvard Law School.
Susan and I were married and we lived in the Cambridge
area. We went to museums, as well as music and theater
performances as often as possible, and I continued to collect
railroad images.

"After Harvard, I took a job as a tax lawyer with the
Norfolk and Western Railway in Roanoke, Virginia, which was
not far from the town where I grew up. The Company had a
tradition of encouraging its people to become involved with
community activities. A fellow lawyer in the Company, who
had been at Harvard with me, was active with a summer the-
ater company called the Mill Mountain Theatre and he asked
me to join the Theatre's Board of Directors. The quality of
this company's productions was very high, but the finances
of the operation were a constant disaster. I remember vividly
our frequent struggles to figure out how we could make it

through one more week in a season. I cut my teeth on this Board. It was a great learning experience, which led to many other activities in the arts.

"Shortly thereafter, I became active with the Art Museum of Western Virginia and eventually became President of the Museum Board. Roanoke being a small city, I was then appointed to serve as a member of the Virginia Commission for the Arts, and a few years later, I became its Chairman. This was in the days when government spent substantial monies on the arts and government support meant a great deal to the people in Virginia. The Commission did some great work in bringing opera, classical music, theater and visual arts to people in areas of the State who would not otherwise have had the opportunity to experience them. I'm proud of the contributions we made then and I regret the current trend away from government support.

"Norfolk Southern was created in 1982 from the combination of two great predecessor railroads — the Norfolk and Western Railway and Southern Railway. From the beginning,

"NO SOCIETY CAN BE STRONG OR HOPE TO SURVIVE WITHOUT ENCOURAGING THE ARTS. AS A BUSINESSMAN WHO WANTS TO BUILD FOR THE FUTURE, I BELIEVE IN BEING VIGILANT IN SUPPORTING THE CULTURAL AND ARTISTIC LIFE OF OUR COMMUNITIES THROUGHOUT THE COUNTRY."

Norfolk Southern was an important supporter of the arts," explained Mr. Goode. "The Company's first Chairman, Bob Claytor, was a lover of the opera and symphony, and he was fond of saying that we located our headquarters in Norfolk, Virginia, because of the strong cultural institutions in the City — the Virginia Symphony, the Virginia Opera and The Chrysler Museum. Under his leadership we became major supporters of the Virginia Opera, and also commissioned Thea Musgrave's opera about Harriet Tubman, *Harriet, The Woman Called Moses.*

NORFOLK SOUTHERN CORPORATION

"My immediate predecessor, Arnold McKinnon, continued the Company's tradition and was very involved with The Chrysler Museum in Norfolk. He was honored recently for his professional and personal contributions to the Museum. It is part of our corporate culture to put something back into the communities we serve. As a company, we support a broad spectrum of cultural organizations, even though each chief executive has a personal interest in one or two arts disciplines," noted Mr. Goode. In Norfolk, the Company provides ongoing support to the Virginia Stage Company, The Chrysler Museum and The National Maritime Center, as well as a variety of arts education programs. In other parts of the Norfolk Southern system, like Roanoke, the Company supports the Art Museum of Western Virginia and the Mill Mountain Theatre. In fact, Norfolk Southern is a long-term sponsor of the Theatre's annual festival of new works. In 1997 the Company became one of the principal sponsors of the first annual Virginia Waterfront International Arts Festival, a three-week performing arts festival held throughout the Hampton Roads area. Additionally, Norfolk Southern supports the arts and cultural organizations in its twenty-state operating area, among them the Arts and Education Council of Greater St. Louis, the Kentucky Historical Society and the High Museum of Art in Atlanta.

"I think there is a very clear relationship between the arts and business," said Mr. Goode. "Much of what I learned from being the President of the Art Museum of Western Virginia and the Mill Mountain Theatre helped me when I became CEO of Norfolk Southern. In the arts, the challenge is to run the organization in a businesslike way without losing the creative spark. In business, the challenge is to spark the creativity that will make a business great. In both business and the arts you have to find the right combination — one that ignites creativity and manages the bottom line. Unfortunately, too often, arts organizations ignore the bottom line, and one day they wake up and discover that the organization is over its head in financial problems. On the other hand, in business you can get into trouble if you are missing the creative spark that enables you to get to the next stage of development or helps you meet a major challenge.

"In all the years I have worked with the arts I have never seen an arts organization that has been close to self-

supporting. It just doesn't work that way and I don't think it ever will," continued Mr. Goode. "If we are going to have the arts flourish in our communities, we must have benefactors, and business must be among them. This is not something new. It goes back to Greek and Roman times. There is almost an unbroken line of business support for the arts throughout history. Government support is also vital, but historically this support is likely to come and go, like the movement of a pendulum. We must do all that we can to encourage strong government support, but whether or not we are successful, we must be able to count on consistent support from business. Business in this country has a solid tradition of giving back to the communities it serves. While we must all keep our eyes on the bottom line, I think we all realize that the arts are important to our quality of life and they provide benefits to our employees and customers, so I believe the relationship between business and the arts will continue to grow in the years ahead. No society can be strong or hope to survive without encouraging the arts. As a businessman who wants to build for the future, I believe in being vigilant in supporting the cultural and artistic life of our communities throughout the country."

Virginia Waterfront International Arts Festival performance. Opposite: Virginia Opera, "Harriet, the Woman Called Moses."

Linking the Arts with the Human Condition

"MY FIRST EXPERIENCE WITH THE ARTS WAS AS A CHILD WHEN I BECAME AWARE OF THE PAINTINGS WHICH I ENJOYED IN OUR HOME," RECALLED DANIEL VASELLA, PRESIDENT OF NOVARTIS INTERNATIONAL AG, A LIFE SCIENCE COMPANY HEADQUARTERED IN BASEL, SWITZERLAND, WHICH WAS FORMED IN 1996 AS A RESULT OF A MERGER OF SANDOZ LIMITED AND CIBA-GEIGY CORPORATION. "MY FATHER, WHO WAS A PROFESSOR OF HISTORY AT THE LOCAL UNIVERSITY IN MY HOMETOWN OF FRIBOURG, ENJOYED OPERA, BUT I LACKED A FEELING FOR IT." GROWING UP I WAS DEEPLY MOVED BY THE MUSIC OF MOZART, BUT I HAVE ALWAYS FELT A CLOSER CONNECTION TO PAINTING AND SCULPTURE THAN TO MUSIC.

"IN HIGH SCHOOL I TOOK CLASSES IN THE HISTORY OF ART. I ESPECIALLY REMEMBER ONE VERY GOOD YOUNG PROFESSOR WHO SPARKED MY INTEREST IN PAINTINGS AND ARCHITECTURE. HE WALKED HIS STUDENTS THROUGH THE OLD SECTION OF FRIBOURG TO TEACH US ABOUT THE GOTHIC STYLE OF THE FOURTEENTH CENTURY. IT WAS FASCINATING.

Daniel Vasella
President

"Dr. Francis Moore"
Roy Calne '92

"I purchased my first works of art, etchings of my hometown and a work by Lucas van Leyden, when I was in high school. Not long after that, I bought some eighteenth- and nineteenth-century Japanese prints, and then I became interested in abstract art and I acquired a Hans Hartung lithograph. Much later, I began collecting works from the Han and T'ang Dynasties. I never collected systematically, rather I bought things that I liked."

Dr. Vasella, a trained physician, worked as a doctor in a teaching hospital in Basel before joining Sandoz in 1988 as a market researcher in the United States. After about four and a half years in the States, he returned to Basel to serve as Vice President of the Company's Global Products Marketing Department and Vice President of Product Development.

"While there are many differences between medicine and business," continued Dr. Vasella, "They have one thing in common — hard work. As a physician you have to work hard to understand and treat patients. As a businessman you have to work hard to understand customers and how to serve them, and at the same time, make a fair profit. In business, one has to focus on profitability, which is one measure of success and an indicator that your products are bringing value to your customers, in addition to being a mark that the company is well managed. I inherited my sense of hard work from my grandparents, who lived in a small village in the mountains of Switzerland where there were few entrepreneurial opportunities. They left this village on foot to settle in the capital of the canton, where my grandfather opened a store. My grandmother, whom I never knew, had nine children. I had a mental picture of her constantly working hard and being a smart businesswoman. This, and the early death of my sisters and my father, when I was 13, made an impression on me that life can be very short.

"All this, along with my belief that you can integrate experiences throughout your life, compels me to try to do several things at once. For example, as a doctor, I learned how to listen, how to be a part of a team considering a complex problem, and how to make a quick decision. These are all important qualities that you need in business," explained Dr. Vasella. "I have a Diego Rivera painting

"I BELIEVE THAT BUILDING ON THE ESTABLISHED TRADITIONS OF SUPPORTING THE ARTS IS CONSISTENT WITH THE LONG-TERM OBJECTIVES OF NOVARTIS."

behind the desk in my office. It is particularly meaningful to me because it captures the commitment and intense team spirit of a group of doctors working together in an operating room. We are trying to create the same sense of commitment and team spirit as an important element in the new culture of Novartis.

"I derive a lot of personal pleasure from this painting and from the arts in general. I am both attracted to and fascinated by the arts from an intuitive, rather than academic, standpoint. Certain works evoke a feeling in me and I find them intriguing, others do not. Overall, art enables me to cross cultural boundaries and encounter human beings throughout the centuries. I am fascinated by Chinese art of 2,000 years ago because it expresses a deep human feeling about the time and the environment and is extremely skillful. The art that evokes my deepest appreciation is that which combines a powerful expression of the human condition with a high degree of technique which disappears behind the spiritual value of the work.

"The arts play a big role in enhancing the work environment," he continued. Over the years, both Sandoz and CIBA-GEIGY developed a strong tradition of supporting a variety of visual and performing arts organizations and projects. In 1990, for example, Sandoz worked with the Headache Research Center to heighten awareness about chronic headaches as a legitimate medical problem by sponsoring a ten-city tour of the exhibition *Through the Looking Glass.* The works in this exhibition were created by individuals who experienced severe headaches. Three years later the Company sponsored a United States tour of *The Gift of Life,* an exhibition which featured paintings and drawings by transplant surgeon and artist Sir Roy Calne and John Sherill Houser, an artist and transplant recipient. One of Sir Roy's works in this exhibition was a portrait of Professor Jean Boreal, the Swiss discoverer of Sandimmune which is a Sandoz product used to inhibit rejection of

Top to Bottom: Sir Roy Calne's "John Bellany, Convalescence" (1988); Sir Roy Calne's "Eileen O'Shea After Three Liver Transplants" (1990). Opposite: Sir Roy Calne's "Dr. Francis Moore" (1992).

transplanted organs. Under the leadership of the Former Chairman of Sandoz, Marc Moret, who was very interested in music, the Company sponsored the International Festival of Music Lucerne and the Royal Concertgebouw Orchestra Amsterdam. Over the years, CIBA-GEIGY supported the Richard Tucker Awards, presented to advance the careers of gifted young opera singers, as well as a number of performing and visual arts organizations in its operating communities, among them The John F. Kennedy Center for the Performing Arts, Carnegie Hall, Lincoln Center for the Performing Arts, Inc. and the Hudson River Museum in Yonkers, New York.

"I am especially interested in projects that help enhance the appreciation of the visual arts in the everyday life of people," commented Dr. Vasella. "One effort that we are currently supporting is the transformation of a tram depot in Fribourg into a new museum for the sculptures of Jean Tinguely.

"As we implement the integration of our two companies into one, we will continue to be involved with the arts," he continued. "However, my highest priority at the moment, is to ensure that we build a solid, strong foundation for Novartis. As the President of Novartis, I have to focus our energies on making certain that we work together to achieve our business goals. We must perform as well as the best companies in our industries; we must surpass our customers' needs; and we must fulfill the expectations of our shareholders. I believe that building on the established traditions of supporting the arts is consistent with the long-term objectives of Novartis."

Paul Suter's "Novae Artes," Novartis Headquarters, Basel. Opposite: Royal Concertgebouw Orchestra Amsterdam.

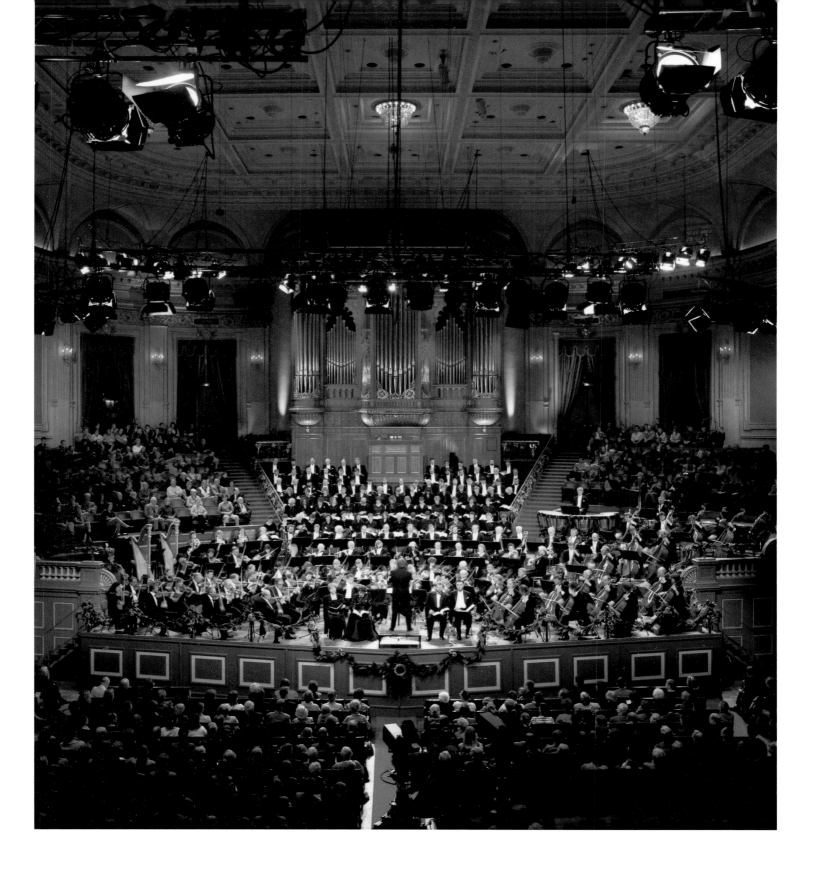

Establishing a Competitive Edge with the Arts

❝I GREW UP IN NEW YORK SO I WAS ALWAYS GOING TO MUSEUMS, WHICH I STILL DO TODAY. AS A TEENAGER I OFTEN WENT TO THE MUSEUM OF MODERN ART. DURING ONE VISIT I REMEMBER STANDING IN A ROOM FILLED WITH CUBIST PAINTINGS. IT WAS SO EXCITING," RECOUNTED DONALD B. MARRON, CHAIRMAN OF THE BOARD AND CHIEF EXECUTIVE OFFICER OF PAINEWEBBER GROUP INC., AN INDEPENDENT FULL-SERVICE SECURITIES FIRM HEADQUARTERED IN NEW YORK, NEW YORK. "MY PARENTS WERE INTERESTED IN THE ARTS, BUT MY INTEREST DID NOT TAKE HOLD UNTIL I WAS IN MY MID-TWENTIES, WHEN I MARRIED AND I BEGAN COLLECTING NINETEENTH-CENTURY ART.

"MY EARLY INTEREST IN NINETEENTH-CENTURY ART FOCUSED ON THE HUDSON RIVER SCHOOL. WHEN I BEGAN TO COLLECT WORKS BY

Donald B. Marron
Chairman of the Board and
Chief Executive Officer

Kensett and Bierstadt they were not well-known, as they are now. In fact, there were only one or two dealers in New York handling their works, and there was very little information or research available. Regardless, they both appealed to me and I could afford them. From this, I moved on to collecting black-and-white American prints from the late nineteenth and early twentieth centuries. I bought my first print, a Thomas Hart Benton, at Guild Hall in East Hampton, and soon added George Bellows, Edward Hopper, Winslow Homer, Grant Wood, John Stuart Davis and others to this collection.

"Then I became interested in contemporary printmaking. I remember visiting Ken Tyler in his Los Angeles studio when he was just getting involved with Frank Stella, Jasper Johns and Robert Rauschenberg. It was a very exciting time. I also got to know Tatyana Grosman and I visited her studio. At the time she was doing great prints for Jasper Johns. One day she called and asked if she could come to see me. I said fine. She brought with her *Decoy* — one of John's greatest prints. It was fresh off the press. Her wrapping of this print was as brilliant as her style. She unwrapped the print, put it on the table and said, 'Donald, what do you think? You must answer quickly. I'm double parked.' It was an incredible print. I quickly answered, yes, certainly, I'll take it.

Art Works: The PaineWebber Collection of Contemporary Masters

The Museum of Fine Arts, Houston

The Detroit Institute of Arts

Museum of Fine Arts, Boston

Minneapolis Institute of Arts

San Diego Museum of Art

Center for the Fine Arts, Miami

Jasper Johns, *Untitled*, 1981, paintstick on tracing paper; collection PaineWebber Group Inc., New York.

This exhibition was organized by the Museum of Fine Arts, Houston.
The exhibition is made possible by PaineWebber Group Inc.

"I love prints. I also had a collection of nineteenth-century European prints. The color lithography process in Europe around 1894 was perfect for making prints. The best, of course, was Lautrec, but there was also Bonnard, Vuillard, Signac, Denis and others. Few bought their work and by about 1900 the technique died, but some incredible work was created during those years.

"When I became interested in contemporary painting, I was President of Mitchell Hutchins & Co., and I started to build a collection for the Company. I believe the office environment is important because people spend at least as much time in the office as they do at home. Contemporary art reflects trends in society and truly outstanding works might even suggest the future. This is a particular benefit in this business. After PaineWebber acquired Mitchell Hutchins, the firm began to build a collection. I've been guiding the development of this collection for more than 20 years. Today, we have about 750 works, and for the past 10 years, we have had a curator with whom I've worked. There are two characteristics essential to building a collection. One is quality. The second is time. You can't build a collection quickly. It takes a lot of time to find the best works. We don't buy to fill walls. We only acquire something that we feel is really marvelous. This means that we might go for months and find nothing, and then all of a sudden we find a number of things.

"Contemporary art is less well-known and accepted so reactions can be strong," continued Mr. Marron. "We have had a range of reactions to works in our collection from employees and visitors. We follow several rules when we install work. We never put art in anyone's office, unless they want it. When we hang a work in a public space, we are very responsive to individual reactions. If individuals do not like the work, we ask them to give it a little time. And, if it is still an issue for them then, we will move it.

"We almost always lend works to museums, if requested. But we find when we do this, our employees miss the art. We also find that by exposing people to first-rate contemporary art, they begin to develop their own sense of quality in contemporary art. When we had offices downtown some of our employees were visited by their art world friends from SoHo who would drop by and say, 'That's a great Jasper

Johns over your desk.' This would stimulate a new look at the work around them.

"Art is marvelous. I'm committed to it and passionate about our Collection, but corporations are businesses first and foremost. Smart corporations have to build on their assets. For us, the Collection is an asset, not only in the sense that it has increased in value, but it has also helped us in our business relationships."

In June of 1995, 70 works from the PaineWebber Collection were organized into an exhibition, *Art Works: The PaineWebber Collection of Contemporary Masters*. This exhibition was presented in seven major museums in the United States during a period of two years. In each venue the Company invited its customers and clients to attend private viewings and special events in connection with the exhibition and provided advertising, public relations and marketing support to help each host museum to encourage the public to view it. PaineWebber also underwrote a series of educational programs in connection with the exhibition which included lectures and mini-courses about contemporary art, as well as special tours for students.

"The reviews of the exhibition were positive and our

employees in each city view the Collection as an asset to business," remarked Mr. Marron. "Some of the people in our Company are beginning to feel passionate about art and they have started their own collections.

"Life is more than just business. In most communities there are lively, active visual and performing arts activities. It's a good idea for a company to be interested in the activities of its own community. By supporting the arts a company enriches the lives of its employees and its clients. With increased focus on the bottom line, it is difficult to support cultural activities if they do not have a business purpose. Our Collection is an asset to our business.

"In addition to our collection, we also maintain the PaineWebber Art Gallery in the lobby area of our headquarters to present exhibitions organized by New York-based not-for-profit cultural organizations that are seeking more exposure for their institutions. It provides a midtown Manhattan venue and an opportunity for these organizations to develop new audiences. We sponsor four shows a year and we help each group organize special events to attract visitors to the exhibition," explained Mr. Marron. Nearly 50 exhibitions from organizations including The Studio Museum

"Rosseau" reception, The Museum of Modern Art, New York. Opposite: Exhibition poster from "Art Works: The PaineWebber Collection of Contemporary Masters."

Top to Bottom: Children of PaineWebber employees participating in "Little Dividends." Opposite: "Bicycles," The PaineWebber Art Gallery, New York.

in Harlem, the Museum of American Folk Art, The New York Botanical Garden, the American Museum of the Moving Image, the International Center of Photography and divisions of the Smithsonian Institution have been presented in the Gallery since it opened in 1985.

"We also have an arts education program for the children of our employees, called *Little Dividends*. We started it in 1992, in part, because people would sometimes say to me, 'My child could do that,' when they spoke about a contemporary work in our collection. Once a year we invite the children of our employees — ranging in age from two to fourteen years — to spend a Saturday here in our headquarters working with professionals from The Studio in a School program to create art. We have a show of the work the children create in our Gallery each year. When you go to the opening of this exhibition you see the faces of parents filled with pride when they see their children's art framed and hanging. It's a great program for the Company because it provides arts education opportunities for children and it draws our employees together." Recently, *Little Dividends* was established in PaineWebber offices around the country.

Over the years PaineWebber has also sponsored a number of major museum exhibitions, including *Picasso and the Weeping Women: The Years of Marie-Thérèse Walter and Dora Maar, Henri Rousseau* and *Frank Stella 1970-1987.* Additionally, the Company has underwritten the documentary series, *The Prize: The Epic Quest for Oil, Money & Power,* based on Daniel Yergin's Pulitzer Prize-winning book, presented on PBS. PaineWebber has also made an ongoing commitment to sponsor classical music radio programs. Since 1975 the Company has co-sponsored the WQXR-FM *Symphony Hall* and for more than a decade it has sponsored *PaineWebber Traditions,* a one-hour classical music broadcast on more than 100 radio stations throughout the United States.

"Most people do not realize the impact the arts have on their lives. Art is not a separate elitist activity. We are all living with the creations of our own time," explained Mr. Marron. "The arts relate to design — the design of a car and clothes. The basis of design often comes from fine art. Then it gets picked up on the design side and goes forward.

"MOST PEOPLE DO NOT REALIZE THE IMPACT THE ARTS HAVE ON THEIR LIVES. ART IS NOT A SEPARATE ELITIST ACTIVITY. WE ARE ALL LIVING WITH THE CREATIONS OF OUR OWN TIME."

The design collection of The Museum of Modern Art includes things people live with everyday. One of the biggest art forms in the world today, probably the one with the largest audience, is music. Contemporary music is just as much an art form as contemporary art created by Frank Stella or Jasper Johns. Somehow visual art is more difficult for people to relate to than music, perhaps because it is frozen on the wall. Captive. It is more removed from people's experience than music. You can buy almost anything in music that you want. This is not the case in the visual arts. The bridge to the visual arts is museums and businesses that are enlightened. Throughout my life I have been trying to make art more accessible, and involve more people with it."

Theodore M. Hutchison
Former Vice Chairman

THE PRINCIPAL
FINANCIAL GROUP

Broadening Horizons
in the Heartland and Beyond

"LIKE MOST KIDS, I TOOK MANDATORY LESSONS IN PIANO, VIOLIN AND TROMBONE. I WAS EQUALLY

UNSUCCESSFUL IN ALL OF THEM. I STUDIED ART AND MUSIC AS PART OF MY PUBLIC SCHOOL EDU-

CATION IN ALGONA — A SMALL RURAL FARM COMMUNITY IN NORTHERN IOWA — BUT FRANKLY,

I WAS MORE INTERESTED IN SPORTS," ADMITTED THEODORE M. HUTCHISON, FORMER VICE

CHAIRMAN OF THE PRINCIPAL FINANCIAL GROUP, A FINANCIAL SERVICES COMPANY HEADQUAR-

TERED IN DES MOINES, IOWA. "MY PARENTS ENJOYED SYMPHONIC MUSIC, AND THEY TAUGHT ME

TO APPRECIATE IT. MY INTEREST IN THE VISUAL ARTS DEVELOPED WHEN I WAS A TEENAGER. I

OFTEN TOOK A NIGHT TRAIN FROM ALGONA TO CHICAGO TO VISIT MY COUSIN, AND WE SPENT

WEEKENDS TOGETHER VISITING MUSEUMS."

AFTER GRADUATING FROM THE UNIVERSITY OF IOWA IN THE 1950S WITH BOTH A BACHELOR'S

AND A LAW DEGREE, MR. HUTCHISON LEFT IOWA TO ATTEND THE UNIVERSITY OF MICHIGAN WHERE

HE EARNED HIS L.L.M. DEGREE. HE THEN TAUGHT LAW AT BOSTON UNIVERSITY, AND

frequently went to concerts, theater performances and museums in Boston and its environs.

"Because of my rural Iowa roots," explained Mr. Hutchison, "I have a strong interest in the environment and conservation. Once I began working for The Principal in 1963 as an attorney I had many opportunities to combine these interests with my interest in the arts. In one instance, I worked with Maya Lin whom we commissioned to create a site-specific environmental work, titled *A Shift in the Stream,* for our new building designed by Helmut Jahn. Maya is also extremely interested in the environment. During one of her visits to Des Moines she participated in a special screening of the award-winning film about her career — *Maya Lin: A Strong Clear Vision* — which benefited the Des Moines Art Center, the Iowa Natural Heritage Foundation of which I am Chairman and the Iowa Chapter of The Nature Conservancy, in which I am very active.

"Another project I worked on was a wetlands sculpture

created by Mary Miss on the grounds of the Des Moines Art Center which The Principal supported," he continued. "Like Maya, Mary is very interested in the environment. The wetlands project draws attention to the fact that we must preserve our wetlands, especially in an agrarian state like Iowa. The project brought together groups that seldom work with each other — the Des Moines Art Center, the Des Moines Founders Garden Club, the Science Center of Iowa, the City of Des Moines Parks and Recreation Department, the Iowa Natural Heritage Foundation and the Polk County Conservation Board.

"It's fascinating to work with artists because they bring another dimension into the workplace. Often they inspire us and help us see things differently," noted Mr. Hutchison. Over the years he played a key role in determining the architects and artists involved with the design of The Principal's facilities and in the selection of the art for the headquarters complex. In 1991 he guided the commission given by The Principal to

James Turrell to create a site-specific work entitled *Last Breath,* for the Company's Corporate Two Building, and two years later, a commission was given to Terry Schoonhoven and Astrid Preston to create murals for another building within the Company's corporate campus.

"Our interest in the visual arts expands beyond our office and into the community," continued Mr. Hutchison. "For more than four decades we have maintained a strong partnership with the Des Moines Art Center. In addition to providing ongoing operating support, we have given the Center a major work by Henry Moore, underwritten many exhibitions including *Jean Michel Basquiat* and *Mary Miss' photos/drawings*, educational programs which serve more than 15,000 at-risk children each year, as well as special programs for our customers and employees."

The Principal began its own art collection in 1985. Today, the Company owns more than 700 works that reflect its commitment to diversity and excellence. Each year six to ten special exhibitions are presented in *ArtZone,* an exhibition space in the Company's Des Moines headquarters. To enhance and broaden accessibility to its art collection, The Principal offers

its employees, their families and community groups special demonstrations, workshops and tours of the Collection. The Principal also collaborated with the Des Moines Art Center and other Des Moines-area companies to organize a walking tour of corporate art collections throughout the City. And in 1997, the Company made a grant of $1.9 million to underwrite the eight-part PBS series, *American Vision: The Epic History of Art in America*, plus the accompanying book, educational materials and employee programs.

The Principal also supports the performing arts. "Being able to work closely with the Des Moines Symphony, an organization that The Principal has supported since 1937 — to underwrite commissioning competitions, to assist with the release of its first compact disc recording, and to be part of the selection process for a conductor — has been an extremely rewarding personal experience," said Mr. Hutchison. "As part of the search for a new conductor, we suggested that the leaders of all the arts organizations in Des Moines get together to meet with the candidates. This was the first time most of these individuals had ever been together. Now, they meet on a regular basis and there is a very

"WE HOPE BY DEVOTING TIME AND RESOURCES TO THE ARTS, ALONG WITH OUR OTHER ACTIVITIES IN EDUCATION, HEALTH AND HUMAN SERVICES, WE ARE ENRICHING THE LIVES OF OUR EMPLOYEES, OUR CUSTOMERS AND THE PEOPLE LIVING IN THE COMMUNITIES IN WHICH WE OPERATE."

healthy collaborative spirit among them, which has resulted in many joint projects that enrich the cultural life of the City.

"The arts have always been important to me and to my family too," said Mr. Hutchison. "We know our customers and our employees enjoy the arts so we make a special effort to provide general support to arts organizations in our operating communities and to share works from our Collection with these communities. We hope by devoting time and resources to the arts, along with our other activities in education, health and human services, we are enriching the lives of our employees, our customers and the people living in the communities in which we operate."

Des Moines Arts Center, Lorna Simpson's "Wigs." Opposite (Left to Right): Des Moines Symphony at the Iowa State Capitol; Des Moines Art Center, Mary Miss' "Greenwood Pond: Double Site."

Leading and Encouraging Others to Follow

"I GREW UP IN A HOUSE FULL OF MUSIC. MUSIC HAS ALWAYS BEEN A VERY IMPORTANT PART OF MY LIFE," SAID EDWIN ARTZT, FORMER CHAIRMAN AND CHIEF EXECUTIVE OF THE PROCTER & GAMBLE COMPANY, A CONSUMER PRODUCTS COMPANY LOCATED IN CINCINNATI, OHIO. "MY FATHER WAS A GIFTED VIOLINIST," HE ADDED. "AS A VERY YOUNG BOY, HE PERFORMED WITH THE SYMPHONY CLUB CHAMBER ORCHESTRA, WHICH WAS FUNDED BY A WEALTHY PHILADELPHIAN, EDWIN FLEISHER, FOR WHOM I AM NAMED. IN 1910, WHEN MY FATHER WAS 14, MR. FLEISHER GAVE HIM A SCHOLARSHIP TO THE VIENNA ROYAL ACADEMY OF MUSIC SO HE COULD STUDY WITH ONE OF THE GREAT VIOLIN TEACHERS IN EUROPE. FOUR YEARS LATER, THE UNITED STATES ENTERED WORLD WAR I AND THE AUSTRIAN GOVERNMENT INTERNED MY FATHER. WHEN ALL THE MUSICIANS OF THE STATE OPERA OF VIENNA WENT OFF TO WAR, MY FATHER AND THE OTHER KIDS AT THE ROYAL ACADEMY WERE ASSIGNED TO REPLACE THESE MUSICIANS SO THAT CONCERTS COULD CONTINUE DURING THE WAR.

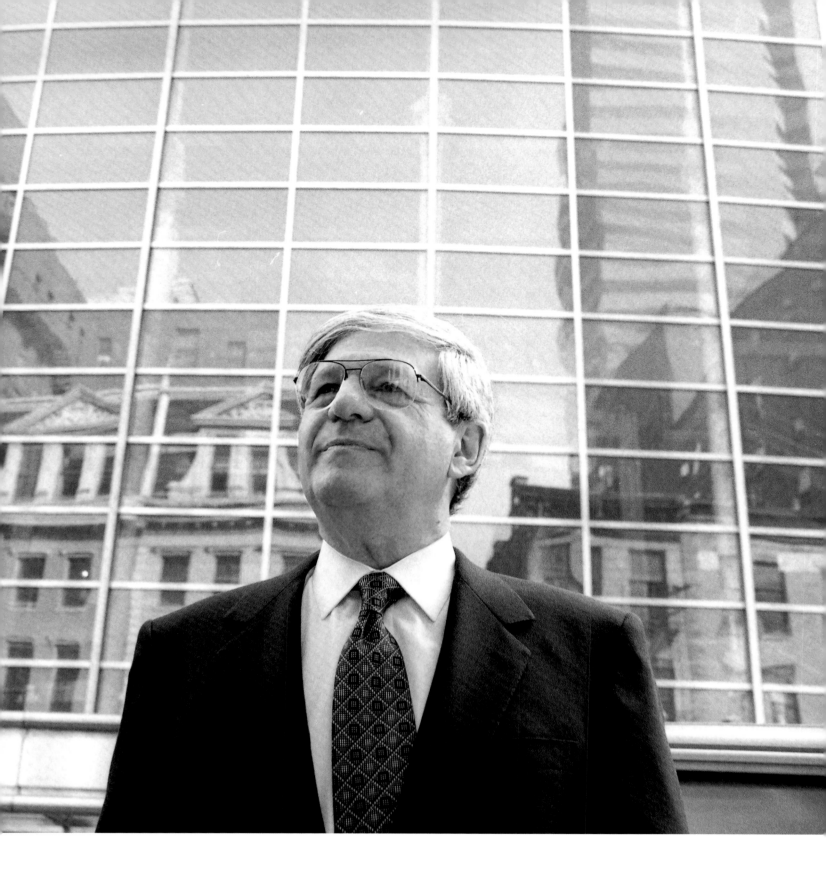

Edwin Artzt
Former Chairman
and Chief Executive

After the War my father returned to the States and joined the New York Philharmonic. Later, he became a jazz musician and played with all the great swing band artists of his time — Benny Goodman, Buddy Berrigan and the Dorsey Brothers. He also composed for network radio programs, played in chamber ensembles and in orchestras for Broadway musicals.

My mother was a professional pianist. When she was four, she practiced eight hours a day. She went to Juilliard, performed at Carnegie Hall many times and also accompanied several opera stars. To this day, my parents' love of music is with me. Whether I am in my office or my car, I listen to works by Mozart, Rachmaninoff, Beethoven or Brahms. I'm never very far away from classical music."

One of Mr. Artzt's special interests is the University of

Cincinnati College - Conservatory of Music. "I funded the William Artzt Memorial Scholarship Fund, named for my father, to enable 10 graduate-level music students from the Conservatory to study with professional musicians and to perform with The Grand Teton Orchestral Seminar during its summer residency at the Grand Teton Music Festival in Jackson Hole, Wyoming," he continued. "I admired my father's dedication, which enabled him to become an accomplished professional musician. No matter what you do, you have to master the fundamentals. You have to start young, as he did, and then work and work and work until you get to the level that very few individuals achieve. If you want to get there in the worst possible way, you have to be willing to make necessary sacrifices throughout your life. Through the Scholarship Fund I wanted to encourage talented young musicians to develop dedication and a commitment to professional excellence. The Fund also enabled them to have professional performance experiences."

Mr. Artzt is a Board member of the Cincinnati Institute of Fine Arts. Established during the 1930s to further music, artistic, educational and cultural opportunities in Cincinnati, this organization manages the City's United Arts Fund. "In 1994 the Fund raised more than $6 million and the following year, a record $6.4 million," said Mr. Artzt. "While this does not address all the financial challenges of the City's major

Top to Bottom: Tide with Bleach television commercial featuring the Dance Theatre of Harlem; Cincinnati Ballet, "Cinderella," Karyn Lee Connell. Opposite: Cincinnati Art Museum, The Procter & Gamble Art Collection.

institutions, it does provide a significant base of support. Procter & Gamble's total annual contributions account for about 15 percent of all that is raised for causes in Cincinnati, including the arts."

In the early 1990s Procter & Gamble made the first leadership grant —- $3.5 million — toward the construction of Cincinnati's new Aronoff Center for the Arts, which opened in the fall of 1995. "We made the commitment at the outset of the campaign to help get it off to a good start and to show that we were serious about the private sector meeting its goal," explained Mr. Artzt. The Center includes an art museum and three theaters, one of which is named Procter & Gamble Hall. "I'm delighted that we have a world-class performing arts center in Cincinnati," he continued. "One of the three theaters in the new Center was designed to accommodate Broadway shows. Having this theater expands the number and scale of shows available to Cincinnati audiences. The Center definitely enriches the public's access to the performing arts in a way that we have never been able to do until now."

Procter & Gamble is a principal supporter of all the major arts organizations in its headquarters city including the Cincinnati Symphony Orchestra, the Cincinnati Ballet, the Cincinnati Art Museum, The Contemporary Arts Center and the Cincinnati Opera. In addition to providing operating support, the Company also underwrites special projects such as the Ballet's production of *Cinderella,* the Symphony's *Summer Concerts Series* and the Cincinnati Playhouse in the Park's *School Outreach Program.* It has also supported exhibitions in The Taft Museum including *Lifting the Veil: Robert S. Duncanson and the Emergence of the African-American Artist* and *Dutch Drawings from the Age of Van Gogh from the Collection of the Haags Gemeentemuseum.*

"I go to lots of museums when I travel. Whenever I am in Madrid, I visit the Prado. I particularly like the Goyas," commented Mr. Artzt. "Every time I am in Amsterdam I go to see the Rembrandts and the Van Goghs. I lived in Brussels for five years and I got to know the great works of art in the museums in Bruges, Ghent and Antwerp. I've also been to museums in London, Paris, Florence and Milan dozens of times. Recently, I've become more interested in contemporary art."

"WE FEEL THAT OUR SUPPORT OF THE ARTS HELPS MAINTAIN THE HIGH QUALITY OF CULTURAL LIFE IN OUR HEADQUARTERS CITY, AND WE REGARD OUR COMMITMENT TO SUPPORT THE ARTS AS PART OF OUR CORPORATE RESPONSIBILITY."

"We have an art collection in our headquarters of which I am quite proud. It focuses on works from 1830 to 1930 created by artists who were born or lived in Cincinnati. In 1987, to mark the Company's l50th anniversary year, the entire collection was shown in the Cincinnati Art Museum. The Company also maintains the *Coffee Silver Collection,* one of the world's most significant collections of antique English silver coffee pots and related serving pieces, which is exhibited in the Company's headquarters." On the national level, Procter & Gamble supports programs of The John F. Kennedy Center for the Performing Arts, the National Museum of the American Indian, the National Symphony Orchestra, the Wolf Trap Foundation, Lincoln Center for the Performing Arts, Inc. and the Metropolitan Opera. In 1990 the Company underwrote the National Symphony

Orchestra's tour of the former Soviet Union. These concerts were conducted by the Orchestra's Musical Director, Mstislav Rostropovich. This was the first time he returned to his homeland since fleeing it in 1974.

In 1990 Procter & Gamble also developed its first market-ing initiative with the arts by collaborating with the Dance Theatre of Harlem (DTH) to develop a special promotion for Tide with Bleach designed to increase market shares for this product and to help DTH expand its audience and increase contributions. As part of this effort, dancers appeared in Tide with Bleach television commercials and the Company issued product coupons. For each redeemed coupon, DTH received 35 cents. Additionally, the Company also underwrote a fund-raising dinner, *Not Black Tie/Black Tights,* for DTH.

Aronoff Center for the Arts, Cincinnati. Opposite: Cincinnati Pops performance.

Procter & Gamble has a long history of supporting the arts, particularly in Cincinnati and more recently in our operating

communities throughout the world," continued Mr. Artzt. "This interest in the arts dates back to the days of William Cooper Procter, one of the members of the founding families. Over the years, many Company executives have been ardent supporters of various arts organizations in the community.

"Like those before me, I feel that the arts play a central role in the quality of life in our operating communities. The fact that the arts and cultural activities are accessible is always an important consideration for families that want to migrate to a new place or stay in a city throughout their working years. We feel that our support of the arts helps maintain the high quality of cultural life in our headquarters city, and we regard our commitment to support the arts as part of our corporate responsibility. Furthermore, we are interested in and committed to getting others in the busi-ness community to join us in contributing to the arts."

Pioneering the Concept of the Arts in Business

"My interest in the arts began when I was about 10 years old and had to stay home from school with a bad cold. To help pass the time I copied some of the paintings that hung in our home," recalled David Finn, Chairman and CEO of Ruder·Finn, Inc., a privately-held international public relations firm headquartered in New York, New York. "I was pleased with the results, so I showed my paintings to the teacher in charge of the art club at my school, and asked if I might join the club. I think I was the only student ever rejected for membership. It turned out to be the best thing that ever happened to me, since I was determined to show the teacher she was wrong." For the past 65 years, Mr. Finn has continued to paint and his works have been exhibited in the United States and abroad.

"My parents were not particularly interested in the arts, but because of me they developed an interest and even took up painting," continued Mr. Finn. "We lived in

David Finn
Chairman & CEO

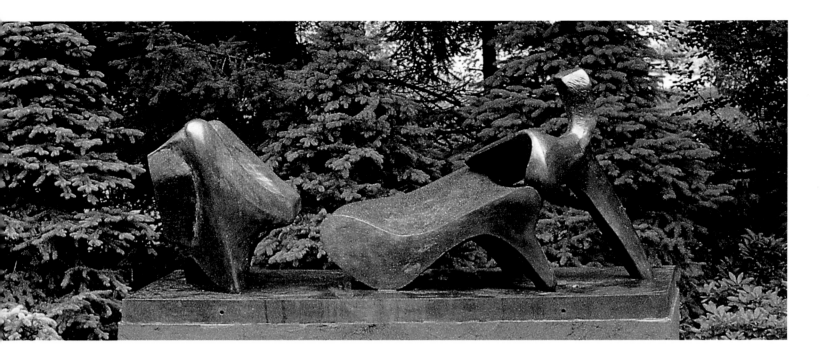

New York and my mother occasionally went to lectures at The Metropolitan Museum of Art, where she met the German art historian, Ernest Zierer. He eventually became my teacher and mentor. In fact, I even took a year off from college to assist him in developing a course and to continue to paint.

"In junior high school I wrote an essay saying I wanted to be an artist-writer when I grew up," he recalled. After graduating from City College of New York (CCNY) with a degree in English Literature and serving in the Air Force during World War II, Mr. Finn and his childhood friend, William Ruder, started a company called Art In Industry. "We wanted to build a bridge between the arts and business that would benefit both," he explained. "The idea of incorporating the arts in business was just emerging, so in a sense we were pioneers. When our client base expanded, we changed the Company's name to Ruder·Finn, and subsequently established a special division, Arts and Communications Counselors.

"Among our first major corporate clients involved with the arts were Philip Morris and Clairol," recollected Mr. Finn. "We suggested that Philip Morris could demonstrate its forward-thinking approach to business by sponsoring the arts. The Company loved the idea. Its first major sponsorship was a traveling exhibition, *Pop and Op*, organized by the American Federation of Arts in 1965. It turned out to be a great experience, which began Philip Morris' long-standing and distinguished history as a major business supporter of the arts throughout the world.

"For Clairol, we organized a national art competition for hairdressers, the individuals who use the products and are artists in their work, as well as a traveling exhibition of drawings and paintings by well-known artists, titled *Mother and Child*," he continued. "We also helped Springs Industries become a leading business supporter of photography exhibitions in The Museum of Modern Art in New York and other major museums. And, we guided Springs in commissioning seven sculptures by Bruno Lucchesi which reflect the Company's seven values. These works are installed on the grounds of the Company's headquarters in Fort Mill, South Carolina."

Through Arts and Communications Counselors, Ruder·Finn also works with visual and performing arts organizations. In 1997 the Company handled the public relations for the opening of three major museums — the Guggenheim Museum in Bilbao, Spain, designed by Frank Gehry; The Getty Center in Los Angeles, California, designed by Richard Meier; and the Miho Museum in Kyoto, Japan, designed by I.M. Pei.

Additionally, the Company provides pro bono services to many organizations such as the National Sculpture Society, for which it produced its magazine, *Sculpture Review*, and the American Academy of Arts and Sciences for which it designs the cover of *Daedalus*, the Academy's quarterly journal. Ruder·Finn also recently helped The Printmaking Workshop in New York organize a fundraising auction of works by current and former students. Since 1973 David

Henry Moore's "Three-Piece Reclining Figure: Bridge Prop." Opposite (Left to Right): Henri Matisse's "Mother and Child" from the Clairol Collection; Bridget Riley's "Untitled," a work in the "Pop and Op" exhibition.

Finn and Bill Ruder have taken turns serving as Directors of the Business Committee for the Arts, Inc., and Mr. Finn has been a guiding force in the organization's national advertising campaign, "The Art of Leadership." Currently, he serves on the Council of the National Endowment for the Humanities, and is involved with many other not-for-profit organizations.

Mr. Finn began collecting sculpture during the late 1950s when he and his wife, Laura, purchased a small sculpture by Henry Moore — who was not well-known at the time — from a gallery in London. They met the artist and this began a friendship that spanned more than three decades. The Finns' collection expanded to include other works by Moore, as well as works by Giacometti, Marini, Manzù, Calder, Lehmbruck and many others. They have donated Moore's *Bridge Prop* to Brown University and *Reclining Figure, 1969* to Columbia University. Mr. Finn also encouraged Henry Moore to place several of his sculptures on the grounds of Arden House, a retreat in New York that belongs to Columbia University, and Ruder·Finn helped George Ablah, a Kansas businessman, organize an exhibition of Henry Moore sculptures from his collection throughout the parks of New York City.

Mr. Finn's interest in sculpture led to his interest in photography. "As I was recovering from a long bout of pneumonia during the early 1960s, I read a series of books about Italian Renaissance sculpture, and I took a map of Italy and marked the location of some of the great masterpieces of the period,"

"...I THINK INVOLVEMENT WITH THE ARTS IS ONE OF THE THINGS IN LIFE THAT CANNOT BE MEASURED. THE ARTS REPRESENT THE HIGHEST EXPRESSIONS OF A SOCIETY'S VALUES AND ACHIEVEMENTS, AND THEY ENRICH OUR LIVES, OUR SPIRIT AND MAKE US BETTER INDIVIDUALS."

recounted Mr. Finn. "After recovering, I went to Italy with a newly purchased Polaroid camera and took photographs of some of these great works. I also used this camera to photograph classic sculptures in Greece and the works created by the early twentieth-century sculptor Gustav Vigeland in Frogner Park in Oslo, Norway. By chance, the publisher Harry Abrams saw enlargements of the Vigeland photographs in my office and suggested that if I went back to Oslo and photographed all of the works in the Park using a more sophisticated camera, he would publish a book of my photographs." In 1967 *Embrace of Life*, Mr. Finn's first book, featuring his photographs of Vigeland's sculptures, was published. Since then, he has completed more than 60 books of his photographs of sculpture, and has written *How to Visit a Museum*, *How to Look at Photographs* and *How to Look at Sculpture*.

While Mr. Finn does not consider himself a sculptor, a number of his three-dimensional works can be found throughout the Ruder·Finn offices. "Many years ago when I stopped smoking cigarettes, I started to play with paper

clips," he explained. "I missed the feeling of holding a ciga-rette in my hand; the paper clips were a good substitute. I made long wires by fastening the clips together and then shaped them into figures of men and women. Over the years, I have created hundreds of paper clip sculptures while on long telephone calls or in meetings." A six-foot male and female paper clip sculpture, along with two life-size wood sculptures, carved from fallen trees on the grounds of his home, are in the reception area of the Company's New York office.

In addition to incorporating the arts into work for its clients, Ruder·Finn also incorporates the arts into its own environment, a tradition that began when the Company was founded in 1948. "We believe that the personal interests of management should help shape the character of a company," said Mr. Finn. "Since Bill and I are both devoted to the arts, we wanted our Company to reflect our interest. During our first years in business, we created *Thoughts and Images*, a portfolio of posters featuring photographs of sculp-tures, each accompanied by a quotation from a well-known artist, writer, philosopher and leader. *Thoughts and Images* has become a hallmark of Ruder·Finn. We have used some of these images in ads, hung the posters in our offices and conference rooms throughout the world, given them to friends, clients, professional associates, as well as to hospi-tals, universities and other organizations. I believe that these posters encourage people to think creatively while they are at work. It is a source of personal gratification when employees tell me they decided to work at Ruder·Finn because our

offices are filled with works of art," acknowledged Mr. Finn.

"We value new ideas and creative initiatives in and out of the workplace, and we encourage our staff to lead an inte-grated life by combining personal and business interests whenever possible," said Mr. Finn. "When I talk to our interns, I always tell them that their personal interests should affect the way they do their business and vice versa. I talk about how my interest, and Bill's, in the arts has affected the way we do business and the character of Ruder·Finn. And, I always refer to one of the quotations from *Thoughts and Images* by Ortega y Gasset — 'We cannot put off living until we are ready'. I tell them the story of one of our executive vice presidents who said he wanted to write a play when he retired. I tried to get him to write it while he was working, but he thought he did not have the time. He died unexpectedly at the age of 42 and the play was never written. So, I encour-age everyone to be creative and to do what they want to do while they are earning a living.

"As I reflect on our 50 years in business, I realize that it is very difficult to measure the value of our involvement with the arts," said Mr. Finn. "While there is great emphasis today on evaluating everything in terms of the impact on the bottom line, I think involvement with the arts is one of the things in life that cannot be measured. The arts represent the highest expressions of a society's values and achieve-ments, and they enrich our lives, our spirit and make us better individuals. Astute business leaders recognize this, and this is why the partnership between business and the arts in this country has evolved beyond what Bill Ruder and I dreamed possible 50 years ago. I am confident that this trend will continue, particularly with organizations like the Business Committee for the Arts developing new initiatives to stimulate businesses of all sizes to continue to expand their involvement with the arts."

Top to Bottom: A series of how-to books written by David Finn; covers of "Daedalus" and "Sculpture Review." Opposite: A poster from the "Thoughts and Images" portfolio.

We cannot put off living until we are ready.

José Ortega y Gasset

Honoring Traditions to Foster Quality and Value

"No one in my family was especially interested in the arts," said John H. Bryan, Chairman of the Board and Chief Executive Officer of Sara Lee Corporation, a global packaged food and consumer products company headquartered in Chicago, Illinois. "I grew up in West Point, Mississippi, a rural community with a population of 7,500. My father had a meat packing business there which I worked in as a young boy. When I was 17 my parents took me on a grand tour of Europe. Although this trip made a lasting impression on me, I don't recall visiting museums. Shortly thereafter I married my wife, Neville, and I became interested in antique furniture. During one of our first trips to England, we visited some antique shops recommended by an architect friend and came home with a houseful of furniture," he recalled.

"I soon became interested in collecting decorative arts, in particular, furniture, textiles, glass, metalware and ceramics. I concentrated on two distinct periods.

John H. Bryan
Chairman of the Board and
Chief Executive Officer

S A R A L E E C O R P O R A T I O N

One is English from the late seventeenth century to the early eighteenth century, from about 1650 to 1730. This includes late Elizabethan and early Georgian, but primarily focuses on the Stuart monarchies in England. The furniture of this period has a high degree of naïveté and restraint and the woods have beautiful colors," he explained. "The other period that interests me is the American Arts and Crafts Movement, which began around the turn of the century and lasted until about 1915. I focus on the works of Gustav Stickley.

"In 1970 Nate Cummings, the Founder, Chairman of the Board and Chief Executive Officer of Consolidated Foods, acquired my family's company, Bryan Foods. He invited me to the opening of an exhibition of his collection in The Metropolitan Museum of Art in New York. I think this was the first time I'd been in The Met. I enjoyed seeing some

paintings that I had previously only seen in books. About four years later, I became an officer of Consolidated Foods and moved to Chicago. I got to know Nate very well and I became familiar with his collection. When Nate and I were in Paris on business, we toured galleries together. He introduced me to Henry Moore and I spent a day with Moore at Much Hadham, Moore's home. I found these experiences very inspiring.

"I now make it a practice to visit museums whenever I go on business trips. I remember arriving in Munich once and discovering that the museum was open late that evening. I spent hours going through its galleries.

"In 1976 I became Chairman of the Board of Consolidated Foods. We later changed the company name to Sara Lee Corporation. Having a collector's instinct, I thought it would be a fitting tribute to Nate Cummings to acquire some of his

paintings and sculptures and keep them together as a reminder of the Company's origins. These works are now part of the Company's Collection which includes works by Degas, Pissarro and Picasso," said Mr. Bryan, who also serves as Vice Chairman of the Board of Trustees of The Art Institute of Chicago. The core of the collection is installed in Sara Lee's Chicago headquarters. Occasionally some of the works are loaned to museums in cities where Sara Lee has offices and plants, as well as to museums abroad. Several books have been published documenting the evolution of the collection.

"I am quite certain that my own interest in art has some bearing on Sara Lee's focus on the arts," continued Mr. Bryan. "The Sara Lee Foundation, founded in 1981, concentrates more than most corporate foundations on cultural programs. Education is another focus of our Foundation. I believe that the arts are an extremely important aspect of education, particularly if people are going to live peacefully together in this multicultural society.

"As I look at the cultural activity in the world today, I think we are living through one of the most stimulating periods of all time," remarked Mr. Bryan. Begining in the late 1980s, a number of cultural projects were undertaken in Chicago, including the construction of a new library and cultural center, a new Museum of Contemporary Art, and additions to The Art Institute of Chicago. Mr. Bryan led a campaign that raised more than $100 million for renovations to Orchestra Hall and the Civic Opera House. There is also a plan under consideration for a new performing arts facility in the City. "In my judgment," Mr. Bryan continued, "Chicago will be defined more for its artistic and cultural activities than anything else in the years to come. I believe the same is true of many cities throughout the United States."

Since the early 1980s Sara Lee has been a major supporter of all the established and many of the emerging arts organizations in Chicago. The Company underwrote various exhibitions in The Art Institute of Chicago, including *British Delft from Colonial Williamsburg, Goya: Truth and Fantasy, Odilon Redon: Prince of Dreams,* and *Gates of Mystery: The Art of Holy Russia.* In 1991 Sara Lee made a substantial grant to facilitate an art exchange between The Art Institute of Chicago, The Metropolitan Museum of Art in New York, The Pushkin Museum of Fine Arts in Moscow and the Hermitage Museum in St. Petersburg. As a principal backer of the Chicago Historical Society, Sara Lee has been a major force in modernizing the Society's facilities and is a frequent supporter of its exhibitions, such as *A City Comes of Age: Chicago in the 1890's* and *Bridges and Boundaries: African Americans and American Jews.*

The Company also supports the performing arts. For example, Sara Lee provides the Lyric Opera of Chicago with annual operating support and frequently underwrites new productions, such as *Il Trovatore* in 1991 and *Mefistofele* in 1993, and was the principal sponsor of the Gala Tribute to

Top to Bottom: Lyric Opera of Chicago, "Madame Butterfly;" Muntu Dance Theatre of Chicago. Opposite: The Goodman Theatre's, "Journey to the West," (Left to Right) Jenny Bacon, Jane Cho and Christopher Donahue.

the Lyric's General Director, the late Ardis Krainik.

Additionally, Sara Lee funds The Goodman Theatre, and was one of the first companies to provide general operating support to the Steppenwolf Theatre Company. Subsequently, the Company underwrote the Steppenwolf's revival of *The Grapes of Wrath,* which opened in Chicago in 1988 and traveled to Broadway, as well as the 1996 world premiere adaptation of *Slaughterhouse-Five.* Sara Lee also funded the *Dance Series* of the *Olympic Arts Festival,* which was part of the 1996 Centennial Olympic Games in Atlanta.

In 1994 Sara Lee joined forces with other leading businesses in the Chicago area to fund the Chicago Arts Partnerships in Education (CAPE), a consortium of 30 schools, 27 community groups and 50 arts organizations

charged with integrating the arts into the public school cur-
riculum. Additionally, the Company supports the Muntu
Dance Theatre of Chicago training classes for students
attending Harper High School, located in one of the most
economically disadvantaged communities in Chicago. In
1991 the Sara Lee Foundation, in partnership with the
John D. and Catherine T. MacArthur Foundation, head-
quartered in Chicago, undertook a *Cultural Marketing
Initiative*, created to heighten public awareness about the
arts and to increase participation in the arts among the
City's various ethnic communities.

Each year Sara Lee provides grants to foster artistic
growth and to increase audiences for many emerging arts
groups in and around Chicago, among these are the
Mexican Fine Arts Center Museum, the Bryant Ballet,
HealthWorks Theatre Company, Hedwig Dances, Inc., the
Latino Experimental Theatre Co., the Lookingglass Theatre
Company and Stories on Stage.

Many of Sara Lee's divisions also support arts organi-
zations in their operating communities. For example,
Hillshire Farm & Kahn's supports the Fox Valley
Symphony in Appleton, Wisconsin; PYA/Monarch sup-
ports the Greenville Symphony Orchestra in Greenville,
South Carolina; Sara Lee Personal Products sponsored
the inaugural exhibition *Women in History* in the North

"THE ARTS ARE THE BEST EXPRESSIONS OF QUALITY THAT
HUMANKIND CAN OFFER...WE ARE SERVING THE INTEREST OF
THE COMPANY AND OUR STOCKHOLDERS BY HELPING TO
STRENGTHEN THE CENTRAL VALUES OF SOCIETY THROUGH OUR
SUPPORT OF THE ARTS."

Carolina Museum of History in Raleigh, and underwrites
scholarships for students attending the North Carolina
School of the Arts in Winston-Salem; Sara Lee Meats
sponsored the exhibition *Duncan Philips Collection: Paris
Between the Wars* in The Dixon Gallery and Gardens in
Memphis, Tennessee; and Sara Lee Bakery supports the
Hubbard Street Dance Chicago.

Mr. Bryan also devotes considerable time to advance
business alliances with the arts on the national level. He has
been a Director of the Business Committee for the Arts
since 1987 and served as the organization's Chairman from
1989 to 1991. Additionally, he is a member of the both the
President's Committee on the Arts and the Humanities and
the Trustees' Council of the National Gallery of Art in
Washington, D.C.

"I believe involvement in the arts is especially relevant to
Sara Lee since we are a brand-oriented company. We have
some of the greatest brands in the world today, and we
nurture them so that they can maintain their prime posi-
tion," explained Mr. Bryan. "Works of art by well-known
artists are similar to brands in many ways. When great
artists create paintings and put their names on them, a real
value is created. In large part, that's what happens in our
business — products of high quality are known by brand
names that define the products and communicate their
value to our audiences.

"The arts are the best expressions of quality that
humankind can offer. We think that our involvement with
the arts expresses our commitment to quality at all levels of
our Company's operations, and that we are serving the inter-
est of the Company and our stockholders by helping to
strengthen the central values of society through our support
of the arts."

*The Art Institute of
Chicago, "Dutch and Flemish
Paintings from the
Hermitage." Opposite
(Top to Bottom): Museum of
Contemporary Art, Chicago;
The Mexican Fine Arts
Center Museum, Chicago.*

Yoshiharu Fukuhara
Chairman

S H I S E I D O C O . , L T D .

Building Bonds of Friendship and Affection

"Throughout my childhood my father used to welcome painters, sculptors, writers and poets to our home. There were no business hours for artists, they came whenever they liked," recalled Yoshiharu Fukuhara, Chairman of Shiseido Co., Ltd., an international cosmetics and pharmaceutical company, headquartered in Tokyo, Japan. "We had a large and comfortable house with all sorts of modern facilities for the time. Our home functioned as a salon for artists, rather than our living space," he continued. "As an only child I spent many hours with my father's artist friends, who were my friends too.

"While in our home the artists discussed art, perhaps love, and they often listened to recorded music of Stravinsky and Ravel and many other contemporary composers. When my father, Nobuyoshi Fukuhara, was not at home, my mother, Aiko, warmly received them in our home. My parents never turned artists away. Many ultimately

became widely recognized in their fields for their excellence.

"My father also ardently liked Kabuki, and he was intrigued by modern Western arts," noted Mr. Fukuhara. "He went to the Kabuki Theatre almost every night, especially when his favorite actors appeared in his favorite plays. He particularly liked *Kanjincho (The Subscription Scroll)*, which was first performed in 1840. At home, he often mimicked the stage voice and gestures of Benkei, the hero in this play. Stage performances had special appeal to him. He also like Rakugo, which is a traditional form of comical talk shows, as well as modern theater.

G.D.

"My mother — who shared my father's interest and was a good companion for her husband — along with my father and his brothers, all had a strong, long-lasting influence on my interest in the arts," explained Mr. Fukuhara. "For example, on the sixth day of the sixth month of the year when I became six years old, my parents urged me to take lessons of Nagauta, the long epic songs you hear when you see Kabuki plays. They were taking lessons, so I started to learn from the master who was teaching them. At first I was reluctant, but being the quick learner that I was, I was soon part of a stage rehearsal. My parents praised me for my good performance although I was intimidated before a big audience.

"I went to Keio School for kindergarten and continued there through my university years. I was thrilled when I was accepted into the Keio kindergarten. It was perhaps one of the happiest moments in my life since the new kindergarten building near my house looked like a castle in a fable," recollected Mr. Fukuhara. "I majored in economics at Keio University at my father's strong suggestion, but I really wanted to be a botanist. My father's greenhouse was one of my favorite playgrounds. I was always fascinated by the plants and the flowers that he kept. I also spent considerable time in a forest behind our house. If I wasn't among my father's artist friends or reading in my room, I was in the greenhouse or the forest. Since the university I attended did not have a botany department, I thought medicine might suit my interests. My father opposed this idea. It was a few years after the Pacific War and our country's future was very much uncertain. My father — who worked lifelong for Shiseido alongside his elder brother, Shinzo Fukuhara — convinced me that I should be a businessman.

"Even after I became an economics major I did not give up my love of plants, flowers and insects. I went to hills and fields outside of Tokyo, generally with friends who had similar interests, to search for plants and insects. My role in the group was to record our discoveries with a camera," recalled Mr. Fukuhara. "My father and my uncles were serious photographers. In fact, in 1994 the photographs taken by both of my uncles were shown in the Fondation Cartier pour l'art contemporain in Paris. I acquired their passion in no time. In college I became a member of the Keio Camera Club, and I began selling my photos to sci-

私は目覚めているとき, 夢をみる……*I Dream but Am Awake*

Parallel Visions
Modern Artists and Outsider Art

ence magazines. I kept doing this during the first 10 years that I worked for Shiseido."

Mr. Fukuhara began his career with Shiseido in sales in 1953, immediately after graduating from Keio. He then moved on to product development prior to a three-year assignment to develop new markets for Shiseido products in the United States. He returned to Shiseido's headquarters in 1969 and worked in a variety of positions in the Company before assuming the position of President in 1987. In 1997 he was named Chairman.

"I believe that corporate culture depends on an accumulation of knowledge and experiences of corporate managers and employees. The process of accumulation has to be oriented by the sensitivity and the philosophy of the corporate leader," explained Mr. Fukuhara. "I was the tenth President of Shiseido. Only three out of ten presidents in our one hundred and twenty five-year history were from the Fukuhara family. You might think only the Presidents from the Fukuhara family were keen about the arts. Not so. Each and every one left a remarkable contribution by supporting the arts and by enhancing Shiseido's sense of beauty. Shiseido could not exist without the arts. I have no doubt that this tradition will continue."

In 1990 under Mr. Fukuhara's leadership, Shiseido established a Corporate Culture Department. "The idea for this department was the result of the resounding success of two exhibitions involving Shiseido that were held in Paris in 1986," explained Mr. Fukuhara. One, in the Centre Georges Pompidou, featured Japan's avante-garde arts from 1910 to 1970 and included Shiseido's posters from the 1930s. The other, *Shiseido Beauty and Advertising 1872-1986,* was shown in the Musée de la Publicité.

"It is my firm conviction that corporate culture is the fourth resource necessary for successful corporate management after employees, products and capital," explained Mr. Fukuhara. "I believe it is our corporate culture that differentiates us from our peers and greatly adds to the success of our company. It is the arts that make important and strong bonds — bonds of affection and bonds of friendship — between companies and the people in the markets a company serves. Assisting artists and arts organizations is a contribution to the community that companies can and must make, even more so in the coming years. The arts also stimulate and encourage employees. And, increasingly,

Exhibition posters for "Parallel Visions: Modern Artists and Outsider Art." Opposite: A performance of Sankai Juku.

Shinzo et Roso
Fukuhara

Fondation Cartier pour l'art contemporain

creative young people want to join art-loving companies."

Since 1984 Shiseido has supported the innovative contemporary dance troupe, Sankai Juku, and in 1992 the Company funded a groundbreaking exhibition, *Parallel Visions: Modern Artists and Outsider Art,* which was organized by the Los Angeles County Museum of Art and traveled to museums in Europe before closing in the Setagaya Art Museum in Tokyo. Two years later the Company joined a group to sponsor *Japanese Art After 1945: Screams Against the Sky* in the Guggenheim Museum SoHo, and

"THE COMMUNITY IS ONE OF THE IMPORTANT STAKEHOLDERS AND HAS INDISPUTABLE INFLUENCE UPON THE COURSE OR EVEN THE FATE OF A COMPANY. AS YOU PAY DIVIDENDS TO YOUR STOCKHOLDERS, YOU NEED TO RETURN PART OF YOUR GAINS TO THE COMMUNITY FROM WHICH THEY CAME. BUILDING ALLIANCES WITH THE ARTS IS ONE OF THE STRONGEST CONTRIBUTIONS A COMPANY CAN MAKE TO THE COMMUNITY."

Drawings by Akira Kurosawa in the ISE Foundation Gallery in New York. Shiseido also provides support to a number of music organizations and festivals, including the Sully Music Festival in France.

"I am very interested in contemporary visual art, especially abstract paintings," Mr. Fukuhara continued. "Privately I collect lithographs. I visit museums and galleries very, very often. Our Company operates the Shiseido Gallery in Ginza in Tokyo, an area of the City where there are hundreds of galleries and where we have our headquarters building. Our gallery is the oldest in Japan. During its nearly 80 years of existence we have exhibited the works of more than 5,000 artists. A handsome number who made their debut in our Gallery during its early years are now part of the Country's heritage. We at Shiseido are proud that we supported these artists and we are equally proud that our product designs and some of our commercial posters created 50 years ago are now treated as works of art." In 1985 Shiseido established The Ginza Art Space to introduce subculture fashion, music and illustration and contemporary visual arts to the public. This Space presents as many as 20 exhibitions each year featuring the works of some of Japan's most popular contemporary artists, among them Yasumasa Morimura.

"I also enjoy orchids," said Mr. Fukuhara. "Through them I have made many good friends, among them the former Chancellor of Germany, Helmut Schmidt, and his wife, Hannelore, who is a botanist. My original collection of orchids is from those that my father left me. I used to help him every weekend by watering and caring for the orchids he kept in a greenhouse. Some of these orchids were there when I was born, they grew up with me and they are still with me now in my three greenhouses." Mr. Fukuhara is Chairman of the All Japan Orchid Society and he has also written a book about orchids, *One Hundred Orchids,* which is illustrated with his photographs.

Hoping to interest other companies in the arts, Mr. Fukuhara is the President of the Association for Corporate Support of the Arts (Kigyo Mécénat Kyogikai) — founded in Japan in 1990 to encourage business to support the arts. "Companies can no longer go on by simply pursuing profits." suggested Mr. Fukuhara. "Consideration of economics in management is very important, but it is not enough.

Serious consideration of ethics and aesthetics are becoming an integral part of doing business. The Association is striving to spread this idea. I believe the idea is being accepted by more and more companies. In 1996 the Association conducted a survey which indicated that 94.7% of the responding companies employing 10,000 or more individuals are supporting the arts. This is one of the primary achievements of the Association.

"Even though our Association is relatively young, I believe it has made a difference. It is making the flow of funds more efficient by matching those who want to help with those who need help," he continued. "And, we are encouraging companies, as well as artists, to work together. I believe things are moving in a positive direction. Companies have learned how to support the arts, and as a result, many companies have launched a function dedicated to this purpose. This means that support of the arts is being institutionalized and is therefore less dependent on the interest of an individual business leader. Companies are also becoming more involved with the community. For example, when the devastating earthquake hit the Osaka-Kobe area in 1995, many companies allowed their employees to take a paid leave to join the rescue effort. Another encouraging development occurred in 1990 when the Keidanren, the Japanese Federation of Economic Organizations, established a One Percent Club. In 1995 the members gave roughly $1.3 billion to social activities. As a result of the recent movement in Japan, more companies are involved and joining forces with government agencies and their departments to support many things, including the arts. As a result, larger and better projects are being realized.

"Companies owe so much to the community for their existence," continued Mr. Fukuhara. "The community is one of the important stakeholders and has indisputable influence upon the course or even the fate of a company. As you pay dividends to your stockholders, you need to return part of your gains to the community from which they came. Building alliances with the arts is one of the strongest contributions a company can make to the community. Supporting contemporary arts stimulates employees and leads to the overall growth of the company."

Weaving the Arts Into a Business Strategy

"My interest in photography came from my father, who was a photographer with the U.S. Army during World War I," recollected Walter Y. Elisha, Chairman and Chief Executive Officer of Springs Industries, Inc., a manufacturer and marketer of home furnishings, headquartered in Fort Mill, South Carolina. "Both of my parents immigrated to the United States from the Christian sector of Northern Iran. My mother, along with her family, settled in Chicago as did my father and his brother, both of whom came here to attend school," he continued.

"During World War I, when international communications were difficult, if not impossible, my father decided to

Walter Y. Elisha
Chairman and
Chief Executive Officer

become an American citizen, enlist in the U.S. Army, and provide for his brother until he finished school. My parents subsequently met in Chicago, through a mutual friend, married, and settled there.

"Because of my father's interest in photography, we always had cameras around as we grew up. My brother, Charles, was constantly taking pictures. In fact, when he was about 15, he and my father built a darkroom in our basement. He was editor of the school newspaper, and I remember helping him print pictures for the newspaper in the darkroom. We worked in the glow of the red light. I, too, always owned a camera and took lots of pictures, especially of my children and family. So, when I joined Springs and learned of the Company's connection with photography, I was delighted.

"I went to public schools in Gary, Indiana. They were wonderful. In addition to all our academic courses, we had vocational shops, a rigorous athletic program, plus band and orchestra. Every student had to participate in both athletics and music. My brother, sister, and I also had music at home. My mother and sister played the piano and my brother and I, played the drums. At best, I was a mediocre musician!

"After graduating from Wabash College in Crawfordsville, Indiana, with a degree in economics, I went into the family

business — Oriental rugs and broadloom carpeting. As kids we used to play marbles on Oriental rugs, using the medallions as the pot. Now, the rugs are collected as art," mused Mr. Elisha. "About four years after joining the business, my father died and a friend suggested that I should get an MBA. Some people were interested in buying the business. I told them I would sell it to them — only if I was accepted at Harvard, Columbia or Wharton. I was accepted at all three schools and entered the Harvard Business School that fall. By then I was married, had three children and a mortgage. We packed and moved to Boston. It is a terrific city. We spent a lot of time at the Museum of Fine Arts in Boston and many of the historic sites in the area.

"We settled in Chicago after I graduated from Harvard and I went to work for the Jewel Companies, Inc. Jewel has a rich history of community-oriented management that encouraged its employees to participate in community activities. Over time, I became President of Jewel Food Stores, Inc., which was the biggest division of the Company. From there I went to Springs.

"Part of my attraction to Springs was the Close family, descendants of the Company's founders, which still has controlling ownership of the Company. Spring's approach to business citizenship began with the Company's Founder, Samuel Elliott White, and his son-in-law, Leroy Springs. Elliott White Springs, Leroy's only son, built on the tradition and it has continued through his successors — his son-in-law, Bill Close, as well as Peter Scotese and me, both of us non-family chief executives.

"Elliott Springs was one of those larger-than-life people who had a variety of interests and the financial resources to do what he wanted to do — all of which he did in a unique, distinct, and special way, whether he was renovating his father's house or creating an enclosed swimming pool with beautiful plants.

"In the 1950s when Springs was planning a new corporate headquarters, he talked with Frank Lloyd Wright and others about designing it. He decided things just weren't working out the way he wanted, so he ended up being his own architect. He was also responsible for the famous 1950s advertising campaign for Springmaid sheets. To this day, we continue to get requests for copies of these ads. For

all his flamboyance, though, Elliott cared about his employees. He began profit-sharing, credit unions, health testing and even an art contest in the '40s and '50s.

"I was, and I continue to be, impressed by the Close family's commitment to people and to improving the quality of life of everyone in the communities in which the Company operates. It is a family with a strong sense of community. For example, they are developing an enormous tract of land — about 7,000 acres — between Fort Mill and Charlotte, North Carolina, for public use. About 2,000 acres with riding and walking trails are already in a permanent land trust. The Leroy Springs Foundation, established by Elliott Springs in memory of his father, created and supports, in nearby communities, several sports centers with swimming pools, tennis

Bruno Lucchesi's "Planning for the Future" (detail). Opposite (Top to Bottom): Bruno Lucchesi's "Education;" "Respect for History" (details), Springs Industries headquarters, Fort Mill.

American landscapes, each more than six feet in length. This exhibition was organized by The Museum of Modern Art and traveled to 11 museums throughout the country over a period of two years. Subsequent exhibitions focused on the works of Ansel Adams, Atget, Edouard Baldus, Eugène Cuvelier, Yousuf Karsh, André Kertész, Nadar, Alfred Steiglitz and Garry Winogrand. In 1986 Springs and The Museum of Modern Art inaugurated another series, *New Photography*, to focus on the works of lesser-known photographers from all over the world.

"When we sponsor an exhibition, we invite our people, our customers, our shareholders and artists to attend the exhibition and special gatherings. We often sponsor a book about the photographer's work which we send to our customers and persons important to the Company. People in art circles tell us that Springs was a major figure in advancing this art form long before it was widely accepted — even by the museum world — and that pleases me. It might be said that photography has little to do with our business, but we capture designs and put them on fabric and photography captures visions and puts them on paper. Like the designs on our products, photography is an art form that can be shared readily with many. Our interest in photography has certainly helped us raise our visibility with our customers and with individuals in our operating communities and it is appreciated by many of our 20,000 associates."

In addition to this program, Springs supports a wide range of arts organizations in its operating communities, such as arts councils, museums and schools. The Company also sponsors *Southern Visions*, a regional photography competition that is presented biannually by the Museum of York County in Rock Hill, South Carolina. For 35 years, until 1993, Springs underwrote the annual *Springs Art Show*, which features works by Carolina artists. The Company also played a major role in championing the South Carolina education reform bill, which now provides mandatory arts education in the public schools.

"To celebrate our centennial, we talked about creating a program that conveyed the idea that people mattered and that it is important for each of us to leave the world a little better because of the things we do along the way," continued Mr. Elisha. "Out of this discussion *The Springs of*

Top and Opposite: Children viewing works in the "Springs Art Show," Lancaster, South Carolina.

courts, a baseball diamond, craft facilities and many other activities for people of all ages.

"It was Pete Scotese, my predecessor, who began the Company's photography program. During the 1970s — at a time when there was very little interest in photography as an art — he met John Szarkowski, the Director of the Photography Department of The Museum of Modern Art in New York. They enjoyed talking about photography and Pete respected John's judgment. Pete decided that Springs should become a major sponsor of photography exhibitions, many of which were organized by John. We also received valuable advice from David Finn, not only a fine public relations executive, but an artist and photographer in his own right. He continues to counsel us to this day on our arts programs."

In 1978 Springs formalized its interest in photography by establishing *The Springs of Achievement Series on the Art of Photography*. Through this program Springs supports the presentation of works by a wide range of established and emerging photographers in major museums, including The Museum of Modern Art and The Metropolitan Museum of Art in New York, the National Gallery of Art in Washington, D.C., The Museum of Fine Arts, Houston, and The Art Institute of Chicago. The first exhibition, *Jerry Dantzic and the Cirkut Camera,* included 12 color panoramic photographs of

Achievement program emerged. In 1990 the Company commissioned Bruno Lucchesi to create seven life-size bronze sculptures depicting the seven Springs Achievement values — Quality, Service, Education, Personal and Family Well-Being, Respect for History, Planning for the Future and Creativity.

The first piece in the series, *Quality*, was installed on the grounds of the Company's corporate headquarters in 1992. By 1997 the sixth work, *Respect for History*, was unveiled. Bruno Lucchesi is working on the seventh and final sculpture, *Creativity*, to be installed in 1998. "We installed these works in a park-like setting to encourage our guests and associates and their families to enjoy them," explained Mr. Elisha. "Families picnic near them, children skate past them and some stop and take photographs of them. At graduation time, young people in caps and gowns have their pictures taken near the sculpture, *Education*. It is really something — it's just great!"

Springs also maintains a corporate art collection that includes more than 600 works which are on display in the Company's headquarters, in its Customer Service Center in Lancaster, South Carolina, and its New York offices, as well as in many of its 39 plants. A number of the photographs, drawings, paintings and sculptures in the Collection were created by Carolina artists who participated in the annual *Springs Art Show.*

"During the early 1970s we were one of the first companies to link our products with our interest in the arts," said Mr. Elisha. "We began by working with The Metropolitan Museum of Art to adapt some of the designs in its rich textile collection for the fabrics in some of our home furnishings. We have a royalty agreement with The Met, which has produced millions of dollars for the Museum over the years. It has also enabled the Museum to increase public awareness about its textile collection through the information that accompanies our products.

"I believe what a company does most often represents the interest of the chief executive. If I were a golfer, perhaps we would participate in more golf tournaments than we do!" reflected Mr. Elisha. "Since I have been Chairman we have sponsored at least one photography event each year. From both the business and the community perspective, I think we are spending our money in a constructive way. The world is a

"LIKE THE DESIGNS ON OUR PRODUCTS, PHOTOGRAPHY IS AN ART FORM THAT CAN BE SHARED READILY WITH MANY. OUR INTEREST IN PHOTOGRAPHY HAS CERTAINLY HELPED US RAISE OUR VISIBILITY WITH OUR CUSTOMERS AND WITH INDIVIDUALS IN OUR OPERATING COMMUNITIES."

teeny bit better because of our investment in photography. We take a balanced approach to meeting our responsibilities to our associates, shareholders, customers and communities. By doing so, I believe we do things — sometimes unique things — that would otherwise not get done."

Eli Broad
Chairman and
Chief Executive Officer

SUNAMERICA INC.

Providing Leadership to Yield Cultural Returns

"I HAD LITTLE FORMAL EXPOSURE TO THE ARTS AS A CHILD. HOWEVER, MY PARENTS, WHO WERE LITHUANIAN IMMIGRANTS, PROVIDED AN ENVIRONMENT IN WHICH INTELLECTUAL PURSUITS AND INDEPENDENT THINKING WERE HIGHLY VALUED. THIS GAVE ME A STRONG FOUNDATION FOR APPRECIATING ART AS AN ADULT," EXPLAINED ELI BROAD, CHAIRMAN AND CHIEF EXECUTIVE OFFICER OF SUNAMERICA INC, A FINANCIAL SERVICES COMPANY SPECIALIZING IN RETIREMENT SAVINGS, HEADQUARTERED IN LOS ANGELES, CALIFORNIA.

"MY FATHER WAS A HOUSE PAINTER BEFORE HE CAME TO THIS COUNTRY. ONCE HERE, HE WAS A MERCHANT WHO EVENTUALLY OWNED TWO FIVE-AND-TEN CENT STORES. MY MOTHER WAS A DRESS-MAKER AND DESIGNER. THEY TOOK ME TO MUSEUMS, BUT THEY WERE NOT COLLECTORS," HE CONTINUED. I WAS BORN IN NEW YORK CITY AND RAISED IN MICHIGAN. WE MOVED THERE AT THE BEGINNING OF WORLD WAR II BECAUSE MY PARENTS THOUGHT THAT MICHIGAN — BEING THE CENTER OF THE AIRCRAFT INDUSTRY — WOULD OFFER BETTER OPPORTUNITIES THAN NEW YORK. I GRADUATED FROM

Michigan State University in 1954 with a degree in accounting, and passed the CPA exam when I was 20 years old. My career in accounting was brief because in 1957 Donald Kaufman, a builder and contractor of homes, and I founded Kaufman & Broad Home Corporation in Southern California. Fourteen years later, we acquired Sun Life Insurance Company of America, founded in 1890, which became SunAmerica Inc. And, in 1994 we split the two companies into separate entities, and I retired from the Kaufman & Broad board to focus my energies on SunAmerica," explained Mr. Broad.

"In the early 1970s I met Taft Schreiber, one of the co-founders of The Museum of Contemporary Art in Los Angeles. He was a collector and very knowledgeable about art. He introduced me to museum directors, curators, dealers and artists, and I soon became an avid collector and student of art. My wife, Edythe, and I started our collection in the early 1970s with a drawing by Van Gogh done in 1893 and a painting done by Miró, dated 1933," he recalled. We gravitated toward contemporary art in particular because of its immediacy and energy. Our private collection includes more than 300 paintings, drawings and sculptures from the 1950s to the present. I am particularly fond of works by Roy Lichtenstein, Ellsworth Kelly and Jasper Johns.

"The rapid growth of our collection, led me to establish The Eli Broad Family Foundation in 1984," he continued. "We had run out of wall space at home and much of our collection was going into storage — hardly an ideal venue for art. At the same time, many American museums were undergoing a fiscal crisis and thus having to forego important acquisitions." The Foundation, located in Santa Monica, California, has developed a collection of more than 500 pieces of contemporary art by internationally-recognized twentieth-century artists including John Baldessari, Jean-Michel Basquiat, Jonathan Borofsky, Leon Golub, Hans Haacke, Jenny Holzer, Keith Haring, Anselm Kiefer, Robert Longo, David Salle, Julian Schnable, Cindy Sherman and Terry Winters. In addition to presenting exhibitions in its facilities, the Foundation also maintains an extensive research center for students, art professionals and scholars and lends its works to museums and university art galleries throughout the world. The Broad family underwrites all of the

Foundation's operating and acquisition costs, and has provided the Foundation with a $10 million endowment fund.

"SunAmerica has a collection of works by Southern California artists," noted Mr. Broad. "Southern California is home to literally thousands of artists. In fact, it has the second largest population of artists in the world. As the head of a company based in Los Angeles, I feel a civic responsibility to support this community. I think corporations should always remember that they are more than economic entities. They are members of the community in which they're located, and they should take an active role in enhancing the well-being of the community.

"Our strategy for building this collection is based on strict aesthetic standards and the idea that we would acquire a large quantity of art so that every employee could have art in his or her work area. There is something for the mind and eye everywhere you look. You really can't help but see, think and talk when you're in one of our offices — the art sparks some type of intellectual or emotional reaction in everyone," remarked Mr. Broad. "The curator of this collection conducts tours for employees and guests to give them a more 45informed perspective about each work, the artist and a sense of how the particular works fit in the broader context of the art world.

"I think a key reason we've been able to outpace our competition is because our collection has helped us create a unique corporate culture. I've tried to develop SunAmerica into a company where independent thinkers feel at home, and where new ideas are welcomed, I'm a great admirer of those who can 'think outside the box' — people who have a unique vision of the world and are able to create something valuable from that vision. Artists, as well as talented businesspeople, have that quality. That's probably why art and business coexist so well at SunAmerica.

"Contemporary art is not a passing interest for me. It's a passion that has greatly enhanced my life," acknowledged Mr. Broad. "Consequently, I've devoted a significant part of my life to giving something back to the art world by making meaningful contributions." As part of this effort, Mr. Broad has served as Founding Chairman of The Museum of Contemporary Art (MOCA) in Los Angeles, the second largest museum of its type in the United States. He led the

Museum's $14 million endowment campaign, made a $3 million gift to this effort from The Eli Broad Family Foundation, and secured a number of major works from private collections for the Museum's permanent holdings. In 1995 the Broad family gave MOCA a $1 million grant to support ongoing exhibitions of works from its permanent collection. Mr. Broad also serves on the Executive Committee of the Los Angeles County Museum of Art, is a Board member of The Armand Hammer Museum of Art and Cultural Center at the University of California, Los Angeles, and the Archives of American Art of the Smithsonian Institution, is a member of the International Director's Council of the Solomon R. Guggenheim Museum, and a National Adviser to the High Museum of Art in Atlanta, Georgia, and the Baltimore Museum of Art. In 1996 he became the Chairman of the Walt Disney Concert Hall Board. The new $230 million concert hall, designed by Frank Gehry, to be built across the street from the Dorothy Chandler Pavilion, will be the new home of the Los Angeles Philharmonic and will be the anchor of the cultural district being developed in downtown Los Angeles.

Mr. Broad has also made substantial contributions to foster an interest in the arts in colleges and universities.

The Museum of Contemporary Art, Los Angeles, "Timepieces: Selected Highlights From the Permanent Collection, 1945-1975." Opposite (Top to Bottom): Eli Broad Studios, California Institute of the Arts, Valencia; Tom Otterness' "Rooftop Sculpture Installation," (1995-1996), The Eli Broad Family Foundation, Santa Monica.

In 1992 he gave $300,000 to the California Institute of the Arts in Valencia, California, for the design and construction of 20 artists studios. The following year, he gave Pitzer College in Claremont, California, a $2.5 million grant for the design and construction of two new buildings which form the campus entryway and include an art gallery and a performance space. Three years later, The Eli Broad Family Foundation sponsored a contemporary art internship in the Harvard University Art Museums. The intern was invited to organize and mount an exhibition of works from the Foundation's collection which was shown in Harvard's Fogg Art Museum and in The Forum in St. Louis, Missouri. Mr. Broad also made a record-setting gift of $20 million to the College of Business at Michigan State University. The University's Graduate School of Management bears his name.

"I'm convinced that there's enormous economic potential to be gained from the arts community, if we spend time and energy to create stronger links with business," suggested Mr. Broad. "I'm also convinced that we should look at the 'big picture' potential of this partnership. California has been and will remain one of the world's most powerful economies. It's the hub for high technology, agriculture, trade, finance and those industries that are key drivers of the national and global economy. Los Angeles, in particular, is positioned to become the country's premier city in the coming century. I predict that it will become an international leader in tourism, media and entertainment, and Pacific Rim trade and finance. However, we can't achieve premier status on economic capability alone. We must also have world-class cultural capabilities.

"The industries that will drive L.A.'s economy in the next century, such as high technology and multimedia, will require well-educated, sophisticated persons. It's very likely that the kind of individuals we need and want for Los Angeles place a high value on a rich cultural life. We simply won't be able to attract the best and the brightest if we can't offer them a substantial cultural life in addition to economic opportunities," warned Mr. Broad.

"I believe a coordinated effort by business and arts leaders could produce significant economic and cultural benefits for citizens collectively and individually, now and in the future. SunAmerica strongly supports this effort and encourages others in the business community to join us."

"I BELIEVE A COORDINATED EFFORT BY BUSINESS AND ARTS LEADERS COULD PRODUCE SIGNIFICANT ECONOMIC AND CULTURAL BENEFITS FOR CITIZENS COLLECTIVELY AND INDIVIDUALLY, NOW AND IN THE FUTURE."

Extending Expertise
to Advance the Arts

" My interest in the arts, particularly painting and ballet, began developing when I took literature and aesthetics classes at Rice University while I was studying for a degree in philosophy," reflected Harry M. Reasoner, Managing Partner of Vinson & Elkins L.L.P., a law firm based in Houston, Texas. "After graduating from Rice, I earned a law degree from The University of Texas at Austin," he continued. "In 1962 while attending The University of London on a fellowship to study international law and comparative law of competition and monopoly, I went to the ballet, opera and theater constantly because I was able to purchase tickets for a pound. Those were great days. I learned at least as much in performances as I did in class."

When Mr. Reasoner, a native of San Marcos, Texas, returned to the

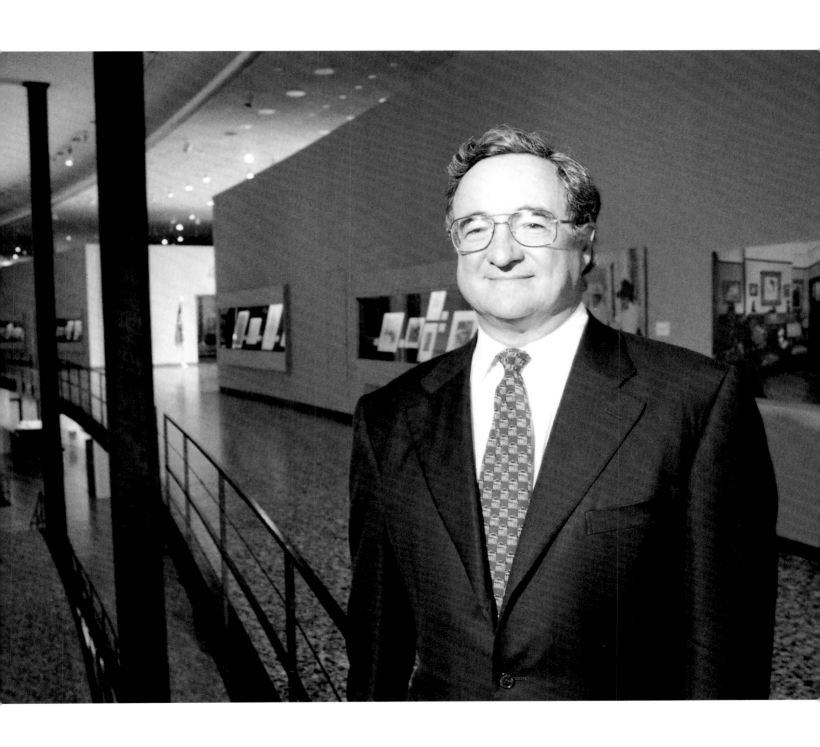

Harry M. Reasoner
Managing Partner

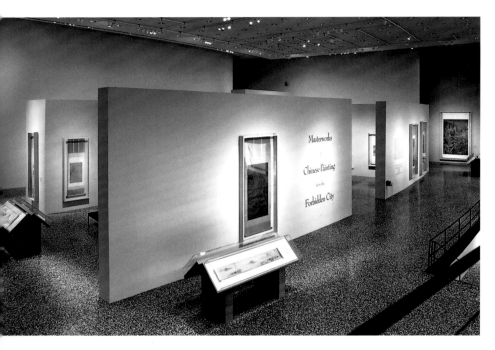

increased substantially. We provide a range of pro bono legal services to all the major cultural organizations in the City, which includes assisting with land acquisitions, securing major gifts, labor relations, contracts, and tax and corporate matters. We also participate actively in fundraising campaigns, strategic planning, and the development of audience expansion and educational programs for the arts. A recent industry survey revealed that we do more for cultural organizations than nearly any other law firm in the country. I think I speak for all of our partners when I say we are extremely proud of what we do for the arts."

Since 1973 Vinson & Elkins has been assisting The Museum of Fine Arts, Houston in a variety of ways. In recent years, the Firm handled legal matters relating to the restoration of the Museum's Bayou Bend facility, as well as the acquisition of land and the design and construction of new buildings, which will enable the Museum to double its exhibition space and expand its conservation and storage areas. "For our seventy-fifth anniversary we purchased a rare daguerreotype of Sam Houston and gave it to the Museum for its permanent collection," explained Mr. Reasoner. During its anniversary year, Vinson & Elkins also underwrote the photography exhibition, *Rescuers of the Holocaust,* presented by the Museum.

States in 1963, he joined Vinson & Elkins and married his wife, Macey. "Macey studied ballet as a girl and was well versed in the arts. We have loved going to performances and exhibitions since the early years of our marriage," he noted. "We are both active with several arts organizations in Houston. I've been a Trustee of The Museum of Fine Arts, Houston and a Director of the Houston Ballet. Macey, who is extremely interested in photography, is a Trustee of The Museum and Co-Chairs its Photography Subcommittee. Macey is also a member of the Board of Directors and an officer of the Houston Ballet. Together, we Co-Chaired the Tenth Anniversary Gala of the Menil Museum.

"Participating in civic affairs and making a contribution to the communities in which we practice law has been a fundamental component of our Firm's culture since we were founded in 1917," explained Mr. Reasoner. "This involvement is personally fulfilling and gives each of us a concrete sense of making a contribution to the community. In recent years, our pro bono work for the arts has

Top to Bottom: The Museum of Fine Arts, Houston, "Masterworks of Chinese Paintings from the Forbidden City;" Holocaust Museum Houston. Opposite: Wortham Theater Center, Houston.

"We take great pride in the role we played in representing the Houston Grand Opera and the Houston Ballet in the development of the Wortham Theater Center," said Mr. Reasoner. In 1983, eight years after undertaking its first pro bono project for the Houston Grand Opera, Vinson & Elkins began a four-year assignment to represent both the Opera and the Ballet in legal and financial matters surrounding the establishment of the Center as a permanent performance venue for both companies. As part of its work on this project, the Firm created a tax-exempt financial structure which was cited by *Institutional Investor* as one of the 10 most innovative tax-exempt financing transactions of 1984. In addition to this project, Vinson & Elkins annually underwrites Houston Grand Opera productions, which have included *Aida, Tosca, Frida, Porgy and Bess* and the 1994 revival of Kurt Weil's *Street Scene.* Additionally, the Firm has sponsored a number of Houston Ballet productions

including *Prodigal Son, The Rite of Spring/Elite Syncopations, Cruel Garden* and *Peer Gynt.*

"When we work with arts organizations we like to help them develop innovative initiatives to achieve their goals, maximize their resources and broaden community participation," continued Mr. Reasoner. In 1991, for example, three lawyers from the Firm were part of the City of Houston/ Harris County Arts Task Force, charged with developing a comprehensive arts and cultural policy for the greater

"ARTS INSTITUTIONS AND THEIR PROGRAMS DEFINE A COMMU-NITY AND ACT AS A UNIFYING FORCE THAT BRING TOGETHER INDIVIDUALS WHO HAVE DIVERSE INTERESTS AND MIGHT NOT OTHERWISE COME TOGETHER."

Houston area. As members of this Task Force, the three spearheaded a successful effort to gain additional support for the arts — in excess of $1.2 million annually — from the City's hotel and motel tax revenues.

Another project in which Vinson & Elkins lawyers assumed a leadership role was the creation of the Houston Arts Education Consortium. By working with the Texas Institute for Arts in Education, the Firm conceptualized and provided advice on structuring the Consortium to coordinate, through one entity, the arts education activities of all the major arts organizations and various local school districts. By doing this, the Consortium eliminates duplicate operating costs, and the participating arts organizations

are able to serve more than 15,000 students annually. In 1992 the National Endowment for the Arts made a major grant to the Consortium and recognized it as a national model. During this same year, Vinson & Elkins also provided the legal services necessary to establish and obtain tax–exemption for the Holocaust Museum Houston. Harry Reasoner served as the Co-Chairman of the Corporate Committee for the Museum's Building Fund, and he and his wife served as Honorary Co-Chairs of the Museum's 1997 Annual Dinner. Additionally, the Firm helped to establish the World Wide (Concurrent) Premieres & Commissioning Fund, Inc. for the purpose of commissioning new musical works and supporting concurrent

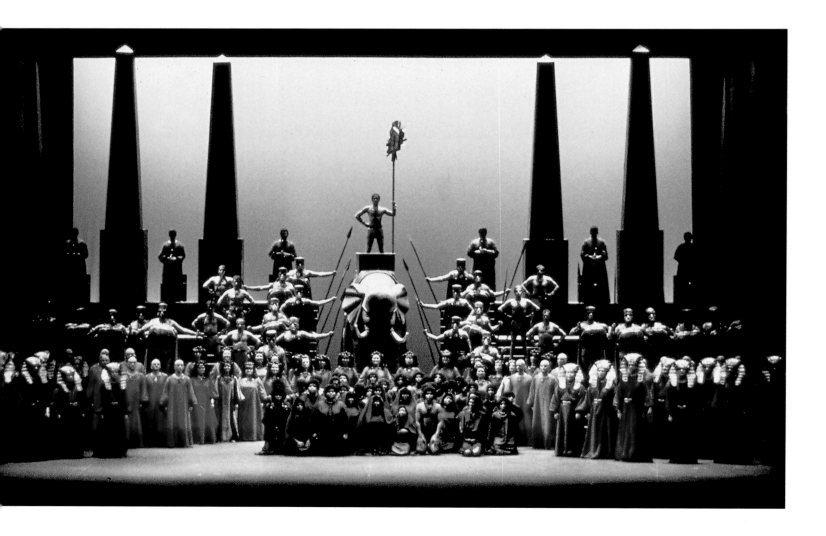

premieres of these works throughout the United States and abroad. As the Fund neared its fifth year of operation, it had commissioned four new works including one by Pulitzer Prize-winning composer John Harbison. These works received more than 200 performances.

In 1993 Vinson & Elkins' lawyers assisted the Houston Museum of Natural Science in structuring an agreement that enabled the Museum to present the first and only exhibition in the United States of gems and jewels owned by the Fersman Mineralogical Museum in Moscow. Simultaneously, the Firm began guiding the Houston Music Hall Foundation with legal and financial issues associated with the development of a new performance hall, theater school and office facility in downtown Houston for Theatre Under the Stars, Houston's civic light opera company.

"Sharing the cultural riches of Houston with our clients and our summer associates, as well as our employees, is also part of our Firm's culture," explained Mr. Reasoner. "We incorporate the arts in our recruiting programs, arrange for discount tickets for our employees to arts presentations and exhibitions, and entertain clients at performances.

"Arts institutions and their programs define a community and act as a unifying force that bring together individuals who have diverse interests and might not otherwise come together," said Mr. Reasoner. "The arts are essential to the quality of life in Houston and to its position as an international city. By providing pro bono legal services to arts organizations we help them realize operating efficiencies and cost savings. It enables them to direct a greater portion of their resources to artistic endeavors, rather than toward overhead and ancillary costs. Everyone benefits."

Documenting the Past
and Exploring the Future

"ART WAS DEFINITELY NOT A PART OF MY LIFE WHEN I WAS A CHILD GROWING UP ON A FARM IN MASSACHUSETTS, NOR DID I HAVE MUCH EXPOSURE TO THE ARTS WHEN I WENT TO ENGINEERING SCHOOL. BUT, I HAD THE GOOD FORTUNE TO MARRY A STUDENT OF THE DECORATIVE ARTS AND TO GET A JOB AS AN ENGINEER IN GERMANY WHERE I WAS SURROUNDED BY GREAT ART. MY CULTURAL EDUCATION BEGAN WITH VISITS TO MOST OF THE GREAT MUSEUMS AND CATHEDRALS IN EUROPE," EXPLAINED PAUL A. ALLAIRE, CHAIRMAN OF THE BOARD AND CHIEF EXECUTIVE OFFICER OF XEROX CORPORATION, A GLOBAL DOCUMENT PROCESSING COMPANY, HEADQUARTERED IN STAMFORD, CONNECTICUT. "WHEN I WAS TRANSFERRED TO ENGLAND, I DISCOVERED THE BALLET," HE CONTINUED. "TO ME, THE ROYAL BALLET IN LONDON WAS MAGIC. MY WIFE AND I WENT TO THE BALLET RELIGIOUSLY AND WE HAVE CONTINUED TO BE

Paul A. Allaire
Chairman of the Board and
Chief Executive Officer

devotees of ballet ever since." In 1990 Mr. Allaire joined the Board of Directors of the New York City Ballet. "At one of our Board meetings I discovered how difficult and complicated it was to schedule rehearsals. Scheduling was the responsibility of one individual artist," explained Mr. Allaire. "After each performance, this individual had to manually determine which dancers needed to rehearse each ballet and in which studio. It was a very complex process that took hours to arrange. The dancers did not know until 10 P.M. or later what they were to rehearse the next day.

"A team of Xerox employees and members of the New York City Ballet staff worked together for six months to set up a system of artificial intelligence to manage all rehearsal scheduling by computer. The artistic staff was most grateful. The project was also a rewarding experience for the Xerox employees involved, many of whom had never been to a ballet performance before working on this project. They learned to appreciate dance and many now attend performances regularly. This creative support we were able to give to the New York City Ballet was particularly satisfying and more valuable than just dollars. We will continue to give more assistance like this and to encourage our employees to assist the arts by volunteering their services and time.

"Another serious interest of mine is photography. My interest in this field began when my wife gave me a birthday present of a Berenice Abbott photograph. Since then I have become a collector and I regularly visit photography exhibitions in museums and galleries, and I attend auctions."

In 1969, three years after Mr. Allaire joined Xerox, the Company announced major underwriting for *New York Painting and Sculpture 1940-1970*. This landmark exhibition, which traveled to 16 museums in the United States and included an extensive educational component, established New York as the successor to Paris as the art capital of the world. In 1978 the Company partnered with the National Endowment for the Humanities to sponsor *Pompeii AD79,* which featured 300 rare examples of Roman art and culture. It traveled to museums in Boston, Chicago, Dallas and New York. Several years later, in 1984, Xerox sponsored the first major exhibition of Jamie Wyeth's work, which was held in the Portland Museum of Art in Portland, Maine. The following year, to celebrate the Centennial of the Statue of Liberty, Xerox sponsored the Museum of American Folk Art exhibition, *Liberties with Liberty*. Previously, the Company supported the Museum's *Access to Art* project which included a series of traveling tactile folk art exhibitions

designed for the blind and visually impaired, plus the *Arts Resource Directory for the Blind and Visually Impaired.*

In 1990 Xerox began a major collaboration with the Smithsonian Institution by making a grant of $500,000 to underwrite *The Information Revolution,* an interactive exhibition that focused on social and cultural changes brought about by the computer age. Two years later, Xerox pledged $100,000 to support the Smithsonian's two-year tour of *Seeds of Change.* This exhibition explored the exchange of peoples, plants, animals and diseases around the globe since the voyages of Columbus. It traveled to 60 libraries and museums throughout the country. In 1996 Xerox provided $1 million in underwriting for *Treasures of the Library,* an exhibition of the original documents from the Library of Congress collection, to be shown in the Library's Great Hall through the year 2000.

To foster greater cross-cultural appreciation, Xerox has funded an array of visual arts projects, including *Ancient Roots/New Visions,* an exhibition examining Hispanic culture, in the Everson Museum of Art of Syracuse and Onondaga County, New York. The Company also supported *Kidsbridge,* a multicultural exhibition presented in The Children's Museum, Inc., in Boston, plus several exhibitions in The Museum for African Art in New York.

In the lobby of its Stamford, Connecticut, headquarters, Xerox maintains a permanent exhibition, *Ten Thousand Years of Recorded Information.* Opened free to the public, it includes items ranging from a printed prayer, dated 770 A.D., to the latest laser printer. The Company also has a corporate art collection of more than 1,100 works that includes a fiber sculpture by Gerhardt Knodel, as well as works by Ilya Bolotosksy and Ansel Adams, most of which are displayed in its headquarters.

Xerox is also a major supporter of the performing arts. In 1986 the Company began co-sponsoring the *Xerox Pianists Program* with the National Endowment for the Arts. This program places talented young pianists in two-week residencies with American symphony orchestras. Additionally, Xerox sponsors the College Preparatory Program of The Harlem School of the Arts in New York; *Introductions,* a program of the Young Concert Artists Series, also in New York; the Young Artists Philharmonic in Stamford,

Connecticut; and *Learning the Language Arts*, a program of Shakespeare & Company in Massachusetts.

During the Nation's Bicentennial, Xerox underwrote The John F. Kennedy Center for the Performing Arts' *Bicentennial Theater* — a series of 10 plays, selected to represent the best in American theater history. The productions, which toured the country following performances at The Kennedy Center, included Eugene O'Neill's *Long Day's Journey Into Night* starring Jason Robards, and Tennessee Williams' *Sweet Bird of Youth* starring Irene Worth.

To encourage artists to explore the use of technology,

"THE ARTS ARE A VITAL PART OF EVERY COMMUNITY. WE FEEL IT IS IMPORTANT FOR US TO PARTICIPATE IN THE CULTURAL LIFE OF THE COMMUNITIES IN WHICH WE OPERATE AND AT THE NATIONAL LEVEL."

pictures made since the mid 1950s; *America: A Personal View*, written and narrated by Alistair Cooke; and *Mission Possible*, a three-part series about ecological problems.

"I'm sure that a CEO's cultural interests always have a bearing on the projects with which the company gets involved. I am particularly interested in The Boys Choir of Harlem. I served on this organization's board during the 1980s. In fact, we have always had a Xerox executive on the board and we have a long history of supporting this organization," said Mr. Allaire.

"The arts are a vital part of every community. We feel it is important for us to participate in the cultural life of the communities in which we operate and at the national level through such institutions as Lincoln Center and The Kennedy Center.

"Our total giving has remained constant in recent years, but requests for support are greater than ever. I think Xerox is the kind of company that will always be involved in the arts. By contributing our skills, as well as our financial resources, we fully expect to maintain our commitment to the arts at the highest possible level."

Top to Bottom: Shakespeare & Company, "Learning the Language Arts," Lenox Memorial High School, Lenox, Massachusetts; Joe Miller's "Our Country Is Free," Museum of American Folk Art, New York Opposite: Xerox headquarters lobby, Stamford.

Xerox funded *Alternative Imaging Systems,* an exhibition featuring works created by artists on Xerox copiers, presented in the Everson Museum of Art of Syracuse and Onondaga County, New York. The Company is also funding a collaboration — *PARC Artists in Residence Program (PAIR)* — which involves collaboration initiatives between Xerox scientists and researchers and artists. Artists participating in this project spend a year in residence at the Palo Alto Research Center (PARC) where they work with scientists and researchers to develop joint projects. In the first collaboration, writer Judy Malloy and scientist Cathy Marshall exchanged information via e-mail and created an electronic book on computer disk.

Xerox was one of the first major sponsors of PBS broadcasts. Over the years the Company has sponsored *Civilization,* a thirteen-part series written and narrated by Sir Kenneth Clark; *Film Odyssey,* a collection of 26 motion

Appendix

BCA Founding Committee — 1967

Roger Blough, *Chairman*
United States Steel
Corporation

Katharine Graham, *President*
Washington Post Company

Devereaux Josephs, *Director*
New York Life Insurance
Company

Gavin K. MacBain, *Chairman*
Bristol-Myers Company

H. Bruce Palmer, *President*
National Industrial
Conference Board

David Rockefeller, *President*
The Chase Manhattan Bank

C. Douglas Dillon, *President*
U.S. and Foreign Securities
Corporation and
Secretary
United States Treasury

BCA Founding Members — 1967

**Bank of America National Trust
and Savings Association**
San Francisco, California

Boise Cascade Corporation
Boise, Idaho

Bristol-Myers Company
New York, New York

The Chase Manhattan Bank
New York, New York

**Colt Industries, Inc., Quincy
Compressor Division**
Quincy, Illinois

**Columbia Broadcasting
System, Inc.**
New York, New York

**Cummins Engine
Company, Inc.**
Columbus, Indiana

Esquire, Inc.
New York, New York

H.J. Heinz Company
Pittsburgh, Pennsylvania

**International Business Machines
Corporation**
Armonk, New York

Kaiser Industries Corporation
Oakland, California

**Manufacturers Hanover
Trust Company**
New York, New York

The Mead Corporation
Atlanta, Georgia

**National Industrial
Conference Board**
New York, New York

**New York Life Insurance
Company**
New York, New York

RCA Corporation
New York, New York

**R.J. Reynolds Tobacco
Company**
Winston-Salem, North Carolina

Time Inc.
New York, New York

Triangle Publications, Inc.
Philadelphia, Pennsylvania

United States Steel Corporation
New York, New York

**United States Trust Company
of New York**
New York, New York

**U.S. and Foreign Securities
Corporation**
New York, New York

Washington Post Company
Washington D.C.

BCA Chairmen — 1967-1997

1967-1970
C. Douglas Dillon

1970-1972
Robert O. Anderson

1972-1974
Frank Stanton

1974-1977
Robert Sarnoff

1977-1979
Gavin K. MacBain

1979-1980
W. H. Krome George

1980-1982
Rawleigh Warner, Jr.

1982-1985
Ralph P. Davidson

1985-1987
Winton M. Blount

1987-1989
Willard C. Butcher

1989-1991
John H. Bryan

1991-1993
John D. Ong

1993-1997
A. Thomas Young

1997- present
David R. Goode

BCA Board Members — 1967-1997

Paul A. Allaire
Xerox Corporation
Member: 1991-95

Hoyt Ammidon
*United States Trust
Company of New York*
Member: 1967-75
Treasurer: 1970-1973

Robert Anderson
*Rockwell International
Corporation*
Member: 1984-87

Robert O. Anderson
Atlantic Richfield Company
Member: 1968-86
Chairman: 1970-72
Vice Chairman: 1972-74

Warren M. Anderson
Union Carbide Corporation
Member: 1980-86

Charles L. Andes
Franklin Mint Corporation
Member: 1977-79

Walter H. Annenberg
Triangle Publications, Inc.
Member: 1967-73

Harry Hood Bassett
Southeast Banking Corporation
Member: 1977-84

James F. Beré
Borg-Warner Corporation
Member: 1982-87

Spencer H. Blain, Jr.
First Federal Savings
Member: 1980-82

Roger M. Blough
United States Steel Corporation
Member of Founding Committee
Member: 1967-77

Winton M. Blount
Blount International, Inc.
Member: 1980-present
Chairman: 1985-87
Secretary: 1984-85
Chairman of the Executive
Committee: 1987-89

Thornton F. Bradshaw
RCA Corporation
Member: 1982-86

John H. Bryan
Sara Lee Corporation
Member: 1987-present
Chairman: 1989-91
Vice Chairman: 1988-89
Chairman of the Executive
Committee: 1991-93

James E. Burke
Johnson & Johnson
Member: 1982-86

Robert A. Burnett
Meredith Corporation
Member: 1987-92

M. Anthony Burns
Ryder System, Inc.
Member: 1988-present

Willard C. Butcher
The Chase Manhattan Bank
Member: 1985-present
Chairman: 1987-89
Vice Chairman: 1985-87
Chairman of the Executive
Committee: 1989-91

Robert Cizik
Cooper Industries, Inc.
Member: 1984-95

John L. Clendenin
BellSouth Corporation
Member: 1991-96

Ralph P. Davidson
Time Inc.
Member: 1981-88
Chairman: 1982-85
Vice Chairman: 1981-82
Chairman of the Executive
Committee: 1985-87

Robert F. Dee
SmithKline Corporation
Member: 1982-84

Mathias J. DeVito
The Rouse Company
Member: 1984-96

John P. Diesel
Tenneco Inc.
Member: 1984-88
Secretary: 1985-88

C. Douglas Dillon
U.S. and Foreign Securities
Corporation
Member of Founding Committee
Chairman: 1967-70
Member: 1967-80

Michael D. Dingman
Shipston Group Ltd.
Member: 1981-95

Hedley W. Donovan
Time Inc.
Member: 1967-72

Albert R. Dowden
Volvo North America Corporation
Member: 1993-present

Roger H. Eigsti
SAFECO Corporation
Member: 1993-95

Paul H. Elicker
SCM Corporation
Member: 1978-88

W. Leonard Evans, Jr.
Tuesday Publications, Inc.
Member: 1973-77

David Finn
Ruder•Finn, Inc.
Member: 1990-present
Treasurer: 1990-present

Christopher Forbes
Forbes Inc.
Member: 1991-present

Alexander H. Galloway
R.J. Reynolds Industries, Inc.
Member: 1967-72, 1974-75

W.H. Krome George
Aluminum Company of America
Member: 1978-84
Chairman: 1979-80
Vice Chairman: 1980-81

Arnold Gingrich
Esquire, Inc.
Member: 1967-77

David R. Goode
Norfolk Southern Corporation
Member: 1993-present
Chairman: 1997-present
Vice Chairman: 1995-present

Katharine Graham
Washington Post Company
Member of Founding Committee
Member: 1967-75

Harry J. Gray
United Technologies Corporation
Member: 1981-86

Najeeb E. Halaby
Pan American
World Airways, Inc.
Member: 1972-75

Armand Hammer
Occidental Petroleum Corporation
Member: 1980-89

R. Philip Hanes, Jr.
Ampersand, Incorporated
Member: 1980-86

Robert V. Hansberger
Boise Cascade Corporation
Member: 1967-73

Arthur L. Harris
Scripto, Inc.
Member: 1967-80

Gabriel Hauge
Manufacturers Hanover
Trust Company
Member: 1967-79

Henry J. Heinz II
H.J. Heinz Company
Member: 1967-81

James A. Helzer
Unicover Corporation
Member: 1980-81

William A. Hewitt
Deere and Company
Member: 1975-82

James R. Houghton
Corning Incorporated
Member: 1973-96

Theodore M. Hutchison
The Principal Financial Group
Member: 1995-97

George M. Irwin
Colt Industries,
Quincy Compressor Division
Member: 1967-71

Judith A. Jedlicka
Business Committee
for the Arts, Inc.
President: 1982-present

Devereaux C. Josephs
New York Life Insurance Company
Member of Founding Committee
Member: 1967-74
Treasurer: 1967-70

Edgar F. Kaiser
Kaiser Industries Corporation
Member: 1967-73

Donald M. Kendall
PepsiCo Inc.
Member: 1981-present

John Kirkpatrick
Kirkpatrick Oil Company
Member: 1977-80

Allen J. Krowe
Texaco Inc.
Member: 1993-96

Duane R. Kullberg
Arthur Andersen & Company
Member: 1987-90

R. Heath Larry
United States Steel Corporation
Member: 1973-80

Harding L. Lawrence
Braniff International
Member: 1975-80

Gavin K. MacBain
Bristol-Myers Company
Member of Founding Committee
Member: 1967-79
Chairman: 1977-79
Vice Chairman: 1976-77

Robert H. Malott
FMC Corporation
Member: 1985-90

Donald B. Marron
PaineWebber Group Inc.
Member: 1991-96

Leslie G. McCraw
Fluor Corporation
Member: 1993-present

Goldwin A. McLellan
Business Committee
for the Arts, Inc.
President: 1967-79

Ruben F. Mettler
TRW Inc.
Member: 1982-87

Michael A. Miles
Philip Morris Companies Inc.
Member: 1991-93

J. Irwin Miller
Cummins Engine Company, Inc.
Member: 1967-82

Raymond D. Nasher
The Nasher Company
Member: 1987-present
Secretary: 1988-present

John D. Ong
The BFGoodrich Company
Member: 1989-present
Chairman: 1991-93
Vice Chairman: 1989-91
Chairman of the Executive
Committee: 1993-96

H. Bruce Palmer
National Industrial
Conference Board
Member of Founding Committee
Member: 1967-74
Secretary: 1967-73

Russell E. Palmer
Touche Ross & Company
Member: 1973-84
Secretary: 1973-84

Charles W. Parry
Aluminum Company
of America
Member: 1984-87

Rudolph A. Peterson
Bank of America National Trust
and Savings Association
Member: 1967-73

Richard I. Purnell
Johnson & Higgins
Member: 1980-82

Harry M. Reasoner
Vinson & Elkins L.L.P.
Member: 1995-present

H. John Riley, Jr.
Cooper Industries, Inc.
Member: 1997-present

James E. Robison
Indian Head, Inc.
Member: 1973-80

David Rockefeller
The Chase Manhattan Bank
Member of Founding Committee
Member: 1967-80

James E. Rogers
Cinergy Corp.
Member: 1996-present

George S. Rosborough, Jr.
The Measuregraph Company
Member: 1973-82

William Ruder
Ruder•Finn, Inc.
Member: 1973-90
Treasurer: 1973-90

Robert W. Sarnoff
RCA Corporation
Member: 1967-82
Chairman: 1974-77
Vice Chairman: 1977-79

Henry T. Segerstrom
C.J. Segerstrom & Sons
Member: 1984-present

George C. Seybolt
William Underwood Company
Member: 1975-82

Virginia Kilpatrick Shehee
Kilpatrick Life Insurance
Company of Louisiana
Member: 1977-91

Andrew C. Sigler
Champion International
Corporation
Member: 1987-91

Frank Stanton
Columbia Broadcasting
System, Inc.
Member: 1967-77
Chairman: 1972-75
Vice Chairman: 1975-76

Edward M. Strauss, Jr.
Business Committee
for the Arts, Inc.
President: 1979-82

David S. Tappan, Jr.
Fluor Corporation
Member: 1982-91

Robert J. Ulrich
Dayton Hudson Corporation
Member: 1995-present

Rawleigh Warner, Jr.
Mobil Corporation
Member: 1973-87
Chairman: 1980-82
Vice Chairman: 1979-80,
1982-85

Thomas J. Watson, Jr.
International Business
Machines Corporation
Member: 1967-75

Helge H. Wehmeier
Bayer Corporation
Member: 1996-present

George Weissman
Philip Morris Companies Inc.
Member: 1982-93

Charles Wohlstetter
Contel
Member: 1972-88

William S. Woodside
American Can Company
Member: 1982-88

A. Thomas Young
Lockheed Martin Corporation
Member: 1991-present
Chairman: 1993-96
Vice Chairman: 1992-93

Business in the Arts Awards

The Business in the Arts Awards were first presented in 1967. The Business Committee for the Arts, Inc. (BCA) and *FORBES* Magazine have sponsored the Awards since 1977. From 1968 until 1976, the Awards were sponsored by BCA and *Esquire* magazine. In 1992, on the occasion of the 25th Anniversary of the Business Committee for the Arts, the Founders Award was established to recognize companies for their exceptional leadership, vision, and commitment in the development of alliances with the arts. In 1993, the Leadership Award was established to recognize a business leader who has demonstrated exceptional leadership, vision and commitment in developing and encouraging business-arts alliances.

Company	Year(s) Received
1776, Inc. *San Antonio, Texas*	1982
Abraham & Straus *Brooklyn, New York*	1969, 1971
Acoustic Research, Inc. *Cambridge, Massachusetts*	1970
Adolph's Food Products *Burbank, California*	1972, 1973, 1974
Advertiser Company *Montgomery, Alabama*	1996
Aetna Life and Casualty Company *Hartford, Connecticut*	1978
The Air Preheater Company, Inc. *Wellsville, New York*	1969, 1971
Alaska Airlines, Inc. *Seattle, Washington*	1982
Alexander & Baldwin, Inc. *Honolulu, Hawaii*	1988
Allegheny International, Inc. *Pittsburgh, Pennsylvania*	1983
Allendale Mutual *Insurance Company* *Johnston, Rhode Island*	1974
Allied Signal, Inc. **(formerly Allied** **Chemical Corporation)** *Morristown, New Jersey*	1977
Allstate Insurance Company *Northbrook, Illinois*	1977, 1979, 1980, 1981
ALPO Petfoods, Inc. *Allentown, Pennsylvania*	1974
Aluminum Company of America/ **ALCOA Foundation** *Pittsburgh, Pennsylvania*	1971, 1976, 1977, 1978, 1979,1980, 1981, 1982, 1984
American Airlines, Inc. *Dallas-Fort Worth, Texas*	1967, 1970
American Express Company *New York, New York*	1980, 1982, 1983, 1985, 1986, 1987, 1990
American Fletcher National Bank *Indianapolis, Indiana*	1976, 1977
American National **Insurance Company** *Galveston, Texas*	1977
American Oil Company *Chicago, Illinois*	1972
American Red Ball **Transit Company** *Indianapolis, Indiana*	1977
American Savings Bank *New York, New York*	1974
Ameritech *Chicago, Illinois*	1986, 1987, 1988
Amoco Corporation (formerly **Standard Oil Company of Indiana)** *Chicago, Illinois*	1976, 1977
Amway Corporation *Grand Rapids, Michigan*	1983
Ann Arbor Railroad Company *Dearborn, Michigan*	1973
ARAMARK Corporation *Philadelphia, Pennsylvania*	1995
Ashland Oil, Inc. *Ashland, Kentucky*	1980
AT&T *New York, New York*	1968, 1980, 1981, 1983, 1984, 1985, 1986, 1987, 1988, 1989, 1990
Atlantic Cement Company, Inc. *Stamford, Connecticut*	1975
Atlantic Richfield Company **& Atlantic Richfield Foundation** *Los Angeles, California*	1971, 1975, 1976, 1977, 1978, 1979, 1980, 1981, 1982, 1983, 1984, 1985
Atlantic Richfield **Hanford Company** *Richland, Washington*	1969
Avco Broadcasting Corporation *Cincinnati, Ohio*	*1970*
Avco Delta *Shaker Heights, Ohio*	*1970*
P. Ballantine & Sons *Newark, New Jersey*	1968
Bank Hapoalim B.M. *Tel Aviv, Israel*	1982
Bank of Boston *Boston, Massachusetts*	1990
Bank of Maryville *Maryville, Tennessee*	1973

Bank One, Greeley (formerly Affiliated National Bank of Greeley) *Greeley, Colorado*	1991	**Boston Globe** *Boston, Massachusetts*	1978
BankAmerica Corporation *San Francisco, California*	1974, 1980, 1985	**Boston Herald Traveler Corporation** *Boston, Massachusetts*	1967, 1971
Bankers Life Nebraska *Lincoln, Nebraska*	1974, 1977	**Boston Store** *Erie, Pennsylvania*	1974
Barnett Bank of Jacksonville, N.A. *Jacksonville, Florida*	1984, 1986, 1987	**Bozell Inc. (formerly Bozell, Jacobs, Kenyon & Eckhardt)** *New York, New York*	1987
Battelle Memorial Institute *Columbus, Ohio*	1980	**Bravo, The Film and Arts Network** *Woodbury, New York*	1995
Batz-Hodgson-Neuwoehner, Inc. *St. Louis, Missouri*	1971	**Bridgeman's Ice Cream Parlor & Restaurant** *Minneapolis, Minnesota*	1981
Baxter Hospital Supply (formerly American Hospital Supply Corporation) *McGaw Park, Illinois*	1983	**Bristol-Myers Squibb Company (formerly Bristol-Myers Company)** *New York, New York*	1974
Bayer USA Inc. *Pittsburgh, Pennsylvania*	1989	**Broad Inc. (formerly Kaufman & Broad, Inc.)** *Los Angeles, California*	1984
Beatrice Foods Companies, Inc. *Chicago, Illinois*	1981, 1982	**Brown-Forman Corporation** *Louisville, Kentucky*	1981, 1985
Bell Atlantic Corporation *Arlington, Virginia*	1985	**Bryant and Stratton Commercial School, Inc.** *Boston, Massachusetts*	1969
BellSouth Corporation *Atlanta, Georgia*	1989, 1990	**Burger Chef Systems, Inc.** *Indianapolis, Indiana*	1968
Bickert, Browne, Coddington & Associates *Denver, Colorado*	1973	**Burlington Industries, Inc.** *Greensboro, North Carolina*	1969
Binney & Smith *Easton, Pennsylvania*	1987	**Burlington Northern Inc.** *Seattle, Washington*	1983
Bird & Son, Inc. *East Walpole, Massachusetts*	1976	**Burroughs Wellcome Company** *Research Triangle Park, North Carolina*	1981
Blount, Inc. *Montgomery, Alabama*	1979, 1983, 1985, 1986	**The Business Alliance for the Theatre** *Las Cruces, New Mexico*	1982
The Boeing Company *Seattle, Washington*	1990, 1997	**C&P Telephone Company** *Washington, D.C.*	1989
Boise Cascade Corporation *Boise, Idaho*	1971, 1982	**Calvert Distillers Company** *New York, New York*	1974
BOORA Architects, Inc. *Portland, Oregon*	1997	**Canandaigua Wine Company** *Canandaigua, New York*	1980
Borg-Warner Corporation *Chicago, Illinois*	1974, 1977		
Boscov's Department Stores, Inc. *Reading, Pennsylvania*	1972		

Cantor, Fitzgerald Group, Ltd. _New York, New York_	1979	Chesebrough-Pond's Inc. _Greenwich, Connecticut_	1974, 1978, 1982
Capitol Broadcasting Co. _Raleigh, North Carolina_	1968	Chevron Corporation (formerly Standard Oil Company of California) _San Francisco, California_	1972, 1974, 1977, 1981, 1982, 1983, 1993
Capitol Newspapers _Albany, New York_	1970	Chicago and North Western Railway _Chicago, Illinois_	1973
Carborundum Company _Niagara Falls, New York_	1971	The Chicago Tribune _Chicago, Illinois_	1968
Cardinal Industries Incorporated _Columbus, Ohio_	1985, 1987	Chicago, Milwaukee, St. Paul and Pacific Railroad _Chicago, Illinois_	1973
Cargill, Incorporated _Minnetonka, Minnesota_	1982	Chubb LifeAmerica _Concord, New Hampshire_	1986, 1993
Carillon Importers Ltd. _Teaneck, New Jersey_	1993	Chubu-Nippon Broadcasting Company _Nagoya, Japan_	1976
Carling Brewing Company _Tacoma, Washington_	1968	CIBA-GEIGY Corporation _Ardsley, New York_	1968, 1972, 1976, 1977
Carnation Company _Los Angeles, California_	1971	CIGNA Corporation _Philadelphia, Pennsylvania_	1982, 1983, 1984, 1985
Carnival Cruise Lines _Miami, Florida_	1984	Circle Centre Development Company _Indianapolis, Indiana_	1996
Cartier, Inc. _New York, New York_	1996	Citibank (New York State) _Rochester, New York_	1987
Castle & Cooke, Inc. _Honolulu, Hawaii_	1967	Citibank, N.A. _New York, New York_	1976, 1981, 1990
CBS Inc. _New York, New York_	1975, 1976, 1978, 1979, 1980, 1984	Cities Service Company _Tulsa, Oklahoma_	1980
Celanese Corporation _New York, New York_	1979	Citizens Fidelity Corporation _Louisville, Kentucky_	1981
Central Carolina Bank & Trust Company _Durham, North Carolina_	1980	City National Bank of Baton Rouge _Baton Rouge, Louisiana_	1986
Central National Bank of Cleveland _Cleveland, Ohio_	1975, 1977	Clorox Company _Oakland, California_	1980
The Central Trust Company, N.A. _Cincinnati, Ohio_	1986	Club Cal-Neva _Reno, Nevada_	1982
Champion International Corporation _Stamford, Connecticut_	1977, 1982	CNG Producing Company _New Orleans, Louisiana_	1986
The Chase Manhattan Bank, N.A. _New York, New York_	1970, 1976, 1977, 1980, 1982	The Coca-Cola Company _Atlanta, Georgia_	1978
Chelsea Place Restaurant _New York, New York_	1984	Colony House Enterprises, Inc. _Charleston, South Carolina_	1993
Chemical Bank _New York, New York_	1978, 1992		
Chesapeake and Ohio _Cleveland, Ohio_	1973		

Colorado National Bank *Denver, Colorado*	1974	**Crocker-Citizens National Bank** *San Francisco, California*	1971
Columbia Gas of Pennsylvania *Pittsburgh, Pennsylvania*	1968	**Crouse-Hinds Company** *Syracuse, New York*	1977
Columbus National Bank *Providence, Rhode Island*	1967	**Cummins Engine Company, Inc.** *Columbus, Indiana*	1968
Commerce Bank and Trust *Topeka, Kansas*	1992	**The Daily News** *New York, New York*	1971
Commerce Union Bank *Nashville, Tennessee*	1980, 1982	**The Dallas Morning News** *Dallas, Texas*	1981
Commonwealth Companies, Inc. *Lincoln, Nebraska*	1983	**Dallas Times Herald** *Dallas, Texas*	1980, 1982, 1983
Commonwealth Edison Co. *Chicago, Illinois*	1967	**Day Companies, Inc.** *Memphis, Tennessee*	1979
Community Federal Savings **& Loan Association** *Philadelphia, Pennsylvania*	1974	**Days Inns of America** *Atlanta, Georgia*	1982
Compos-it, Inc. *Montgomery, Alabama*	1984	**Dayton Hudson Corporation** *Minneapolis, Minnesota*	1967, 1971, 1981, 1983, 1984, 1985, 1986, 1987, 1988, 1989, 1990, 1991
Consolidated Edison **of New York, Inc.** *New York, New York*	1972, 1974, 1976, 1977, 1978, 1981, 1987	**Deere and Company** *Moline, Illinois*	1969, 1976
Container Corporation of America *Chicago, Illinois*	1967, 1969	**Deseret News** *Salt Lake City, Utah*	1984
Contel Corporation *Atlanta, Georgia*	1987	**Detroit and Mackinac Railway** *Tawas City, Michigan*	1973
Continental Financial **Services Company** **(Continental Group's Insurance Division)** *Richmond, Virginia*	1981	**The Detroit Edison Company** *Detroit, Michigan*	1969
		Detroit Free Press *Detroit, Michigan*	1981
Continental Illinois National Bank *Chicago, Illinois*	1984	**Detroit, Toledo and** **Ironton Railroad Co.** *Dearborn, Michigan*	1973
Cooper Industries, Inc. *Houston, Texas*	1983	**Diamond's Department Stores** *Tempe, Arizona*	1983
Corning Incorporated/ **Corning Incorporated Foundation** **(formerly Corning Glass Works &** **Corning Glass Works Foundation)** *Corning, New York*	1975, 1976, 1977, 1978, 1979, 1980, 1981, 1982, 1983, 1986, 1994	**Digital Equipment Corporation** *Maynard, Massachusetts*	1985, 1986, 1987
		Dillingham Corporation *Honolulu, Hawaii*	1971
Courier-Journal & **Louisville Times Company** *Louisville, Kentucky*	1970, 1981, 1984	**Walt Disney Productions, Inc** *Burbank, California*	1970
		Dominion Bankshares Corporation *Roanoke, Virginia*	1989
CRESTAR Bank **(formerly United Virginia Bank)** *Norfolk, Virginia*	1987	**Dow Corning Corporation** *Midland, Michigan*	1973

E.I. du Pont de Nemours & Company			
Wilmington, Delaware	1980	The Fidelity Bank	
Philadelphia, Pennsylvania	1971		
Eastern Air Lines Incorporated			
Miami, Florida	1968	First American Bank of Virginia	
McLean, Virginia	1982		
Eastman Kodak Company			
Rochester, New York	1971, 1978	First Bank System, Inc.	
Minneapolis, Minnesota	1987, 1988		
EBSCO Industries, Inc.			
Leeds, Alabama	1985	First Federal Savings	
and Loan Association			
Milwaukee, Wisconsin	1970		
Eli Lilly and Company			
Indianapolis, Indiana	1970, 1996	First Florida Banks, Inc.	
Tampa, Florida	1988		
El Paso Natural Gas Company			
El Paso, Texas	1987, 1988	First Interstate Bank	
of California Foundation			
Los Angeles, California	1983		
El Paso Products Company			
Odessa, Texas	1967	The First National Bank of Atlanta	
Atlanta, Georgia	1971		
Electronic Data Systems Corporation			
Dallas, Texas	1978	The First National Bank of Chicago	
Chicago, Illinois	1972		
Embarcadero Center			
San Francisco, California	1975	The First National Bank of Cincinnati	
Cincinnati, Ohio	1975		
Emerson Electric Company			
St. Louis, Missouri	1977, 1978, 1980	First National Bank of Louisville	
Louisville, Kentucky	1986		
Enron Corp.			
(formerly Northern Natural			
Gas Company and Internorth, Inc.)			
Houston, Texas	1977, 1983, 1986	First National Bank of Midland	
Midland, Texas	1973		
Entergy Corporation			
New Orleans, Louisiana	1994	The First National Bank	
of Montgomery			
Montgomery, Alabama	1972		
The Equitable Life Assurance			
Society of the United States			
New York, New York	1982	First National Bank of Pulaski	
Pulaski, Tennessee	1989		
The Equitable Trust Company			
Baltimore, Maryland	1971	First Security Bank of Idaho, N.A.	
Boise, Idaho	1975		
Esmark, Inc.			
Chicago, Illinois	1984	First Tennessee Bank of Memphis	
Memphis, Tennessee	1980		
Evans Products Company			
Portland, Oregon	1981	First Union National Bank	
Charlotte, North Carolina	1980		
Exchange National Bank of Chicago			
Chicago, Illinois	1974	First Vermont Bank	
Brattleboro, Vermont	1982		
Exxon Corporation (formerly			
Standard Oil Company of New Jersey)			
Plano, Texas	1972, 1973, 1974, 1975,		
1976, 1977, 1978, 1979,			
1980, 1981, 1982, 1983,			
1984, 1985, 1986	First South, F.A.		
Pine Bluff, Arkansas	1986		
		Flanigan's	
Rochester, New York	1974, 1975, 1979		
Famous-Barr Company			
St. Louis, Missouri	1968, 1969, 1970, 1972	Florida National Bank	
Jacksonville, Florida	1987		
Fayette Bank and Trust Company			
Uniontown, Pennsylvania | 1967, 1971 | Fluor Corporation
Irvine, California | 1982, 1983, 1984, 1985 |

Award Recipients 1967-1997 *(continued)*

Foley's
Houston, Texas
1969

Ford Motor Company
Dearborn, Michigan
1970, 1974, 1976, 1978, 1980, 1985, 1988

Frank Russell Company
Tacoma, Washington
1997

Franklin Mint Corporation
Franklin Center, Pennsylvania
1976, 1977

Freedom National Bank of New York
New York, New York
1981

Freeport-McMoRan Inc.
New Orleans, Louisiana
1992

Frisch's Restaurants, Inc.
Cincinnati, Ohio
1975

H.B. Fuller Company
St. Paul, Minnesota
1977

GAF Corporation
New York, New York
1977

Gannett Newspaper Foundation
Rochester, New York
1978

General Electric Co.
Fairfield, Connecticut
1973, 1976, 1979, 1985

General Mills
Minneapolis, Minnesota
1978, 1980, 1991

General Motors Corporation
Detroit, Michigan
1986, 1987

Genesee Brewing Company
Rochester, New York
1977

Getty Oil Company
Los Angeles, California
1982, 1983

Geyer Printing Co., Inc.
Pittsburgh, Pennsylvania
1987

GFI/Knoll International
New York, New York
1980

GHK Gas Corporation
Oklahoma City, Oklahoma
1982

**Gibson & Silkworth,
Architects & Associates, Inc.**
Vero Beach, Florida
1985

Girard Bank
Philadelphia, Pennsylvania
1971

Glendale Federal Savings
Glendale, California
1972

Good Citizens Life Insurance Company
New Orleans, Louisiana
1973

The BFGoodrich Company
Akron, Ohio
1970

**The Goodyear Tire &
Rubber Company**
Akron, Ohio
1973

Grand Trunk Western Railroad
Detroit, Michigan
1973

The Great Frame Up Systems, Inc.
Franklin Park, Illinois
1997

**Greater New Haven
Chamber of Commerce**
New Haven, Connecticut
1982

GTE Corporation
Stamford, Connecticut
1984, 1985

Gulf Oil Corporation
Pittsburgh, Pennsylvania
1976, 1977

Gwinnett Industries, Inc.
Decatur, Georgia
1986

Hallmark Cards, Inc.
Kansas City, Missouri
1970, 1971, 1974

Hamel Real Estate, Inc.
Chocorua, New Hampshire
1987

John Hancock Financial Services
Boston, Massachusetts
1991

Hanes Dye and Finishing Company
Winston-Salem, North Carolina
1967, 1969, 1972, 1978, 1979, 1982

The Hartford Courant
Hartford, Connecticut
1987, 1988

The Hartford Insurance Group
Hartford, Connecticut
1983

Hearst Corporation
New York, New York
1974

The Heathman Hotel
Portland, Oregon
1997

Heery & Heery, Architects & Engineers
Atlanta, Georgia
1975

The Herald-Sun
Durham, North Carolina
1996

Hewlett Packard Company
Palo Alto, California
1982

Holiday Inn, Suwanee
Suwanee, Georgia
1987

Home Federal Savings & Loan Association *San Diego, California*	1979	Johnson & Johnson *New Brunswick, New Jersey*	1992
Home Federal Savings & Loan Association *Columbia, South Carolina*	1972	S.C. Johnson & Son, Inc. *Racine, Wisconsin*	1970
The Honolulu Advertiser *Honolulu, Hawaii*	1968	Jones & Pellow Oil Company *Oklahoma City, Oklahoma*	1977
The Hoover Company *North Canton, Ohio*	1973	J.A. Jones Construction Company *Charlotte, North Carolina*	1981
William R. Hough & Company *St. Petersburg, Florida*	1978, 1984	Kaiser Aluminum & Chemical Corporation *Oakland, California*	1969, 1981
Houston National Bank *Houston, Texas*	1972	Kaiser Permanente *Portland, Oregon*	1986
The J.L. Hudson Company *Detroit, Michigan*	1979, 1984	Karlsberger and Associates, Architects Inc. *Columbus, Ohio*	1974
Humana Incorporated *Louisville, Kentucky*	1980, 1982, 1984 1987, 1995	Karmazin Products Incorporated *Wyandotte, Michigan*	1981
Hunt Manufacturing Co. *Philadelphia, Pennsylvania*	1988	Kelton Mathes Development Corporation *Arlington, Texas*	1986
E.F. Hutton & Company Inc. *New York, New York*	1987	Kemper Insurance Companies *Long Grove, Illinois*	1976
IBM Corporation *Armonk, New York*	1967, 1973, 1974, 1975, 1976, 1977, 1978, 1979, 1980, 1981	KFAC AM/FM *Los Angeles, California*	1978
Illinois Bell *Chicago, Illinois*	1968, 1986	King Unlimited Advertising *Loveland, Colorado*	1994
The Indiana National Bank *Indianapolis, Indiana*	1973, 1975, 1978	Kirkpatrick Oil Company *Oklahoma City, Oklahoma*	1975, 1976
International Minerals and Chemical Corporation *Northbrook, Illinois*	1980	Knight Publishing Company *Charlotte, North Carolina*	1973
International Multifoods Corporation *Minneapolis, Minnesota*	1978	Koger Properties, Inc. *Jacksonville, Florida*	1986
International Paper Company *Purchase, New York*	1981	Kohler Co. *Kohler, Wisconsin*	1974
Interway Corporation *New York, New York*	1979	The Koll Company *San Jose, California*	1983
The Irvine Company *Newport Beach, California*	1985, 1986, 1989	KRON-TV Channel 4 Chronicle Broadcasting Company *San Francisco, California*	1974
ITT Corporation *New York, New York*	1978, 1979, 1981, 1985	KTEW-Channel 2 *Tulsa, Oklahoma*	1973
Jaeger Development Company *Cerritos, California*	1992, 1993	Ledler Corporation *Burbank, California*	1975
Johns-Manville Corporation *Denver, Colorado*	1972	Lever Brothers Company *New York, New York*	1977

Award Recipients 1967-1997 (continued)

Lexus *Torrance, California*	1992	**McGraw-Hill, Inc.** *New York, New York*	1970
The Liberty Corporation *Greenville, South Carolina*	1981	**McKesson Corporation** *San Francisco, California*	1984
Liberty National Bank and Trust Company of Louisville *Louisville, Kentucky*	1978	**The Mead Corporation** *Dayton, Ohio*	1967
Liggett Group Inc. *Durham, North Carolina*	1997	**Measuregraph Company** *St. Louis, Missouri*	1970
Lincoln Bank *Philadelphia, Pennsylvania*	1972	**Merchants Savings Bank** *Manchester, New Hampshire*	1977
Lincoln National Life Insurance Co./ Lincoln National Corporation *Fort Wayne, Indiana*	1972, 1990, 1992	**Meredith Corporation** *Des Moines, Iowa*	1985
The Lincoln Savings Bank *Brooklyn, New York*	1976	**Merrill Lynch & Co., Inc.** *New York, New York*	1984, 1985, 1986, 1987, 1988
R.H. Macy & Company, Inc. *New York, New York*	1967	**Mervyn's** *Hayward, California*	1983
John Madden Company *Englewood, Colorado*	1986	**Metromedia, Inc.** *New York, New York*	1969
Maguire Thomas Partners *Los Angeles, California*	1990	**Metropolitan Life Insurance Company and Metropolitan Life Foundation** *New York, New York*	1978, 1980, 1981, 1987, 1988, 1989, 1991
Manufacturers and Traders Trust Company *Buffalo, New York*	1975	**The Miami Herald Publishing Company** *Miami, Florida*	1984
Manufacturers Hanover Corporation *New York, New York*	1981, 1985, 1986, 1987	**Miller & Rhoads, Inc.** *Richmond, Virginia*	1967
Marine Midland Bank, N.A. *New York, New York*	1989	**Miller Brewing Company** *Milwaukee, Wisconsin*	1971
Mark Twain Bancshares *St. Louis, Missouri*	1969, 1978	**Minnesota Mining & Manufacturing Company** *St. Paul, Minnesota*	1984
I.W. Marks Jewelers, Inc. *Houston, Texas*	1990, 1991, 1993	**Mission Viejo Company** *Mission Viejo, California*	1984, 1985
Martin Marietta Corporation *Bethesda, Maryland*	1977, 1989	**Mobil Corporation/ Mobil Foundation** *Fairfax, Virginia*	1969, 1971, 1972, 1975, 1976, 1977, 1978, 1979, 1980, 1981, 1982, 1983, 1984, 1985, 1986, 1988, 1991
Kaye Marvins Photography, Inc. *Houston, Texas*	1987		
The May Department Stores Company *St. Louis, Missouri*	1985	**Modesto Lanzone's** *San Francisco, California*	1989
McClatchey Newspapers *Sacramento, California*	1969	**Monsanto** *St. Louis, Missouri*	1970, 1979, 1981, 1996
McDonald's Corporation *Oak Brook, Illinois*	1976, 1980	**Monumental Corporation** *Baltimore, Maryland*	1987

Morgan Construction Company *Worcester, Massachusetts*	1982	Northwestern National Bank of Minneapolis *Minneapolis, Minnesota*	1973, 1981
Morgan Guaranty Trust Company of New York *New York, New York*	1982	NYNEX Corporation (formerly New York Telephone) *New York, New York*	1987, 1989, 1992
Mountain Bell *Albuquerque, New Mexico*	1971	Occidental Petroleum Corporation *Los Angeles, California*	1981, 1983
Movado Watch Corporation *New York, New York*	1990	ODS Health Plans, Inc. *Portland, Oregon*	1995
Mrs. Paul's Kitchens Inc. *Philadelphia, Pennsylvania*	1975	Ogilvy & Mather *New York, New York*	1986
Murjani Industries Ltd. *Kowloon, Hong Kong*	1981	Old Kent Bank and Trust Company *Grand Rapids, Michigan*	1970
The Nasher Company *Dallas, Texas*	1976, 1987	Olin Corporation *Stamford, Connecticut*	1982
National Bank of Commerce *Lincoln, Nebraska*	1974	Olivetti Underwood Corporation *New York, New York*	1969
National Bank of the Commonwealth *Indiana, Pennsylvania*	1975	Olympia & York Companies (U.S.A.) *New York, New York*	1990
National Broadcasting Company *New York, New York*	1987	Olympia Brewing Company *Olympia, Washington*	1968
National Westminster Bank USA *New York, New York*	1985, 1987	Oneida Tribe of Wisconsin *Oneida, Wisconsin*	1987
NCNB Corporation *Charlotte, North Carolina*	1968, 1979, 1989	Oscar Meyer & Company *Madison, Wisconsin*	1976
Neiman-Marcus *Dallas, Texas*	1968, 1974	Owens-Illinois, Inc. *Toledo, Ohio*	1983
The New England *Boston, Massachusetts*	1986	Pacific Telesis Group *San Francisco, California*	1987, 1991
New England Fish Company *Seattle, Washington*	1973	PaineWebber Group Inc. *New York, New York*	1985
New England Telephone *Boston, Massachusetts*	1983	Panasonic Company *Secaucus, New Jersey*	1993
The News-Journal Corporation *Daytona Beach, Florida*	1991	Parisian Inc. *Birmingham, Alabama*	1974
Nissan Motor Corporation in U.S.A. *Carson, California*	1985	Paul Masson Vineyards *Saratoga, California*	1970
Norfolk Southern Corporation *Norfolk, Virginia*	1985	Pea Soup Andersen's Restaurants *Buellton, California*	1979
The Norlin Foundation *New York, New York*	1976	R.L. Peatross & Hueber, Inc. *Altamonte Springs, Florida*	1984
Northern Television, Inc. *Anchorage, Alaska*	1970	Peck Meat Packing Corporation *Milwaukee, Wisconsin*	1983
Northwest Energy Company *Salt Lake City, Utah*	1983		

Penn Central Transportation Company *New York, New York*	1973
J.C. Penney Company, Inc. *New York, New York*	1976, 1978, 1983
Pennwalt Corporation *Philadelphia, Pennsylvania*	1975
PepsiCo Inc. *Purchase, New York*	1981, 1984, 1987
Perkins Engines Group *Peterborough, England*	1974
Phelps Dodge Corporation *New York, New York*	1976
Phelps, Inc. *Greeley, Colorado*	1989
Philadelphia Gas Works *Philadelphia, Pennsylvania*	1969, 1970
Philip Morris Companies Inc. *New York, New York*	1967, 1972, 1975, 1977, 1978, 1979, 1980, 1981, 1982, 1984, 1985, 1986, 1987, 1990
Phillips Petroleum Company *Bartlesville, Oklahoma*	1979, 1982
Pilot Oil Corporation *Knoxville, Tennessee*	1987
Polaroid Corporation *Cambridge, Massachusetts*	1972
Primerica Corporation (formerly American Can Company) *Greenwich, Connecticut*	1985
The Principal Financial Group *Des Moines, Iowa*	1988
The Progressive Corporation *Mayfield Heights, Ohio*	1989
Prospect Hospital *Bronx, New York*	1972
The Prudential Insurance Company of America *Newark, New Jersey*	1975, 1976, 1978
PSI Energy, Inc. *Plainfield, Indiana*	1993, 1994
Public Service Company of New Mexico *Albuquerque, New Mexico*	1976
The Quaker Oats Company *Chicago, Illinois*	1979
Rapides Bank & Trust Company *Alexandria, Louisiana*	1983
Raytheon Company *Lexington, Massachusetts*	1977
RCA Corporation *New York, New York*	1977, 1979
Reader's Digest Association *Pleasantville, New York*	1969, 1976
Republic Acceptance Corporation *Minneapolis, Minnesota*	1979
Rexnord Inc. *Milwaukee, Wisconsin*	1981, 1982
Reynolds Metals Company *Richmond, Virginia*	1971
Rheingold Breweries Incorporated *Brooklyn, New York*	1967
Rich's, Inc. *Atlanta, Georgia*	1968
Riverside Press-Enterprise *Riverside, California*	1973
RJR Nabisco, Inc. *Winston-Salem, North Carolina*	1978, 1979, 1980, 1981, 1982
Robinson's of Florida *St. Petersburg, Florida*	1980
Rodale Press, Inc. *Emmaus, Pennsylvania*	1982
Rothman's of Pall Mall Canada Limited *Toronto, Canada*	1972, 1977
The Rouse Company *Columbia, Maryland*	1967, 1979, 1980, 1982, 1983, 1984, 1985
Rubbermaid Incorporated *Wooster, Ohio*	*1985*
Joel E. Rubin & Associates *New York, New York*	1987
Ruder Finn & Rotman, Inc. *New York, New York*	1969, 1973
S & C Electric Company *Chicago, Illinois*	1976
Sachs New York *New York, New York*	1970

SAFECO Corporation *Seattle, Washington*	1981	Society for Savings *Hartford, Connecticut*	1973
Sara Lee Corporation (formerly Consolidated Foods Corporation) *Chicago, Illinois*	1984, 1987, 1989, 1992	Sonoco Products Company *Hartsville, South Carolina*	1970
		Soo Line Railroad Company *Minneapolis, Minnesota*	1973
Jos. Schlitz Brewing Company *Milwaukee, Wisconsin*	1967, 1968, 1969, 1971, 1972, 1976	South Carolina National Bank *Columbia, South Carolina*	1991
SCM Corporation *New York, New York*	1977	South Central Bell Telephone Company *Birmingham, Alabama*	1978, 1985, 1986
Sea-Land Service Inc. *Edison, New Jersey*	1973		
Joseph E. Seagram & Sons, Inc. *New York, New York*	1977	Southeast Banking Corporation *Miami, Florida*	1976, 1977, 1978, 1979, 1980, 1981, 1982
Sears, Roebuck and Company *Chicago, Illinois*	1969, 1973, 1976	Southern Bell *Miami, Florida*	1988
Seattle Trust & Savings Bank *Seattle, Washington*	1981	Southern Furniture Market Center *High Point, North Carolina*	1976
The Second National Bank of Warren *Warren, Ohio*	1989	Southern New England Telephone Company/SNET *New Haven, Connecticut*	1984
Security Central National Bank *Portsmouth, Ohio*	1978	Southtown Economist, Inc. *Chicago, Illinois*	1972
Security Pacific National Bank *Los Angeles, California*	1978, 1980	Southwestern Bell Corporation *St. Louis, Missouri*	1986, 1987, 1988, 1989
C.J. Segerstrom & Sons *Costa Mesa, California*	1983, 1984, 1985, 1986, 1987, 1989, 1995	Sovran Bank/Central South *Nashville, Tennessee*	1988
Sentinel Star Company *Orlando, Florida*	1977	Springs Mills, Inc. *Fort Mill, South Carolina*	1971, 1979
The Seven-Up Company *St. Louis, Missouri*	1982	E.R. Squibb & Sons, Inc. *Princeton, New Jersey*	1976, 1979
Shaklee Corporation *San Francisco, California*	1982	St. Paul Area Chamber of Commerce *St. Paul, Minnesota*	1976
Shawmut Bank of Boston, N.A. *Boston, Massachusetts*	1975	The St. Paul Companies *St. Paul, Minnesota*	1992
Shell Oil Company *Houston, Texas*	1979, 1980, 1981, 1982, 1983, 1984, 1985, 1986	The Standard Oil Company of Ohio *Cleveland, Ohio*	1982
Shillito's *Cincinnati, Ohio*	1972	Stix, Baer and Fuller *St. Louis, Missouri*	1968
The Silvertree Hotel *Snowmass Village, Colorado*	1994	The Stratton Corporation *South Londonderry, Vermont*	1986
Simon's General Store *Ancram, New York*	1975	L.A. Swyer Company, Inc. *Albany, New York*	1983
SmithKline Beckman Corporation *Philadelphia, Pennsylvania*	1979	T.F.H. Publications, Inc. *Neptune, New Jersey*	1981

Tandy Corporation/Radio Shack *Fort Worth, Texas*	1985		TRW Inc. *Cleveland, Ohio*	1979, 1983, 1997
Tappan Air Conditioning Division *Elyria, Ohio*	1973		U S West *Englewood, Colorado*	1985
Targeted Communications Corporation *Falls Church, Virginia*	1984		U.S. Bank *Portland, Oregon*	1988
TECO Energy Inc. *Tampa, Florida*	1988		U.S. Pioneer Electronics Corporation *Moonachie, New Jersey*	1978
Tenneco Inc. *Houston, Texas*	1982		Wm. Underwood Co. *Westwood, Massachusetts*	1975, 1977
Texaco Inc. *White Plains, New York*	1967, 1978, 1981, 1983, 1990		Unicover Corporation *Cheyenne, Wyoming*	1980
Texas Eastern Corporation *Houston, Texas*	1983		Union Pacific Corporation *New York, New York*	1981, 1986
Texas Gas Transmission Corporation *Owensboro, Kentucky*	1979		UNISYS Corporation (formerly Burroughs Corporation) *Detroit, Michigan*	1979
J. Walter Thompson Company *Detroit, Michigan*	1971		United Airlines, Inc. *Elk Grove Village, Illinois*	1988
Tiffany and Co. *New York, New York*	1975		United Bank of Denver, N.A. *Denver, Colorado*	1971
Time Inc. *New York, New York*	1980, 1981, 1985		United Brands Company *New York, New York*	1973
Time Warner Inc. *New York, New York*	1993		United Coal Companies *Bristol, Virginia*	1979
The Times Mirror Company *Los Angeles, California*	1979, 1984		United Oklahoma Bank *Oklahoma City, Oklahoma*	1978
The Toledo Edison Company *Toledo, Ohio*	1967		United States Steel Foundation, Inc. *Pittsburgh, Pennsylvania*	1976
Tosco Corporation *Los Angeles, California*	1981		The United States Trust Company of New York *New York, New York*	1973
Touche Ross & Co. *New York, New York*	1972, 1978		United Technologies Corporation *Hartford, Connecticut*	1979, 1984, 1985, 1986
Trans World Airlines *New York, New York*	1969		Fredrick J. Urbaska Investments *Billings, Montana*	1991, 1994
Transamerica Corporation *San Francisco, California*	1982		US-USSR Marine Resources Co. Inc. *Seattle, Washington*	1982
Transco Energy Company *Houston, Texas*	1988		Valley Bank of Nevada *Las Vegas, Nevada*	1978
The Travelers Insurance Companies *Hartford, Connecticut*	1980		Valley Cable Television *Encino, California*	1982
The Troy Savings Bank *Troy, New York*	1989		Valley National Bank *Phoenix, Arizona*	1968

Vermont Marble Company *Proctor, Vermont*	1969	**Western Savings Bank** *Philadelphia, Pennsylvania*	1980
Vinson & Elkins L.L.P. *Houston, Texas*	1989, 1994	**Weyerhaeuser Company** *Tacoma, Washington*	1981
Wachovia Bank and Trust Co., N.A. *Winston-Salem, North Carolina*	1972, 1980	**WFMT, Inc.** *Chicago, Illinois*	1983
John Wanamaker *Philadelphia, Pennsylvania*	1974	**WGIR** *Manchester, New Hampshire*	1980
Warner Communications Inc. *New York, New York*	1980, 1981, 1982, 1983	**WGN Continental** **Broadcasting Company** *Chicago, Illinois*	1970
Waterville Valley Resort - **Waterville Company, Inc.** *Waterville Valley, New Hampshire*	1987	**Whirlpool Corporation** *Benton Harbor, Michigan*	1986
The Watson-Casey Companies *Austin, Texas*	1985, 1986	**Whitney-Fidalgo Seafoods, Inc.** *Seattle, Washington*	1973
WBZ-TV, Westinghouse **Broadcasting Company** *Boston, Massachusetts*	1968	**Williams Investments, Ltd.** *Thomasville, Georgia*	1987
Wells Fargo Bank Foundation *San Francisco, California*	1986	**The Winter Construction Company** *Atlanta, Georgia*	1985, 1986
West One Bancorp *Boise, Idaho*	1990	**Worthen Bank and Trust Company** *Little Rock, Arkansas*	*1970*
West Publishing Company *St. Paul, Minnesota*	1980	**WQXR Radio** *New York, New York*	1977
Western Airlines *Los Angeles, California*	1973	**WSIX Broadcasting Company** *Nashville, Tennessee*	1973
		Xerox Corporation *Stamford, Connecticut*	1970, 1971, 1976, 1979, 1981

Founders Award Recipients 1993-1997

Company	Year Received	Company	Year Received
American Express Company *New York, New York*	1992	**Hallmark Cards, Inc.** *Kansas City, Missouri*	1993
AT&T *New York, New York*	1992	**Metropolitan Life Insurance Company/ Metropolitan Life Foundation** *New York, New York*	1996
The Chase Manhattan Bank *New York, New York*	1994	**Mobil Corporation** *Fairfax, Virginia*	1994
Corning Incorporated Corning Incorporated Foundation *Corning, New York*	1995	**Philip Morris Companies Inc.** *New York, New York*	1992
Dayton Hudson Corporation *Minneapolis, Minnesota*	1992	**Sara Lee Corporation** *Chicago, Illinois*	1995
Ford Motor Company *Dearborn, Michigan*	1997	**Texaco Inc.** *White Plains, New York*	1992

Leadership Award Recipients 1993-1997

Recipient	Year Received	Recipient	Year Received
Winton M. Blount *Chairman of the Board Blount, International, Inc. Montgomery, Alabama*	1995	**Henry T. Segerstrom** *Managing Parter C.J. Segerstrom & Sons Costa Mesa, California*	1993
Eli Broad *Chairman and Chief Executive Officer SunAmerica Inc. Los Angeles, California*	1997	**James D. Wolfensohn** *President and Chief Executive Officer James D. Wolfensohn Incorporated New York, New York*	1994

Awards Art Commissions

Year	Artist	Title	Year	Artist	Title
1967 - 71	Award Plaques		1986	Richard Anuszkiewicz	*Trans-Lumina with Turquoise*
1972 - 76	Demetrois Mavroudis	*Untitled Sculptures*	1987	Romare Bearden	*Out Chorus*
1977	Stanley Boxer	*Untitled*	1988	Louisa Chase	*Untitled*
1978	Romare Bearden	*Untitled*	1989	Robert Peterson	*Spiral*
1979	Alice Neel	*Untitled*	1990	Louise Bourgeois	*Progression*
1980	Will Barnet	*Woman, Cat and Yarn*	1991	Judy Pfaff	*Cat's Cradle*
1981	Chi Chen	*Spring in Central Park*	1992	John Buck	*A Little America*
1982	Carol Summers	*Athos*	1993	Alison Saar	*Stride Piano*
1983	Bob Haozous	*Untitled*	1994	Yvonne Jacquette	*Aerial Rotation*
1983	Ed Paschke	*Execo*	1995	April Gornik	*Waterway*
1984	Mattie Lou O'Kelley	*Thanksgiving Visitors*	1996	Mary Miss	*Untitled*
1985	Lois Lane	*Untitled*	1997	Maya Lin	*Flatland*

BCA Affiliates

Austin Business Committee for the Arts
Austin, Texas

Colorado Business Committee for the Arts
Denver, Colorado

Dallas Business Committee for the Arts
Dallas, Texas

Montgomery Area Business Committee for the Arts, Inc.
Montgomery, Alabama

New Hampshire Business Committee for the Arts
Concord, New Hampshire

Northwest Business Committee for the Arts
Portland, Oregon

Orange County Business Committee for the Arts, Inc.
Costa Mesa, California

Tampa Bay Business Committee for the Arts, Inc.
Tampa, Florida

International Associations

Austria
Austrian Business
Committee for the Arts
Wirtshaft für Kunst
Vienna

Belgium
Foundation for the
Promotion of the Arts
Foundation pour la
Promotion des Arts —
Prométhéa
Brussels

Foundation for the
Promotion of the Arts
Stichting voor Kunstpromotie
Brussels

Canada
The Council for Business and
the Arts in Canada (CBAC)
Toronto, Ontario Canada

France
Association for the Development
of Industrial & Commercial Cul-
tural Support (ADMICAL)
Association pour le Développe-
ment du Mécénat Industriel et
Commercial
Paris

Germany
Germany Arts Sponsorship
Working Group
Arbeitskreis Kultursponsoring
Cologne

Greece
Association for the Support of
Cultural Activities
(OMEΠO)
Athens

Ireland
The Business Council for the Arts
(Cothú)
Dublin

Israel
Business for the Arts (ALMA)
Tel Aviv

Italy
Fitzcarraldo s.r.l.
Torino

Japan
Association for Corporate Sup-
port of the Arts
Kigyo Mécénat Kyogikai
Tokyo

Korea
Korean Business Council
for the Arts
Seoul

The Netherlands
Dutch Advertising Association
for Arts Sponsorship
Genootschap voor Reclame
Sectie Sponsors voor Kunst
Amsterdam

South Africa
Business Arts South Africa
Johannesburg

Spain
Spanish Association for the
Development of Business
Sponsorship (AEDME)
Asociación Española para el
Desarrollo del Mecenazgo
Empresarial
Barcelona

Sweden
Swedish Association for
Business Sponsorship
Föreningen Kultur och Näringsliv
Stockholm

Switzerland
Swiss Association Economy
for the Arts
Schweizerische Vereinigung
Wirtschaft für die Kultur
Zurich

United Kingdom
Association for Business
Sponsorship of the Arts (ABSA)
London

Index

Photo Credits

The photographs of all of the business executives — with the exception of Randall L. Tobias, Eli Lilly and Company, David R. Goode, Norfolk Southern Corporation and Yoshihara Fukuhara, Shiseido Co., Ltd. — were taken by David Finn. Michael Schubert photographed David Finn. All other photographs were provided by the companies and arts organizations mentioned throughout the book. The following photo credits were requested: page 20, David Finn - Henry Moore sculpture; page 39, R. Kusel Turandot; page 41, Shaun Proctor; page 44, Carol Rosegg; page 46, Robert Ruschak; page 50, Roger Mastroianni - Blossom Music Center; page 51, Anastasia Pantsios; page 52, Roger Mastroianni; page 53, J.J. Prekor - Ohio Ballet, Roger Mastroianni - Cleveland Orchestra; pages 74-75, Lyons Photography, Mark and Cathy Lyons; page 89, Mike Fender; page 92, Stan Sholik; page 94, Michael Daniel; page 100, Larry Stein - "Messing Around in Boats;" pages 106-107, David Finn; page 116, Jim Caldwell; page 117, Ellis Vener; page 118, Key Sanders - Wortham Theater Center; Sheila Cunningham Photography - "Diamonds & Divas;" page 119, Jim Caldwell; page 128, Malcolm Varon - "Hunting Wild Turkey;" page 131, Paul B. Goode - Alvin Ailey Repertory Ensemble; page 140, Peter Aaron - The Chrysler Museum of Art; page 164, Photonics Graphics - Cincinnati Ballet; pages 188-189, David Finn; page 200, Kelman Design Studio - Holocaust Museum Houston; page 201, Ava Jean Mears; page 202, Jim Caldwell; page 203, Jim Caldwell - Houston Grand Opera, Geoff Winningham - Houston Ballet; page 208, Schecter Lee - Shakespeare & Company.

Special Thanks

This book was made possible through the efforts of many. Special thanks to Shisho Matsushima, Managing Director of Strategies Inc. who conducted the interview with Yoshihara Fukuhara, Chairman of Shiseido Co., Ltd. in Tokyo; to Stacey R. Dodge, Jemma Gould and Dr. Ensaf Thune for their editorial direction and assistance; to Christopher Forbes, Vice Chairman, Forbes Inc. for providing encouragement to transform the BCA advertising campaign into a book; and to Arthur Lubow, President, AD Lubow, Inc. for creating the title.

Thanks, too, to the persons at the various companies who assisted in gathering information, including: Michael Kuhlin, Ameritech; Sandy Dietch, Bayer Corporation; Lois Sumegi, The BFGoodrich Company; Shirley Milligan, Blount International, Inc.; Alice Sachs Zimet and Kathleen Pavlick, The Chase Manhattan Bank; Joseph Hale, Cinergy Corp.; Paul Freeman and Lori White, C.J. Segerstrom & Sons; Ben Cameron, Dayton Hudson Corporation; Thomas King, Eli Lilly and Company; Suzanne Huffmon Esber and Kim Morgan, Fluor Corporation; Margaret Kelly-Trombly; Forbes Inc.; Ronald Reis, Goldstein Golub Kessler & Company, P.C.; Howard Spector, Guardsmark, Inc.; Susan Farb, I.W. Marks Jewelers, Inc.; Irene Wong, Metropolitan Life Insurance Company; Annette Williams and Elliot Cattarulla, The Nasher Company; Leanne McGruder, Norfolk Southern Corporation; Mark Vassallo and Linda Sullivan, PaineWebber Group Inc.; Colleen Vojvodich, The Principal Financial Group; Charlotte Otto, The Procter & Gamble Company; Robin Tryloff, Sara Lee Corporation; Hiromi Takatsuji, Shiseido Co., Ltd.; Robert Thompson, Springs Industries, Inc.; Joanne Heyler, SunAmerica Inc.; Glen Rosenbaum, Vinson & Elkins L.L.P.; and Joseph Cahalan, Xerox Corporation.

A special thanks to past and present BCA staff members for their myriad contributions: Diane L. Blair, Michele C. DeSantis, Elena T. Dinh, Paula D'Introno, Amy Gong, Melanie Gribbin, Marquita Harris, Catherine Herrold, Dee Hughes, Allison V. Malcolm, Sarah S. Marcus, Kelly A. Reuba, Abigail V. Treu and the BCA Affiliate Directors: Elmore DeMott, Joan Goshgarian, Kathleen Johnson-Kuhn, Betty Moss, Tina Poe, Patricia Porter and Franci Golman Rudolph; Ruder·Finn staff members: Kyle Johnson, Rosie Lue, Helen Manganello and Susan Slack and the Ruder·Finn Design team of Michael Schubert, Lisa Gabbay, Gregory Lipman, David Rubin and Steve Brady for their contributions.